THE
CARRY ON
GIRLS

THE CARRY ON GIRLS

GEMMA
ROSS
AND ROBERT
ROSS

To our mothers, Francesca Fanning and Eileen Ross,

Two very strong and independent women of the *Carry On* era.

With love.

First published 2023
Reprinted 2024

The History Press
97 St George's Place, Cheltenham,
Gloucestershire, GL50 3QB
www.thehistorypress.co.uk

British Library Cataloguing in Publication Data.
A catalogue record for this book is available from the British Library.

ISBN 978 1 80399 340 9

Typesetting and origination by The History Press
Printed in India, by Thomson Press Ltd

CONTENTS

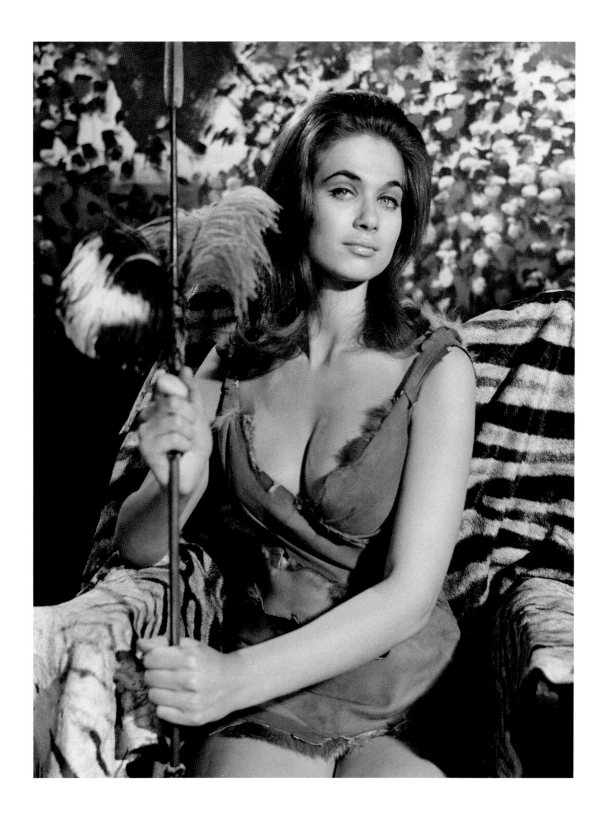

FOREWORD BY VALERIE LEON

When I made my first faltering steps into the world of *Carry On* one chilly day back in 1968, little did I think it would be the start of my ongoing and seemingly everlasting identity as a 'Carry On' Girl' – let alone that many years later I would be writing the introduction to this wonderful book celebrating the girls of *Carry On*!

Oddly enough, my entire career came about almost by accident. As a child I was stage-struck and used to hang around stage doors to collect autographs, but I never seriously expected to take to the stage myself because I was terribly shy and introverted. This may seem strange, given my image as a man-eating temptress, but nothing could have been further from the truth at that time in my life!

After I left school, my mother encouraged me to apply for a place at RADA but unsurprisingly I failed the audition. Putting all thoughts of show business aside I began working in sales for a fashion house called Dereta, and then became a trainee fashion buyer at Harrods in Knightsbridge before eventually becoming controller of their sportswear department. Actually, I got my first taste of acting when I joined the Harrodian Entertainments Society and appeared in a play called *The Shop at Sly Corner*.

Over Christmas 1965, I went carol singing with the actress Eleanor Bron, who told me she had an excellent singing teacher. I signed up for lessons with the same lady, and she encouraged me

Valerie Leon in her signature comedy role as Leda of the Lubi Dubbi tribe in *Carry On Up the Jungle*.

to read *The Stage* newspaper where I would find details of new shows that were casting. One day, *The Stage* announced that singers were required for a musical called *Belle of New York*, so just for fun I played truant from Harrods, went along to the audition, and amazingly enough got the job! I say amazingly because I was head and shoulders taller than all the other chorus girls – and indeed some of the men!

When *Belle of New York* finished, I went up for the highly anticipated West End musical *Funny Girl* starring Barbra Streisand, and after six auditions I was finally cast as a Ziegfeld showgirl with a small speaking role. Working in a smash hit show with Barbra, THE superstar of the day, was something of a dream come true. It was a great credit to have on my CV, and when the show closed it led to small roles in films and on television.

One day in April 1968, along with several other young hopefuls, I found myself walking through the gates of Pinewood Studios to be seen for *Carry On … Up The Khyber*, the sixteenth in the wildly successful film series, and you could say I have never looked back. As a harem girl in the court of the Khasi of Kalibar, played with unforgettable aplomb by the outrageous Kenneth Williams, I did little more than proffer fruit and try to look exotic, but it was a start.

Six months later I was delighted to be back at Pinewood filming *Carry On Camping*, in which I struggled to keep a straight face whilst showing Charles Hawtrey how to put his pole up! His TENT pole, I hasten to add! We had tremendous

trouble with the censor over that risqué line. It was an extra bonus that my scene featured three of the team I had worked with in *Khyber*: Charlie Hawtrey, Sid James and Bernie Bresslaw.

In March 1969 I was back – this time as Jim Dale's amorous secretary Deirdre in *Carry On Again, Doctor*, vamping away as if there was no tomorrow. A couple of years earlier I had played Jim's fairy godmother in pantomime at Bromley, so it was another happy reunion.

In October 1969 I filmed *Carry On Up the Jungle*, my personal favourite of the six films I made with the team. Dressed in a fur bikini à la Raquel Welch in *One Million Years BC*, I played the aptly named Leda, head of an intrepid all-female tribe called the Lubi Dubbis. We inhabited the village of Aphrodisia and were manhunters of a different variety! Once again, I shared scenes with Sid, Charlie and Bernie, as well as another cast member I had worked with previously, the inimitable Frankie Howerd. Frankie and I got on very well, and he and Joan Sims were old pals and wonderfully funny together. They could not stop giggling during filming, and I am smiling even now thinking of them in the scene with the snake.

In 1972's *Carry On Matron* I was Jane Darling, a heavily pregnant film star admitted to the event-filled hospital ruled by Matron Hattie Jacques, where my triplets were eventually delivered by 'nurse' Kenneth Cope. Hattie was such a wonderful warm human being and so very kind. She was beloved by every single member of the cast and crew.

I was back with Hattie, as well as Joan, Barbara Windsor, Kenneth Connor, Peter Butterworth and Jack Douglas for the seasonal television special that year: the *Carry On Christmas* for 1972 – this is also blessed with the cheeky alternative title of *Carry On Stuffing*!

My final appearance of the series was in *Carry On Girls*, playing Bernard Bresslaw's uptight girlfriend, Patricia Potter, who later blossoms into a beauty contestant and shares the catwalk with Barbara Windsor and Margaret Nolan. The severe-looking glasses I wore as plain Patricia were in fact my own, which I had used when working at Harrods before I invested in contact lenses!

And only recently did I learn through an agent friend that in late 1973 I might have had the opportunity to work one last time with the gang, in the musical comedy revue *Carry On London!* at the Victoria Palace Theatre. I was on the list of casting ideas but, unfortunately, I was already committed to other projects.

I treasure my memories of working with great talents such as Sid, Kenneth, Hattie, Charlie, Bernie and co., and I will never forget how warm

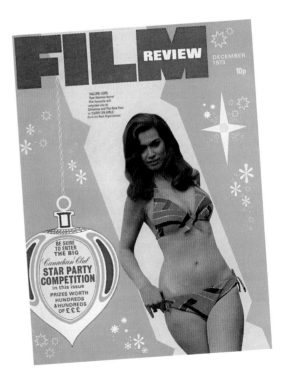

A Hammer glamour girl thanks to *Blood from the Mummy's Tomb*, Valerie was your 1973 Christmas Cracker for the December release of *Carry On Girls*.

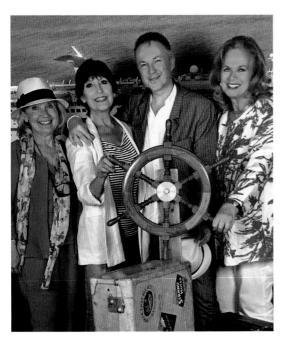

Jacki Piper, Anita Harris, Robert Ross and Valerie Leon off *Carry On Cruising* for Cruise & Maritime Voyages, in 2017.

and welcoming Barbara Windsor was to me. She took me under her wing and really was the epitome of the joyous, earthy, funny Cockney sparrow – a true professional who could sing, dance, make you laugh and make you cry. Sid James was a true gentleman and not at all like his lecherous *Carry On* persona. In the 1960s, along with many young actresses, I often had to endure unwanted attention which nowadays would be deemed sexual harassment, but on the *Carry On* set I never saw any such behaviour – and, in fact, Sid was very quick to step

in and intervene when a visiting executive once tried it on with one of the girls.

I have been so fortunate in my career to have been associated with three iconic British film institutions: Hammer Horror (in *Blood from the Mummy's Tomb*), James Bond (in *The Spy Who Loved Me* and *Never Say Never Again*) and of course the *Carry On* series. I love greeting fans of all three genres at conventions throughout the world, and I am always delighted by how many young people tell me they have grown up watching the *Carry On*s and how much they enjoy them. In recent years I have even joined BritMovieTours on their tours of the *Carry On* film locations, meeting fans in the pub featured in *Carry On Dick*. The legacy of *Carry On* is still very much a big part of my life.

I formed enduring friendships with several of my fellow *Carry On* girls, most especially the late Maggie Nolan, the irreplaceable Fenella Fielding, and my great friend Jacki Piper. A few years ago, Jacki and I joined Anita Harris on a wonderfully happy *Carry On*-themed cruise organised by Robert Ross, co-author of this book. He is the official *Carry On* historian, and someone I have known since he was a very young aspiring writer and fan! Jacki, Anita and I had the best time ever, laughing uproariously as we recounted stories of our days as *Carry On* girls. And even though it is many years since the series came to an end and we have all matured, *Carry On* GIRLS we will remain, as the films continue their extraordinary popularity on television, DVD, Blu-ray and beyond. May they *Carry On* forever!

Valerie Leon
London
March 2023

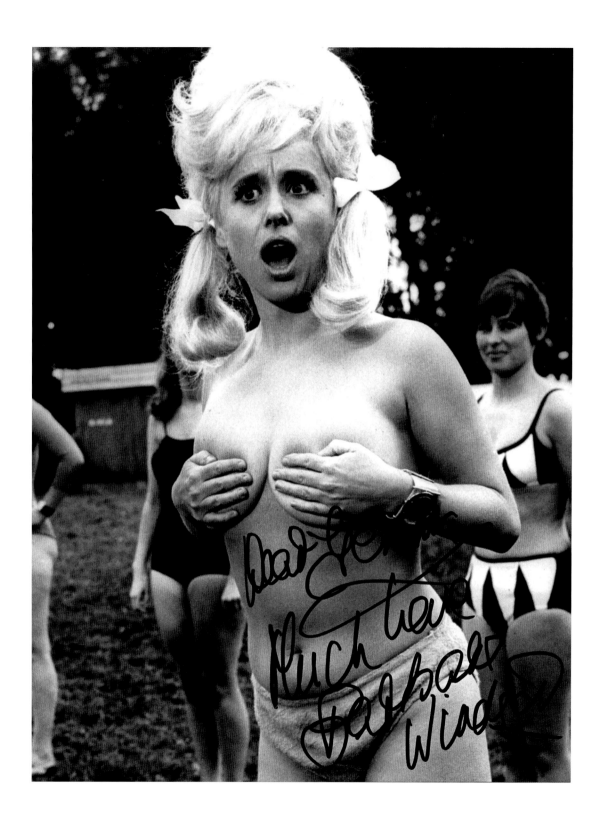

INTRODUCTION BY GEMMA ROSS

My first encounter with the *Carry On* films was at a young age. My grandmother took my brother and me to Blockbuster video store every Saturday and introduced us to an array of films, including the greats such as *Gone with the Wind*, *My Fair Lady* and *The Sound of Music*. It must be said though, that before I hit the heavier stuff, I was introduced to *Carry On Up the Jungle*. I distinctly remember seeing the cover with Valerie Leon towering over the lecherous Sid James, and I was intrigued. To me Valerie was (and still is) one of the most beautiful women in film. How brave to be standing there, in a skimpy outfit and oozing charm and strength as a woman. I don't view this as sexist at all, although many may argue it's a poor portrayal of women in film, to have such beauty, in little clothing, on the cover of the VHS.

When we set out to create this book, we felt the need to turn to some research into the subject of women and humour. It is argued that women fit into categories: the spinster, the feminist, the girl next door etc. However, academics will go on to argue that other than giving them a label there is no psychological depth to these roles. Yet, women are funny! Many will argue that women in *Carry On* films are being sexualised for the male characters; however, it is my belief the writers choose particularly to go deeper than this, and allow the women to have the last laugh.

Barbara Windsor, in her iconic *Carry On Camping* moment, signed to the author at the Cinema Museum, in November 2015.

If we conduct historical research of women in literature, one of the first female authors to present women as humorous was Jane Austen. As women, we know how to joke, despite the argument that it is men who decide what is universally funny. Women tend not to find certain situations funny, such as a spate of back luck or being embarrassed. However, women do laugh and when we do, we do it with great enthusiasm. This is why I believe so many women love *Carry On*. Women laugh at situations which enable us to feel empowered; we also find systematic misappropriation funny. Our humour is based on the controls we have on our own lives, and this is certainly something the *Carry On* girls give us. The women tend to have the last laugh. A scene which springs to mind is one in *Carry On Henry*, in which Sid James takes Barbara Windsor outside for a bit of fresh air and a chance to play his card. It is Barbara, though, who has the last laugh, by placing two watermelons in Sid's hands before giggling and running away. Here is a perfect example of a woman in control and taking over the situation, thus resulting in females roaring with laughter, because she has got one over on poor old Sid. We've all been there: how many times do our girlfriends call us after a date and relate the stories of how they defeated the man? And we laugh!

Perhaps the best argument for women laughing at comedy is that if the joke is about 'us' and told by 'us' then it's okay. However, if the joke is about 'them' then the 'us' part will make us feel offended. Interestingly, though *Carry On* was

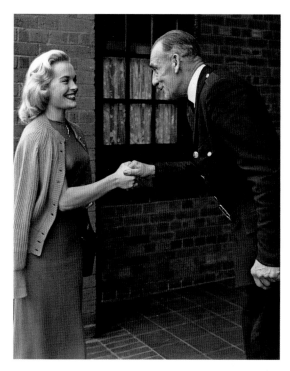

Old School Film-Making: Shirley Eaton is greeted by the Pinewood Studios commissionaire during the production of *Doctor at Large*, in 1956.

film set, there is no girl there at all. Once Gerald has got all the shots he wants of the girl, he sends her home. Then he takes her place. So the reaction shots you see on the screen of a bloke getting going, are done opposite Gerald. He sits there and prompts you. 'Come on,' he says, 'you're throbbing with it. She's getting them out! You can't believe your eyes!' And, of course, you respond to this like mad.

I believe that this is something which was quite forward thinking of the director. The fact that he was so protective of the ladies and sent them home so they didn't feel objectified, is something we don't hear too much about in films of the era, or indeed today.

A wonderful piece of modern research has highlighted the difference between what men and women find funny; women do not like to have their appearance commented on, and this can lead to mental health issues, whereas men do not like to be told they're weak or vulnerable. Although, upon reflection, perhaps one of the biggest arguments we miss about *Carry On* films and their relevance today, is that they do indeed also poke fun at male weaknesses. Calling back to *Carry On Henry*, it is poor Sid James who is subjected to this, whilst Mistress Bettina (Barbara Windsor) runs off with the younger, richer and more handsome Francis King of France (Peter Gilmore). Sid's King Henry VIII also has to contend with the insult that his current wife, Queen Marie (Joan Sims), gives birth to a child conceived by another man.

When celebrating our favourite actors, we split them between men and women, e.g. best female artist, best male actor, best actress, the list is endless. It is only really in the last two years we have started to see the likes of BAFTA-nominated actors as a whole. We have made it far too specific with 'male' comedy and 'female' comedy, but why do we do this? Perhaps because with comedy

produced, directed and written by men, the affection the ladies have towards the scripts and the way director Gerald Thomas took care of them rings true for all the ladies who were involved in the films. How Gerald Thomas, in particular, looked after the ladies on set is a little-known fact. It was none other than Kenneth Williams who revealed a story about how love scenes or, dare I say it, scenes which could be seen to objectify women, were shot. During the filming of the links for *That's Carry On*, Kenneth was feeling nostalgic, but he was also perceptively reflective on the making of the comedy:

When you see a love scene in a *Carry On* film or a bloke getting in a lather over some girl's boobs, the chances are that, in reality on the

we map out every detail of our lives and how we respond to it comedically – be it religion, race, social class, age and of course, men and women. All of these are undoubtedly a way in which we respond and subject ourselves to comedy. However, *Carry On* was always the star, no man or woman was above its title. Of course, certain actors were paid more, but this was not down to gender – in fact, Jim Dale received the same pay as Joan Sims in certain films – it was merely down to favouritism and simply most of the favourites of the time were men.

There is an argument today, in 2023, that *Carry On* films would no longer be considered to be funny for fear of upsetting certain generations. How often do we hear that phrase 'I used to be able to crack this joke, but now women are in the workplace I can't say it for fear of offending the ladies'. Yet I find this more of a sexist remark than that of the actual joke. It's about educating, and understanding the concept of the joke. If I look back on *Carry On*, personally, I did not feel offended by anything; in fact, I would often hear people say these are family films. Sure, I didn't always get the joke – I think it took me until my mid-twenties to understand the joke from *Carry On Abroad*, another classic scene with Sid and Barbara where he says 'How about the other half?' referring to her top, and her not really getting it, very much like me. However, he quickly realises what he's said, and I like to think a moment of 'oops did I just say that out loud' to save Barbara the embarrassment. Going back to my first point, women don't find being embarrassed funny, but we do laugh when we see the guy is uncomfortable. We girls come out on top again! If you pardon the pun!

I think another important argument to make about the *Carry On* girls is why would they (to coin a phrase) *Carry On* making the films if they felt a) objectified and b) underpaid? Well, Hattie Jacques summed up with this answer: 'For fun. Not for the money. No, that's not quite fair. But it was for fun … Good chums … We used to have lots of laughs.' Along with Hattie's comments, June Whitfield touched on the point that whether you loved or hated them, the critics would endlessly discuss them, but for everyone else, we continue to look back on them with fondness and memories of the very best in British comedy.

Angela Douglas, as Annie Oakley in *Carry On Cowboy*, was a seasonal pin-up during the film's release in December 1966.

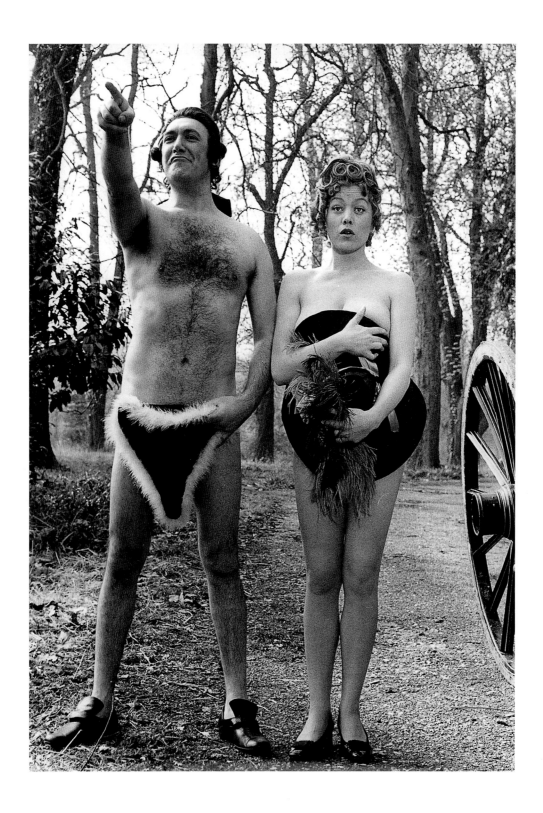

Left: Sir Roger Daley (Bernard Bresslaw) and his wife (Margaret Nolan) are stripped of everything by the notorious highwayman Big Dick Turpin, in *Carry On Dick*.

Below: A cheeky reverse angle of the scene during filming, with director Gerald Thomas in dark glasses, chuckling merrily, and proof of the production's laudable protection of Maggie's modesty thanks to a pair of briefs. Bernie was given no such luxury!

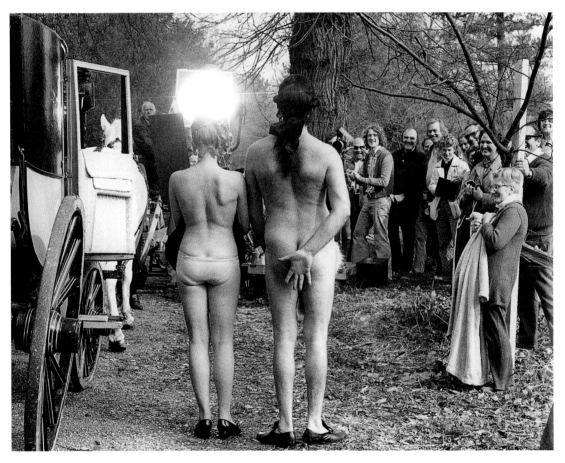

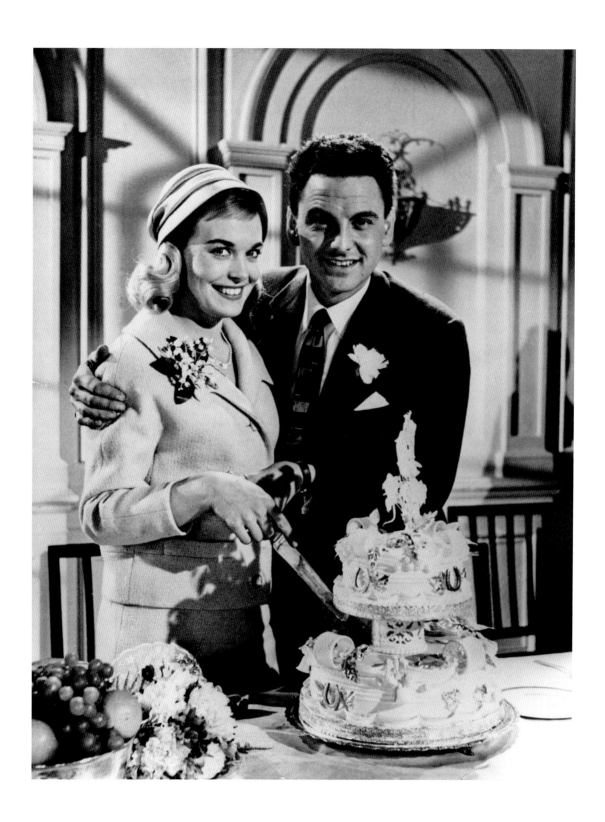

THE GIRLS

SHIRLEY EATON

The typical girl next door, as long as your neighbours were Princess Margaret and Kenneth More, Shirley Eaton had a dash of the derring-do of a Hitchcock Blonde, and remains an icon of postwar British film.

Having made her debut in revue at the age of 12, Shirley found stardom opposite Dora Bryan in *At the Lyric*. She provided glamorous support for the star comedian on television, notably episodes of *And So to Bentley*, with Dick Bentley, and *Mostly Maynard*, with Bill Maynard. Shirley even had her own adventurous comic strip in *TV Fun*.

Early, eye-catching film appearances include *You Know What Sailors Are*, written and produced by Peter Rogers in 1953; *Doctor in the House*, produced by Peter's wife, Betty Box, in 1954; playing Arthur Askey's daughter in *The Love Match* (1955); and as one of the three gorgeous young ladies in *Three Men in a Boat* (1956).

By the winter of 1957, Shirley had joined the top comic ranks of Peggy Mount, Peter Sellers, and Terry-Thomas, as one of Dennis Price's blackmail victims in Mario Zampi's jet black comedy hit *The Naked Truth*. Hardly surprising then that Peter Rogers turned back to this attractive and very able leading lady to play bride Mary Sage in *Carry On Sergeant*, with a £1,000 pay cheque for the 21-year-old starlet – the same fee as seasoned British film actor Bill Owen, and £100 more than Kenneth Williams!

Shirley was on-call at Pinewood Studios for extensive publicity photographs on 15 April 1958, returning on 24 April, the first day of the schedule, to shoot the first of eleven days on set. A historic day to be sure; our original *Carry On* girl, Shirley Eaton, is far from the image of a sweet little housewife. Bearing in mind the year that this film was produced, and the stereotype and expected behaviour of a newly-wed from this era, Shirley's performance taps into the deconstructive script of Norman Hudis, to show that she is far from her sex's expectations in society. She is sassy, cunning and determined.

Newly-weds Mary and Charlie Sage (Shirley Eaton and Bob Monkhouse) in a publicity pose from the very first scene of the one that started it all, *Carry On Sergeant*.

Shirley returned to the series for a guest star cameo as Sally Barry in *Carry On, Constable*. Her marquee value was utilised in the publicity, including this alluring portrait.

With her husband called up on their wedding day, she does not dutifully sit at home waiting for his return. She follows him, determined to spend her wedding night with her new husband. In fact, Bob Monkhouse is resigned to the fact of spending the night alone. As the pioneer of the franchise, Shirley establishes the morality and sexuality of women throughout the series. She paves the way for the determined screen sirens personified by the Lubi Dubbis in *Carry On Up the Jungle* to the playful Barbara Windsor, turning the tables and pinching Peter Butterworth's bottom in *Carry On Girls*, via June Whitfield enthusiastically throwing off her inhibitions and having a fling with Georgio the barman (Ray Brooks) in *Carry On Abroad*.

Shirley gracefully returns as the staff nurse in *Carry On Nurse*, falling under the spell of the dashing doctor (John Van Eyssen) but finally succumbing to the gorgeous reporter Ted York (Terence Longdon). She is sublime as the perfect nurse, but maintains that twinkle in her eye as she tells a floundering Joan Sims to put the suppository in the 'other end'. At this point though we see Shirley's worth to the studio and its producers, with a pay increase of £250. Indeed, already recognised as the leading lady of the company, Shirley's income for just nineteen days' work on the film was exactly the same as co-star Kenneth Connor. Furthermore, film actor of nearly forty years' experience and fellow *Carry On Sergeant* cast member Charles Hawtrey was paid just £800 for the film. It is clear there were no gender discrepancies in pay here, and Shirley was in fact being paid in relation to her performance and billing.

It's also Shirley's favourite *Carry On*. She chuckles:

> Those of us who had been in the original production were delighted to be back together again, at Pinewood Studios, for *Carry On Nurse*. Only Kenneth Connor had sensed

She was aware of her impact from an early age, and the camera simply adored Shirley. Here, in *Carry On, Constable*, it's Leslie Phillips as Police Constable Tom Potter who is getting hotter under the collar.

something special about *Carry On Sergeant* but even he wasn't all 'I told you, so!' while we were filming *Nurse*. It was just another film, but we were part of a gang now: the *Carry On* team. It was all very exciting and, as far as I'm concerned, the films never got funnier than the operating room scene, with the laughing gas. My fellow mad men were hilarious in that. *Carry On Nurse* is the tops, but I would say that, wouldn't I?

It was during the making of *Nurse* that Shirley found out she was pregnant, and thus unavailable for the next film, *Carry On Teacher*. That didn't stop the publicity department adorning the poster with a caricature of a sexy educator that looked exactly like Shirley Eaton! She would return for the glorified cameo of Sally Barry in *Carry On, Constable*. A fond farewell to the franchise that she had helped define and a personal favour to the series, one which was fully exploited in terms of her '& Shirley Eaton' billing on the poster. Shirley's appearance was also tied in with a skilful marketing campaign with the Kayser Bondor lingerie and gingham sleep coat that she wears in the film. When *Constable* was released

across the United States as 'the clowning achievement of the year' in 1961, Shirley's come-hither likeness was fully to the fore on the poster.

In British screen promotion too, it was happily noted that during location filming, when Sid James escorted Shirley across the road, her loveliness had stopped traffic.

In a quick burst of screen activity thereafter Shirley capitalised on her increased marquee value and escalating wages by accepting even more lucrative leading lady roles in film producers' deliberate attempts to cash in on the craze for *Carry On*. In the winter of 1960, Shirley was back with Sid James, over at Hammer Films, for the caravan caper *A Weekend with Lulu*. The film, starring Bob Monkhouse, was released the following spring, during which time Shirley was filming a jolly reunion with *Carry On Sergeant*

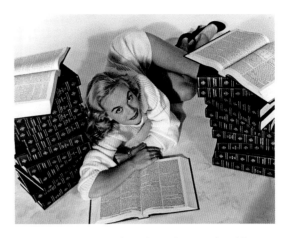

Brains and beauty combined was the spearhead for this publicity photograph session for the Betty Box production *Doctor at Large*.

cohorts Monkhouse, Kenneth Connor, and Eric Barker, for *Dentist on the Job*. Foreign territories even released it as *Carry On TV*.

Later in 1961, Shirley was back with Connor, as his leading lady in the Royal Air Force comedy film *Nearly a Nasty Accident*, and the haunted house romp *What a Carve Up!*

Thereafter it was mostly intrigue and espionage, including the first episode of *The Saint*: 'The Talented Husband' (30 September 1962), with Roger Moore at Elstree Studios, and a return to Pinewood to play the ill-fated golden girl Jill Masterson in the third James Bond film, *Goldfinger* (1964). There was Agatha Christie incrimination in *Ten Little Indians* (1966), sub-aqua adventure in *Around the World Under the Sea* (1966), and an encounter with Christopher Lee's inscrutable oriental mastermind in *The Blood of Fu Manchu* (1968).

Happily retired to family life in the sun, thirty years later Shirley published her memoirs, *Golden Girl*, and enjoyed a lengthy career on the signing convention circuit. Once a Bond girl, forever a Bond girl; and once a *Carry On* girl, forever a *Carry On* girl.

Their first tiff! Shirley Eaton playfully minces Bob Monkhouse's hand in this hilarious, candid publicity lark during the making of *Carry On Sergeant*.

DORA BRYAN OBE (1923–2014)

Having made her West End debut in Noël Coward's *Peace in Our Time* and immediately followed that production with a two-year run opposite Yvonne Arnaud in *Traveller's Joy*, Dora Bryan was gloriously philosophical about her concurrent roles in British film. 'If they wanted a shop girl, a barmaid, or a tart with a heart they would usually call me in. I was grateful for the work, but it wasn't the most challenging.' Indeed, her first screen role was as a girl in a telephone kiosk in Carol Reed's *Odd Man Out* (1947). The following year, Reed used her again, this time as Rose in *The Fallen Idol*. Dora was a sales assistant in Harold French's comedy *Adam and Evelyne* (1949) shot at Pinewood Studios, and was a beautician in *Don't Ever Leave Me* (1949). At Ealing Studios, she was cast as goodtime girl Maisie in pivotal police drama *The Blue Lamp* (1950), while Hammer Films saw her as La Fosse in rollicking crime thriller *Whispering Smith Hits London* (1951).

It was on cinema's poverty row that Dora began to enjoy fuller, funnier roles, memorably Tilly, the inquisitive girlfriend of policeman Richard Wattis, in *Mother Riley Meets the Vampire*; and the rather malicious Peggy Stebbins in *Time, Gentlemen, Please!* (both 1952). Soon after, she was swimming in the ken of Peter Rogers, playing Gladys in *You Know What Sailors Are*.

She was Berengaria in *Mad About Men* (1954), Ralph Thomas's sequel to the Glynis Johns mermaid comedy *Miranda*; Sergeant Hortense Tipp in the Tommy Trinder vehicle *You Lucky People* (1955); and Lily, opposite Alastair Sim, in *The Green Man* (1956). By the September of that year, she was such a family favourite that Granada Television launched her in her own situation comedy, *Our Dora*. Ill health forced her out of the show after just four episodes, with Eleanor Summerfield being drafted in as replacement and the show's rebranding as *My Wife's Sister*.

Dora returned to work at the behest of comedian Ronald Shiner, playing his wife in *The Love Birds*, at the Adelphi theatre. Dora's first return to film was *Carry On Sergeant*.

Dora is NAAFI girl, Norah. She is the girl who is desperate to find a husband. A great contrast with Shirley Eaton, the girl who, in Norah's eyes, appears to have it all. Even so, she takes pity on Shirley, offering her a job, despite the high heels and the fact she has never worked in a NAAFI before. She certainly can't cut chips, that's for sure. Still, the two rub off on each other, coaxing one another to get their man. Norah isn't afraid to play her card when a nervous Kenneth Connor is shying away from her intentions. It was quite groundbreaking to see a lady chase after a man on screen, but to get married and have a family was the goal of many women watching the film in the late 1950s. When girls left school, the vast majority went straight into work as secretaries, bank tellers or clerical workers, sales clerks, private household workers and teachers – in fact, all those roles Dora Bryan had been playing on screen for the last decade. These were the jobs women did until they got married, so it's no wonder Norah was looking for a husband.

That being said, women from poorer backgrounds had always done some sort of work to earn a crust, often through casual occupations

The first girlfriend to the leading lady, Dora Bryan is the embodiment of resigned dependability in *Carry On Sergeant*, with star-crossed lovers Bob Monkhouse and Shirley Eaton.

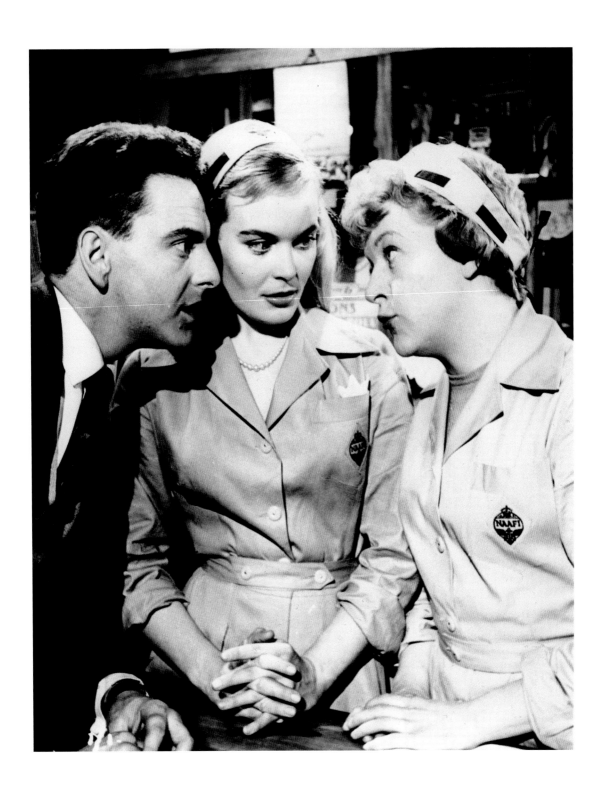

such as charring, baby-minding and taking in lodgers. In the film, it's unclear exactly how long Norah has worked on the base camp and whether she would actually give up her job if she was made an honest woman through marriage. We know that the proportion of married women in regular paid work grew dramatically from the 1950s onwards. In fact, it may have become likely that Shirley Eaton's character would end up in work, so her time with Norah would have been a good experience.

Dora's long and prolific career included films with Sid James in *Desert Mice* (1959) and Frankie Howerd, *Up the Front* (1972); a BAFTA-winning role as Rita Tushingham's mother in *A Taste of Honey* (1962); and her defining stage role as Mrs Levi in *Hello Dolly* at the Theatre Royal.

In the late 1950s, Dora and Joan Sims were always being mistaken for each other, so it was more than fitting that Joan took on the role tailor-made for Dora in *Carry On Nurse*. There were certainly no hard feelings though. Indeed, nearly fifteen years later when Joan was down on location in Brighton for *Carry On Girls*, local resident Dora Bryan greeted her by shouting, 'Oh, Dora! Dora!' Joan returned with an enthused, 'Oh, Joan. Joan!', as they collapsed with laughter into each other's arms.

Dora gleefully joined Shirley Eaton and Terence Longdon for the audio commentary for *Carry On Sergeant*, some fifty-five years after its production. She was as enthusiastic and outrageous and energetic as ever. 'I used to dance a lot in my variety act, but I never went to dancing lessons or exercised or anything like that to keep trim, I just have that kind of body!'

LEIGH MADISON (1934–2009)

Leigh Madison played Sheila in *Carry On Sergeant*, an attractive bit of fluff for Miles Heywood (Terence Longdon) to fraternise with, and attractive female Doctor Winn in *Carry On Nurse*. No wonder Jack Bell (Leslie Phillips) is greeted with outraged jealousy: 'He gets her for a bunion!'

What is most innovative in her casting for *Nurse* is that during the 1950s it was very rare to see a female doctor. In fact, in the early 1950s the number of women listed in the medical directory as doctors is 12,500. It's quite an impressive number, and yet we still underestimate it. We

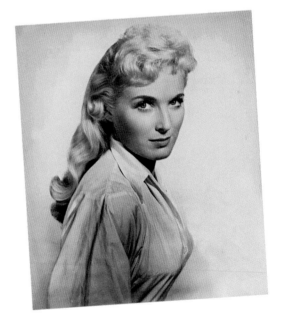

Leigh Madison in a 1958 publicity portrait – the year she filmed the first two *Carry Ons*.

know that many women would have been involved in supporting the war effort and it's a theme that is also echoed in *Carry On Sergeant* with Hattie Jacques as the doctor.

Blonde, shapely and spirited on screen, Leigh Madison had proved decorative and engaging on such television successes as *The Dave King Show* and *Six-Five Special*, where her singing talents matched her beauty and charm.

Her film roles outside the environs of the *Carry Ons* included the thriller *Blind Spot* (1958); the advertising satire *Make Mine a Million* (1959); and as Jean Trevethan, the female lead in *Behemoth the Sea Monster* (1959).

On television she played three different roles in three different episodes of the Peter Rogers-produced historical adventure series *Ivanhoe*, starring Roger Moore as the fearless knight: Lady Agnes in 'Slave Traders', 12 January 1958; Bess in 'Murder at the Inn', 12 April 1958; and Winfreda in 'The Monk', 30 November 1958, by which time her first *Carry On* had been released, and her second and last was in production.

The producer used her one final time, as a cashier in the reality versus fiction comedy *Please Turn*

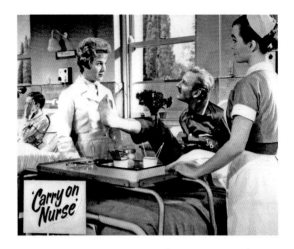

Ding Dong! Humphrey Hinton (Charles Hawtrey) chooses to ignore the good fortune of Jack Bell (Leslie Phillips) as Doctor Winn (Leigh Madison) and Staff Nurse Dorothy Denton (Shirley Eaton) tend to his tender bunion!

Over, in 1959. Soon afterwards, Leigh joined fellow *Carry On* veterans Charles Hawtrey, Norman Rossington, and Hattie Jacques in the Norman Hudis-scripted sitcom *Our House*. In December 1960, two months into the show's transmission, she married its director Ernest Maxin.

HATTIE JACQUES (1922–1980)

One of the greatest, and most garrulous, comedy actresses of her or any other generation, Hattie's career was launched by old-time music-hall antics and pantomime fairies with the Players' Theatre, from the mid-1940s. She came to national fame as a tail-end member of Tommy Handley's repertory company in the radio sketch show *It's That Man Again*, or *I.T.M.A.* as it was more famously shortened to.

Hattie was a late addition to Ray Galton and Alan Simpson's *Hancock's Half-Hour* too, although her at turns bombastic and coy secretary Grizelda Pugh was more than a match for her employer Tony Hancock, and as often as not set the romantic pulse of Sid James racing.

At the time of her casting and filming for *Carry On Sergeant*, Hattie's work with Hancock – and Kenneth Williams, of course – was at fever pitch;

having her extremely thick gravy condemned in 'Sunday Afternoon at Home', beating all-comers in wrestling in 'The Grappling Game', and displaying her talent for characterisation in the Walter Mitty-like revisionism of 'Hancock's War'.

From the very outset, Hattie is strong and determined in a role that could, with the slightest of rewrites, have been played by a man. Indeed, Kenneth Connor is shocked that Medical Officer Clark isn't a man but a twist of femininity in khaki. It's a terrifying buckling of the wheel of the expected normality. Cor, madam, mate …

Next came *Carry On Nurse*, and Hattie's first appearance in her defining role as Matron. Incredibly, her role took just three days to film, but the moment she retrieved that daffodil from the posterior of the troublesome Colonel (Wilfrid Hyde-White) Hattie was the nation's visual image of the merry Matron. Even now.

Producer Peter Rogers went on to explain:

When one wag on the set made a noise like a champagne cork popping out of a bottle, as she lifted up the daffodil, she was a complete goner. [Director] Gerald [Thomas] tried take after take, but she couldn't keep a straight face. We had to abandon the shoot for the day. When we picked it up again the following day Hattie was still delightfully tickled by the conceit of the scene. We finally managed to get her through that scene, but that final grin at the end is pure Hattie. She just couldn't help herself.

That joy in the robust comedy of the *Carry Ons*, and that skilful ability to regain the character while allowing her genuine, sheer exuberance to twinkle through, was key to Hattie's staying power in the team, and the lasting legacy of her greatest comedy roles.

The legacy of her days with Tony Hancock also loomed large over her twenty years as part of the *Carry On* team. Unsubtle references to her size had been part and parcel of her comedy career since *I.T.M.A.*, but Hattie was genuinely hurt by some of the cruel jibes directed at her in Hancock's programmes. The *Carry Ons* were peppered with them too, be it self-deprecating commentary in *Carry On Cabby*, ruefully reflecting that her husband (Sid James) spends his time tinkering on his fleet of taxis because 'he knows I can't get under one!'; or in *Carry On Doctor*, with Jim Dale's clumsy, 'Come, come, you're not that big Matron!' The young medic is trying to appease an awkward situation but, typically, makes it worse. The fact remains though that Hattie was large, and clearly it is a common reference point in their shared place of work, be that the fiction of the hospital or the fact of the film studio.

For Hattie, one of the pressures of being a woman was to keep fit and lose weight. During the post-war period, with rationing having been abolished, women's magazines and media culture started to publish articles about how to lose weight. It marked the start of the modern slimming culture which has since permeated all aspects of women's lives. The idea was in the 1950s that as housewives you could trim your figure by polishing and dusting in such a way that would enable you to lose weight. In fact, by the mid-1960s the pressure had mounted for women to begin to diet, and this became the centre of women's magazines as part of their beauty advice. No wonder poor Hattie felt under pressure, with the executives wanting to follow the trend, and in her personal life continually seeing magazines stating that slimming was part of an expected look to be considered attractive. Moreover, female slimness was portrayed as an ideal post-war femininity.

Even more than half a century on, Hattie's personification of the hospital matron is an indelible part of the British psyche. Here promoting *Carry On Again, Doctor*, for its December 1969 release.

During the 1960s, however, research into obesity began and it fuelled a growing slimming culture and an increased popularity of slimming clubs. This was rapidly becoming a capitalist market. Articles were written about the dangers of being overweight and even more derogatory language such as 'All fat people tend to look alike' from *Women's Own* magazine in 1969 along with 'Fat has a knack of ironing and flattening out all the features, obliterating them'. It's no wonder Hattie suffered because of this language. Thankfully, today, attitudes have shifted and we can be grateful to women like Hattie that we really do come in all shapes and sizes.

Despite her personal concerns, and the concerns of film production insurance policies, Hattie saw the *Carry On* team as part of her family. She certainly had great admiration for director Gerald Thomas. In an interview for the promotion of the compilation film *That's Carry On* (1978), Hattie said:

> Gerry is a darling, benevolent headmaster. He knows his job and expects you to know yours. You can't turn up not having learnt your lines. But, apart from any other reason, you just wouldn't do that anyway, for his sake. You wouldn't want to let him down.

With *Carry On, Constable* on general release in 1960, that year had seen Hattie's television ratings increase too. From January, she was playing the twin sister of Eric Sykes on the BBC, while from September she was the loud-mouthed librarian Georgina Ruddy in Norman Hudis's house-share sitcom, *Our House*.

In *Carry On Cabby*, we see Hattie taking up her role as the early feminist, about to embark on a war with her husband Charlie (Sid James). It is lovely to see Hattie being a fighter for all women, although interestingly enough she wanted to play even more diverse roles. During a promotion of

A moment that sums up the sheer affection at the heart of *Carry On*: Sidney Bliss (Sidney James) plants a smacker on the nose of Sophie (Hattie Jacques) in *Carry On Loving*.

A rare display of joyous abandon as Floella (Hattie Jacques) dances the night away with Brother Martin (Derek Francis) in *Carry On Abroad*.

Behind the scenes on one of the most oft-screened scenes in all of British film: director Gerald Thomas coaxes Kenneth Williams and Hattie during the making of *Carry On Camping*.

the film, Hattie stated, 'I want to be a murderer. The idea of playing a thoroughly sinister woman in an Alfred Hitchcock type production appeals to me. I'm sure I could frighten most people out of their wits.' We know what a marvellous actress she was, and although she has a chance to shine in a meaty role in this film, just imagine what she could have done in a Hitchcock film!

The year 1964 proved to be exciting. If not a character from the dark side she was personally selected by Noël Coward himself as his celebrated medium, Madame Arcati, for a television adaptation of his play *Blithe Spirit*.

From July to October, Hattie starred as intrepid Stacey Smith in ABC's comedy adventure serial *Miss Adventure*, in which her frustrating love life led to jewel thieves in Greece. There was a murder or two too, so the thirteen-week run was

Hattie's ideal sandpit in which to play. Hattie was at her fittest and funniest alongside comic couple Peter Sellers and Britt Ekland, in *The Bobo*. It was shot in Barcelona and Rome during the blistering summer of 1966.

By the time the film went on general release, Hattie was back at Pinewood Studios, reprising her best-loved role of Matron in *Carry On Doctor*. She would play the part three more times. Interestingly, the NHS was developing at exactly this time. In 1966, the Salmon Report had recommended changes to the senior nursing structure and effectively heralded the end of the traditional

matron role. However, the end of matron was resisted for some time and the role evolved. Hattie's Matron, though, recalls back to the days of a matron with power, who would have been incredibly fierce. Matron is associated best with Hattie's portrayal, a very interesting twist given the times.

Having played the role one final time, and in the central spotlight, for *Carry On Matron*, Hattie reunited with Eric Sykes for a reboot of the old *Sykes* format. From 1972, the team was remaking, reworking, and repolishing the partnership, in full colour, and to even greater popularity. It was this popularity that secured Hattie top billing in the 1972 *Carry On Christmas*, although it also rendered her unavailable for a one-day cameo as the hospital matron in *Carry On Girls*.

Her final original contribution to the series was a beguiling turn as Queen Elizabeth I in the *Carry On Laughing* episode 'Orgy and Bess', gamely facing yet more jokes at the expense of her size, this time penned by Barry Cryer and Dick Vosburgh.

It wasn't until the laborious task of shifting through the extant twenty-eight *Carry On* films for the big screen compilation, *That's Carry On*,

The serious business of being funny. Gerald Thomas on the studio floor with Sidney James and Hattie during the making of *Carry On At Your Convenience*. A budgie, a bet and a belly laugh.

that Peter Rogers decided Hattie was just too good not to employ again. Problematic insurance clauses or not. The maternal role in *Carry On Emmannuelle* was written in the hope of attracting Hattie back for a few days. It was further commitment to Eric Sykes that prevented this: the two were starring in the theatre tour *A Hatful of Sykes*, ultimately appearing across Australia when the film was released for Christmas 1978.

Suitably enough, during Hattie's final interviews in the autumn of 1980, she excitedly hinted at the prospect of returning Down Under to star in a brand-new *Carry On* film in the spring of 1981. Sadly, this was not to be. Still, that beaming face and bundle of energy that is Hattie's unique contribution to the *Carry On*s continue to lift the spirits of anyone who watches her.

October 1971. Gerald Thomas talks Hattie and Terry Scott through the next scene for *Carry On Matron*.

JOAN SIMS (1930–2001)

The most prolific of all the *Carry On* girls, Joan Sims loved her time as part of the team. 'Without them life wouldn't be the same. I always look forward to starting a new one. It's like going back to school and getting together with all your old chums again.'

Bewitched by show business from an early age, Joan joined a drama group near her home in Laindon, Essex, before winning a scholarship for three years at the Royal Academy of Dramatic Art. Repertory theatre allowed her to stretch her versatility, while her eighteen months in the revue *Intimacy at 8.30*, at the Criterion Theatre, made her swift wit and ease with perfectly defined comic characterisation razor-sharp. Theatrical impresario Peter Myers encouraged her tireless work ethic. At one point, in the early 1950s, Joan was juggling three jobs: Assistant Stage Manager for the Grand Guignol Plays; appearing in comedy revue *The Bells of St. Martin's*, with Douglas Byng and Hattie Jacques; and then rushing off to the Irving Theatre for the play *Just Lately*. Also at this time, Joan had started her prolific film career – at the top – as the secretary to Boris Karloff in *Colonel March Investigates*. Joan quickly found her niche as the overly enthusiastic friend of the glamour girl who usually made the romantic hero run a mile, memorably playing the slightly gawkish, fruit-chopping Rigor Mortis, opposite Dirk Bogarde, in *Doctor in the House*.

Joan became a regular in the subsequent *Doctor* series, playing everything from a sluggish stripper in *Doctor in Love* to a bombastic Russian sea captain in *Doctor in Trouble*. She made a stiff-collared hospital matron in *Doctor in Clover* too.

Her *Carry On* career ran concurrently with these other comedy films from Pinewood Studios, with her first role, suitably enough, coming in the

Joan breaking up with laughter with dear old chum Charles Hawtrey during the production of *Carry On Up the Jungle*.

medical smash hit, *Carry On Nurse*. Joan's Nurse Stella Dawson is typically gauche and accident-prone. She is the girl we've all been. Starting out at the bottom of the pile and trying our utmost to impress, but making mistakes along the way. If the role was created today, perhaps we wouldn't feel the warmth towards her, as she would surely be portrayed as being arrogant and over ambitious. Instead, due to Joan's own personal charm, we fall in love with her. We can understand her, and more importantly, it is not the men who put her down so much in this film, it is her own peers – Sister (Joan Hickson) being particularly tough on her. True, the colonel (Wilfrid Hyde-White) is also quite disparaging of her, but then he was like that with everyone! It's interesting to see how other members of her own sex refer to her as a 'silly' girl. Something Joan wasn't! Even today, as young women in the workplace, be it a hospital, a school, or an office, how many times have we ladies been made to feel we are worthless

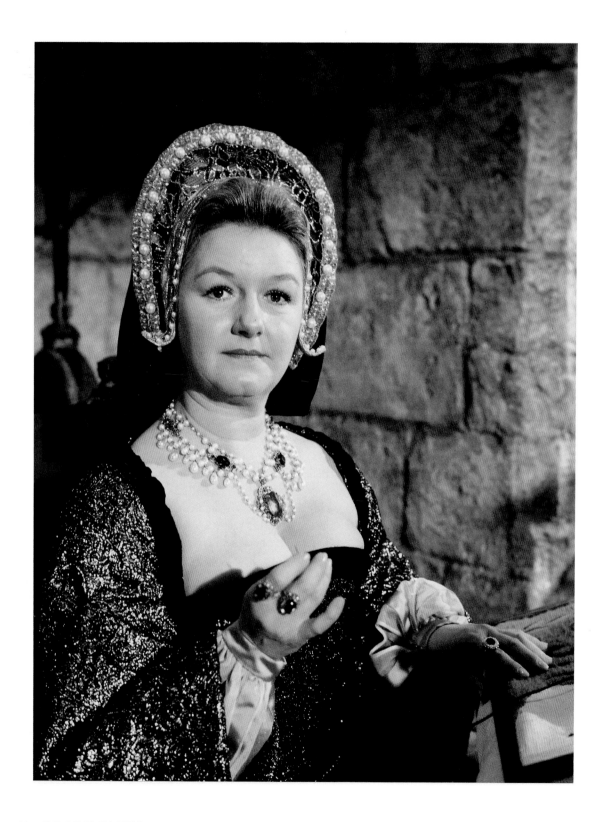

and that, simply because of our age, we don't know anything. Therefore, we cheer Joan on to make a success. We need characters like Stella Dawson to add that touch of reality.

Returning immediately for *Carry On Teacher*, Joan is at her most relatable. She's a little more mentally mature in her role; she is a young teacher, but she knows a bit about the world. Most of all though, she is an intelligent woman, she's a thinker. Whilst she is wooed by the suave Alastair Grigg (Leslie Phillips), she still keeps her head. He may win her heart, but he won't win her mind. This role particularly comes across as the real Joan Sims. She was wise and warm, but she also liked fun! Throughout the various candid shots, we can see she is laughing infectiously. So much so that we all want to be part of her inner circle. However, we know from her fellow cast members that they all have the dearest respect for her. If Hattie was mother hen, then Joan was the big sister of the gang.

We really see Joan in this role as an independent woman. She has a fantastic career, she loves the children she teaches and she's not afraid of being on her own. Quite rightly, she knocks Alastair Grigg out when she reads his drivel. Like many teachers, they will defend their pupils, particularly when anyone who has never stood in front of a class of thirty teenagers tries to theorise and challenge what they do. She is the modern teacher, she's different from her colleagues. Hattie's character, in particular, is still a vocal advocate of the cane. Even Kenneth Williams challenges Hattie when asked about sending children to be caned, replying, 'Yes, but only as a last resort.' He has a level of conflict that Joan shares simply by keeping out of the argument.

Joan does experience her own form of body

Every inch the queen of *Carry On*: Joan as Marie, in publicity for *Carry On Henry*.

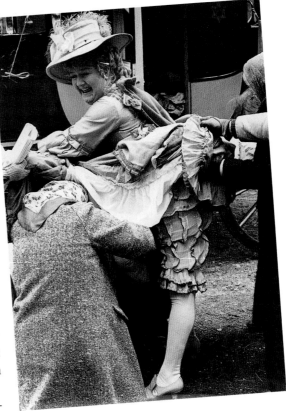

Joan was at her happiest making the *Carry Ons*, here laughing off a costume malfunction on location in Iver Heath, Buckinghamshire, for *Carry On Dick*, when she was cast as Madame Desiree, the faux French presenter of a travelling tableau.

shaming in this film. One of the reasons we all love her the most is because the majority of women will have had a moment in their life where their weight fluctuates and we begin to feel self-conscious. Whilst it's the naughty children who swap Joan's shorts, it is Joan's uttered thought that 'I must diet'. This is a very clever, multifunctional line of dialogue. Teachers are told to be careful about what they wear, and the staff room is very quick to comment on other colleagues' dress sense. Therefore, taking this scene, where a young teacher is about to

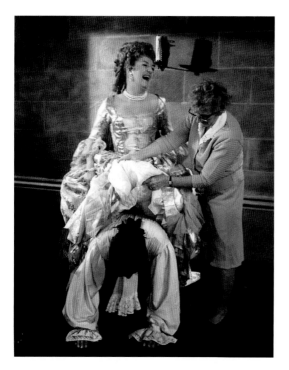

Joan and Sid keep position as Wardrobe Mistress Vi Murray makes adjustments to her *Don't Lose Your Head* costume. Having worked for Chaplin and Ealing Studios, Vi was regularly employed on the series for over a decade, from *Carry On Cleo* through to *Carry On England*.

go out and teach a group of teenage girls gymnastics, why wouldn't you feel self-conscious? Although, on the surface, the gag is a low blow at weight, it's also a perceptive one that the character is thinking about. She is, after all, the gym-mistress and she has a pressure to stay in shape. The majority of us can certainly reflect back on our own physical education classes and recall comments in our heads about our teachers' weight, and how we'd like to see them try running around the field. We applaud Joan for being that teacher that gets involved in her lessons, and wears the same shorts as the girls in her charge, rather than being the teacher shouting from the sidelines.

Moreover, Joan's performance in *Teacher* is all the more remarkable considering she was battling a problem that would haunt her throughout her career. That of her own weight.

Jacki Piper remembers that Joan still had weight issues on her mind ten years later, conquering them by sending them up, 'We were sat watching her double during the shower scene in *Carry On Up the Jungle*, and Joan was cracking up with laughter, saying, "Haven't I got a fabulous body?"' A wistful thought masked by humour, but although Joan was fundamentally a happy person, she was in and out of hospitals and health farms; forever trying the latest slimming techniques … Indeed, during a break from the *Carry On*s, which had resulted from health issues, other work commitments, and bad feeling over a short-lived romance with a studio carpenter, Joan's assignments for Peter Rogers became prudish and more spinster-like. She is the fussy sister in *Twice Round the Daffodils* (1962); and the man-hungry frump in *The Big Job* (1965). Moreover, Joan had lost the leading role in *Nurse on Wheels*, purely because of her increased weight. Peter Rogers sweetened the bitter pill by offering her any other role in the film, at the same fee, with Joan plumping for the lovesick vicar's daughter, but it was another shake to her confidence, and signposted the path to character parts. Some are sexy, certainly, but all are rather unlucky in love.

Throughout the series, Joan generally played the independent single girl. She was, in fact, in her own life an independent single girl. Whilst she went through highs and lows in her romantic life, she still remained positive, continually coining the oft-used phrase that she must '*Carry On*'. Her *Carry On Loving* character of Esme Crowfoot sees her again as an independent single girl. Yes, she has Gripper Burke (Bernard Bresslaw) as her on–off boyfriend and Sidney Bliss (Sid James) as her on–off lover. However, like any independent single girl, she keeps her feet on the ground, and

uses these men on her string to her own advantage. The male company is there when she wants it, but the character is also not afraid of being on her own. It works for her. In fact, this role is almost a cry back to Miss Allcock in *Carry On Teacher*. It's as though we revisit that character in her late thirties, and whilst the men still get her heart, they haven't won her mind! Actually, quite revolutionary for women, and where we are today.

Carry On Cleo had marked Joan's return to the series, and saw her morph into more of a matriarchal character. The film cast her as Calpurnia, the wife of Caesar. It's a perfect piece of casting, as Joan's beauty does resemble that of the two previous screen actresses to play the role: Gertrude Michael and Greer Garson. However, Joan adds her comical twist to the role, and makes Calpurnia almost into an Essex girl, who is lavished and lazy. It is a small role, but we see Joan evolve and finally see her playing a wife. Her co-star, Cleo herself, Amanda Barrie saw the depth of Joan's performance, 'Joan was such a wonderful actress, the sky could have been the limit, she could have been

part of the Royal Shakespeare Company. She was so direct, she bounced off the screen.'

Joan is another neglected wife, Lady Ruff-Diamond in *Carry On … Up the Khyber*. Again, she makes her a stereotypical Essex girl made good – as the nouveau riche Lady. Her costumes in this film are gorgeous, and she is such a big character on the screen. So good was Joan that she could match Sid James at his peak. They are effortlessly marvellous as husband and wife or boyfriend and girlfriend.

Witness Joan as Cora Flange in *Carry On Abroad*. She is so strong in this film. She knows exactly what her husband, Vic Flange (Sid James), is up to, but she's not silly and she's determined to 'have a good time' as Sid puts it, albeit sarcastically. She has some wonderful moments of reaction acting. In particular, the scene on the coach. Joan's glances and facial expressions steal the scene, and there's a lot going on, but whenever she is in shot, she makes sure her character doesn't have a poker face.

Whilst she's determined to get her own back on Sid in this film, she remains moral. She really does play the role of wife extremely well. Despite the fact she never married, she really does understand how married women react. When Stanley Blunt (Kenneth Connor) propositions her, and even goes as far as to pinch her bottom, Joan stands up for herself. Yes, she is embarrassed, but all her character is trying to do is make her husband see she's still there, and she succeeds. By the end of the film it's lovely to see her rekindle her love with Sid. They are a believable established married couple.

Joan's definitive *Carry On* role is Belle Armitage, in *Carry On Cowboy*. What a fabulous character! She is strong and independent and beautifully glamorous. Joan loved this role, and as an audience we sit there and feel thrilled for her. It's a far cry from Nurse Dawson – finally we celebrate the sexier side of Joan. It's every girl or woman's

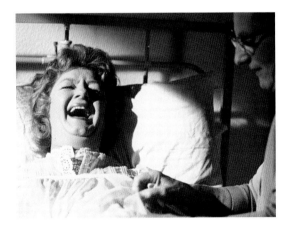

Vi Murray to the rescue again, as Joan's mother-to-be Mrs Tidey needs her bedgown seeing to, during the making of *Carry On Matron*. A photo that tangibly echoes with laughter.

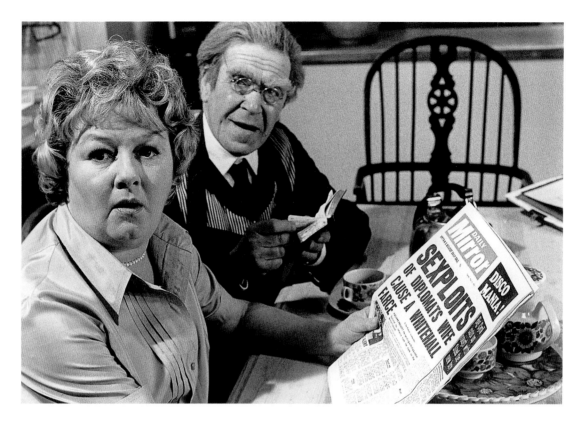

'Sexploits of Diplomats Wife Cause A Whitehall Farce': a headline that sums up *Carry On Emmannuelle*, and causes a discussion with the downstairs staff Mrs Dangle (Joan Sims) and Richmond (Peter Butterworth).

dream to walk down that staircase, in that dress and pull out a gun at that rogue we all love to hate. To pull this off, you have to be mature.

Joan certainly isn't the unrepresentative sourpuss on the poster for *Carry On At Your Convenience* but a cheeky, sexually forthright, frustrated housewife and factory worker who tolerates the bilious twaddle of husband Bill Maynard, and relishes the innocent, full-on cat and mouse attractiveness with Sid James on the factory floor. For all her wanton innuendo and come-hither eye contact when the opportunity arises – after the beanfeast to Brighton – Joan doesn't betray her marriage vows. Even for a cup of tea. Simply because of the neighbours looking on, or, much more than that, because fundamentally she is a loyal wife, the personification for the moral code that runs through the *Carry On*s like a stick of seaside rock.

Indeed, Joan proved herself time and time again as a fine stage actress. In the wake of playing the mother of Patsy Rowlands – just seven months her junior – in *Carry On Behind*, Joan had been filming the Restoration comedy *The Way of the World*. Six years earlier, again just ahead of playing prim and proper but rather saucy Lady Bagley in *Carry On Up the Jungle*, Joan had been starring as Lady Fidget in *The Country Wife* at the Bath Festival. A contrast between respected stage Restoration comedy and knockabout screen antics, but, in the end, not all that different – rather an ideal dress rehearsal for the *Carry On*. A thoroughly fabulous actress, incorporating those skills learnt from

classical theatre and deploying them to astounding effect in the robust monkey business of the *Carry Ons*. Jacki Piper saw this talent at first hand, particularly in the scene when Lady Bagley is crying to her husband Walter (Charles Hawtrey): 'Joan is such a brilliant actress, she has real tears in her eyes, and you believe her anxiety. Completely.'

Modestly, Joan herself would be more eager to talk about the tears of laughter she shed during the film's production, particularly in the company of Frankie Howerd:

It was just impossible to work with Frank. He's got a forlorn face but there's a twinkle in his eye. It was fairly hysterical because he made me giggle all the time. Once we went to thirteen takes which was unheard of, because we usually did it all in one take.

Indeed, despite Joan's expertise and diligence, even her most hard-hearted characterisations have an essence of her natural cheer and joy, whether it be the sarcastic wink in *Carry On Screaming!*; the sexually aggressive ball-squeezing in *Carry On England*; or the befuddled pomp of her Mrs Breeches in the *Upstairs, Downstairs* parodies in *Carry On Laughing*. Whilst the likes of Barbara and Hattie often played similar roles over and over, Joan was allowed to be the acting chameleon she loved, playing various different characters, over the years.

After the *Carry Ons* ceased production, it was primarily television that allowed Joan to continue to display her versatility, with everything from a pious baby-farmer in *Lady Killers*, 'Suffer Little Children' to a verbose warrior queen in *Doctor Who*, 'The Trial of a Time Lord'. Still it was comedy that kept her most gainfully employed, enjoying regular roles in two sitcoms, *As Time Goes By* and *On the Up*, the latter giving star Dennis Waterman a popular catchphrase at the affectionate expense of Joan's character's love of

a tipple – 'just the one, Mrs Wembley'. Joan also guest-starred as Trigger's ebullient Aunt Rennie in the Christmas Day 1987 episode of *Only Fools and Horses*, effortlessly and enchantingly delivering great swathes of expositional dialogue for 'The Frog's Legacy'.

Joan looked back fondly on her *Carry On* days though, remembering them as:

The happiest I have ever been. This business can eat you up and spit you out, you know, but the people on the *Carry Ons* were more than just colleagues. They were friends. Practically family. And we laughed and laughed and laughed. From morning to night. I remember we were put on a coach from Elstree Studios to some location during the *Carry On Laughing* television series. I was sitting next to darling Bernard Bresslaw, and he was flicking through the *Times*, when suddenly there was a photograph of that hunky cricketer Tony Greig. He was looking gorgeous, of course, and I blurted out, 'Cor, now that's who I fancy. He's beautiful!' Without a beat, Bernie said, 'It's funny, you know, because everybody says I look a lot like Tony Greig!' I'm ashamed to say I spluttered, 'You? Tony Grieg?!' and he said, 'Yes, can't you see the resemblance?' All that day, in any break we had from filming, Bernie would come up to me, point at his adorable face and say, 'Now can you see it? Tony Greig!' I was crying with laughter. 'No?' he continued, 'Well, I'm always being bothered by people asking for autographs. Sign this, Mr Greig, they say.' Through my uncontrolled laughter I managed to say, 'Honestly, darling, I just can't see it!' The next day he turned up at the studios, in full cricketing whites, knee pads, cap, the lot, and walked straight up to me and said, 'Now do you see it?' I exploded with laughter. I loved that man. And every day on the *Carry Ons* was like that. No wonder we all couldn't wait to get to work.

SUSAN SHAW (1929–1978)

One of the most popular products of the Rank Charm School, Susan Shaw had been employed as a typist at the Ministry of Information at the time of her screen test. By the late 1940s she was a regular in British cinemas, chalking up the first association with Peter Rogers in the 1947 comedy drama *Holiday Camp*. Cast as flirty Patsy Crawford, the film saw a spin-off series for the Huggett family where she was recast as Susan, the daughter of Ma and Pa Huggett as played by Jack Warner and Kathleen Harrison, with Rogers co-writing the first, *Here Come the Huggetts*, and his wife-to-be, Betty Box, producing all three. Susan was also gainfully employed at Ealing Studios, with featured roles in *It Always Rains on Sunday* (1947), *Train of Events* (1949), and the Harry Secombe tragi-comedy *Davy* (1958).

Her second husband, Bonar Colleano, the gum-chewing Yankee actor prolific in British film and television, had been killed in a car crash in August 1958. Devastated, Susan kept on working, with Peter Rogers and Gerald Thomas coaxing her through her one day on set for *Carry On Nurse*, on 28 November 1958. In the film she plays the wife to boxer Bernie Bishop (Kenneth Connor); with her love for her husband being so great, she willingly suffers the angst of his chosen profession simply because she knows it's his passion.

Subsequently, Susan drifted into low-budget productions, playing minor supporting roles in her last two films *Stranglehold* and *The Switch* (both 1963). She died fifteen years later, at the age of just 49. Her funeral expenses were covered by the Rank Organisation.

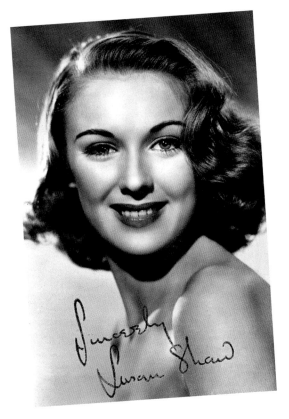

The Rank Charm School postcard that Susan Shaw would sign for fans when she first found fame in the late 1940s.

A happy family reunion as Jane and Jeremy Bishop (Susan Shaw and Jeremy Connor) accompany Bernie (Kenneth Connor) out of Haven Hospital in *Carry On Nurse*.

JOAN HICKSON OBE (1906–1998)

Before becoming television's definitive Miss Marple (and reuniting with Joan Sims in 'A Murder is Announced'), Joan Hickson was very content to be a seasoned, reliable and extremely busy character actress. Even from an early age she was happy to be the 'plain Jane' in British film and stage: witness her downtrodden Effie in *The Man Who Could Work Miracles*, while still in her twenties.

By the time this RADA-trained doyen of stage and screen had first been cast by Betty Box, as Mrs Pearson in *Marry Me!* (1949), she was an established scene-stealer, specialising in overbearing mothers and crotchety domestic help. She is Mrs Groaker in *Doctor in the House*; and Mrs Thomas in *Doctor at Sea*; Mrs Bostwick in *Raising the Wind*; and Mrs Wood in *Nurse on Wheels*; a barmaid in *Chain of Events*; and a saleswoman in *Please Turn Over*.

Joan's face fitted a hospital setting too, working her way through playing a nurse in *Doctor in Love*, a sister in *Carry On Nurse*, and the matron in *Carry On Regardless*. There's real heart pumping behind the authoritative scowls though: a warm shake of the head at the continual mishaps

One of the great fussy busybodies of British stage and screen, here Joan Hickson plays prim perfectly as Mrs Grubb, in *Carry On Loving*.

William (Jack Douglas) is understandably shocked when Mrs Dukes wants him to take her knickers down, in this Front of House still for *Carry On Girls*.

of Joan Sims; and a nervous burst of laughter at the eccentric inappropriateness of assumed millionaire Sid James.

Always a welcome addition to the Pinewood set, Joan relished subtly shifting into caricature when the role required. Her hilariously inebriated role of Mrs May in *Carry On, Constable* was one of her favourites: clearly of good stock, fallen on hard times and into drink, but still charming, dignified, jolly, and beloved … even by the policemen who pick her up. The assignment also reunited Joan with comedian and writer Eric Barker. The two hadn't worked together since Joan had starred as *Dick Whittington*, in Oxford, a quarter of a century earlier. The two pros warmly embraced on set, and the years melted away.

Frantically busy throughout her career, Joan would 'always say yes to a *Carry On* if I possibly could', returning to play Mrs Grubb, the disapproving mother of Imogen Hassall, in *Carry On Loving*; and the wonderfully befuddled Mrs Dukes in *Carry On Girls*.

An actress of warmth and truth, her collection of cameos is a joy to cherish.

IRENE HANDL (1901–1987)

A consummate character actress and invaluable support to the nation's greatest comedians, including Benny Hill, Terry-Thomas, and Tony Hancock, where the combination of live television and Irene's beloved dogs proved a test to the professionalism of Sid James when one gave him a nasty nip during transmission.

The year 1959 proved to be useful for Irene. Her role as the wife of Fred Kite (Peter Sellers) in union satire *I'm Alright, Jack* had proved a sensation when it was released in the August and certainly gave gravitas to *Carry On Nurse*, still on general release across the country and on the verge of racking up a huge profit in America too, where, in selected cinemas, it was showing into the 1960s. Mrs Kite and Mrs Hickson are very much cut from the same cloth. Her naive, apologetic, and easily upset characterisation frustrates then mollifies her uncouth husband (Bill Owen). That little girl lost moment as she fills in his accident at work claim form and she realises she should have been using block letters sums up

Irene putting on the ritz for her publicity session as Mrs Dailey in *Doctor in Trouble*. Her saucy daughter, Dawn, was played by *Carry On Loving* actress Janet Mahoney.

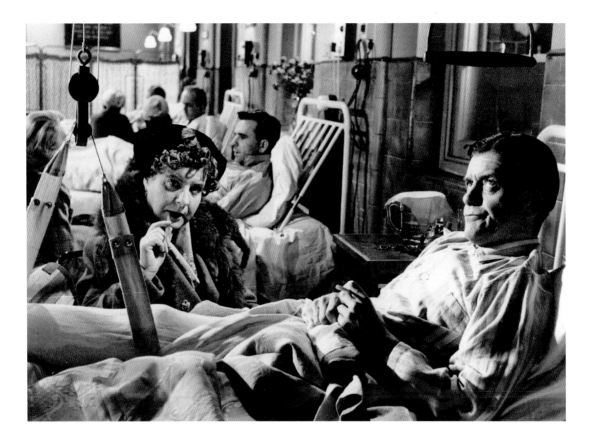

Marge Hickson (Irene Handl) infuriates husband Percy (Bill Owen) in *Carry On Nurse*. In conference with Brian Oulton, the back of Hilda Fenemore's head can be spotted in the background!

an entire marriage. She muddles her way through life; he simply rolls his eyes in inevitable, disgruntled disbelief.

At the end of 1959, Irene was back with the team, walking the streets of Ealing, for her cameo in *Carry On, Constable*. The working-class mother schtick is still in evidence here, but her 'distraught woman' is a much tougher cookie. She's not above giving her misbehaving kid a clip round the ear, and even more keen to give the fussy, overly helpful PC Grose (Charles Hawtrey) a taste of her acid tongue. That condemnation as 'bluebottle!' is harsh indeed. And hilarious. And only Irene Handl could make a line of innocuous dialogue so rewarding.

Very much part of the ensemble pool of comic talent of Peter Rogers and Betty Box, Irene was the proficient Professor MacRitchie in *Doctor in Love*, and the rather dotty Mrs Dailey in *Doctor in Trouble*; she throws her weight about in *Upstairs and Downstairs*, and gives of her most demure, as Mrs Spicer, in *No Kidding*. Perhaps her finest comedy film role came soon after *Constable*'s release, when she was reunited with Tony Hancock, this time as his dismissive and disinterested landlady Mrs Cravette in *The Rebel*. Her withering comments on Hancock's artistic offerings are legendary: 'Ooh, what's this 'orrible thing!'

One of the true eccentrics, and a valued minor gem in the *Carry On* crown.

SUSAN BEAUMONT (1936–2020)

The daughter of actress Roma Beaumont and theatrical impresario Alfred Black, Susan Beaumont left the Royal Academy of Dramatic Art after just one term, to join the chorus of the Norman Wisdom show *Painting the Town* at the London Palladium. At just 19, in 1955, Susan became a contract player at the Rank Organisation, appearing in such comic fare as *The Man Who Liked Funerals* (1959), with Leslie Phillips, the Frankie Howerd comedy *Jumping for Joy* (1956), and *Simon and Laura* (1955), directed by Muriel Box, the sister-in-law of Peter Rogers. In *Carry On Nurse* Susan plays Frances James. Thereafter, she starred in a couple of cheap and cheerful thrillers produced by the Danziger brothers: *Web of Suspicion* and *No Safety Ahead* (both 1959), before retiring from the film industry to raise a family.

Susan Beaumont was one of British films prettiest and busiest ingénues. Her only *Carry On*, *Carry On Nurse*, cast her as Nurse Frances James.

SUSAN STEPHEN (1931–2000)

Susan Stephen was a bubbly 28 when she made her one and only appearance in the series, as gauche and gullible Nurse Georgie Axwell in *Carry On Nurse*, but not nearly as gauche and gullible as her chum Joan Sims. Susan had been a familiar and welcome face in British films since the early 1950s, notably joining Jimmy Edwards on a *Treasure Hunt* (1952); playing Bicky, one of four troublesome daughters in the Richard Attenborough domestic romp *Father's Doing Fine* (also 1952); and graduating to the romantic lead opposite Dirk Bogarde in the newly-weds comedy *For Better, For Worse* (1954).

In 1957, Susan was cast in a strong supporting role in the big budget Metro-Goldwyn-Mayer British production *The Barretts of Wimpole Street* and married her second husband, Nicolas Roeg, who, at the time, was part of the cinematography

department at Marylebone Studios. It was a momentous year!

Susan put her screen career on slow after the wedding, although her remaining screen credits are fascinating: cast by the Danziger brothers in *Return of a Stranger* (1961) and making her last film, *Three Spare Wives*, the following year. The film was adapted from his own play by Talbot Rothwell, on the brink of being the new *Carry On* scriptwriter. Susan starred as Susan, alongside Robin Hunter, the actor son of Ian Hunter, as George. Robin would marry Cleo herself, Amanda Barrie, in 1967, and four years later pop up in *Carry On Matron* as the nefarious husband of Valerie Leon. It's a small world, isn't it?

In the medical hierarchy of *Carry On Nurse*, Student Nurse Stella Dawson (Joan Sims) is perpetually at the bottom, aided and abetted by her chum Nurse Georgie Axwell (Susan Stephen).

JILL IRELAND (1936–1990)

With her Parisian beret, blonde bob and elfin calmness, Jill Ireland is cute as a button, and even cute enough to attract Kenneth Williams in *Carry On Nurse*. Just 23 at the time of filming, Jill had met David McCallum on the set of *Hell Drivers* in 1957 and married soon after. Previously, she had notched up half a dozen decorative roles in British film comedy of the era, notably the Michael Powell and Emeric Pressburger musical costume spectacular *Oh … Rosalinda!* (1955); *Simon and Laura* (also 1955) starring Peter Finch and Kay Kendall; and Ken Annakin's colourful adaptation of Jerome K. Jerome's *Three Men in a Boat*. Jill was one of the three girls, joining Shirley

Eaton and Lisa Gastoni in turning the heads of Laurence Harvey, Jimmy Edwards, and David Tomlinson. Jill followed it up with *The Big Money*. Although it had been filmed at Pinewood in the spring of 1956, Rank head John Davis deemed it unsuitable for release until it finally escaped in June 1958. It certainly wasn't as bad as all that. A rather atypical role for star Ian Carmichael, as the head of a family of thieves and confidence tricksters, Jill played his doe-eyed sister Doreen. The film may have indirectly led to the termination of Carmichael's contract, but Peter Rogers was impressed enough with Jill to cast her as Jill Thompson in *Carry On Nurse*. She remained in

the producer's franchise through two further films: playing Janet in both *Raising the Wind* and *Twice Round the Daffodils*. Although different characters, they capitalise on Jill's rather other-worldly quality. She is like an avant-garde artiste in a world of Gainsborough; a John Cage in a Grieg piano concerto …

Marrying her second husband, Hollywood icon Charles Bronson, in 1968, Jill went on to star opposite him in such box-office smashes as *Violent City* (1970); *The Mechanic* (1972); *Chino* (1973); the genre-defying sequel *Death Wish II* (1982); and her penultimate screen role, as Lara Royce Craig, in *Assassination* (1987).

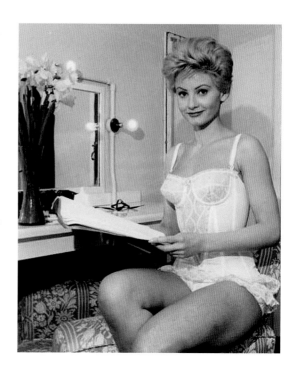

The vase of daffodils in the Pinewood Studios dressing room is a nice touch, as Jill Ireland studies her script during the making of *Twice Round the Daffodil*. It was released in spring 1962.

ANN FIRBANK

A 25-year-old Ann Firbank came to the set of *Carry On Nurse* as Staff Nurse Helen Lloyd.

She was cast as Lady Katherine in the Brian Rix prison comedy *Nothing Barred* (1961) and subsequently enjoyed a distinguished screen and stage career, ranging from playing Laura in Harold Pinter's *Accident* (1967), for director Joseph Losey, to taking on the role of Rebecca in the 2014 Old Vic staging of Arthur Miller's *The Crucible*.

Ann Firbank kisses her director, Gerald Thomas, while fellow *Carry On Nurse* cast members Terence Longdon, Susan Beaumont and Joan Hickson gather around with series creator and producer Peter Rogers. Joan Sims seems on the verge of scoffing the lot!

DAME JUNE WHITFIELD (1925–2018)

One can get the measure of June's extraordinary seventy-year career simply by taking a casual stroll through the tiniest proportion of her credits, alphabetically: there's the autumn years masterwork of Mother in *Absolutely Fabulous*; *Bob the Builder*; *Coronation Street*; *Doctor Who* (when she was papped by the tabloids with her hand cheekily on David Tennant's bottom, with the journalist noting it was like she was back on a saucy *Carry On* epic); as a mother superior in *EastEnders*; *Friends* – oh, yes!; *The Goodies* – battling Joan Sims in a mash-up of gangster flicks and ballroom dancing …

June's defining *Carry On* role is Augusta Prodworthy, a synonymous name very much cut from the cloth of Restoration comedy; she is, in fact, the epitome of the Feminist Woman. The term 'feminist' is defined as 'An advocate or supporter of the rights and equality of women'; however, the character that June plays in *Carry On Girls* feeds into a contentious interpretation of feminist women. June cleverly allows her role to play into the implication that feminists are militant and have an 'anti-man' stance. Interestingly this definition has become associated with elite groups of women. Therefore, June's character is given an elitist role. She is a councillor, but even June described the character as 'an overbearing feminist councillor'.

June was as candid and reflective about *Carry On Girls* in general, recalling that during the burning of the bra scene, the cast nearly set fire to themselves. The passage of time also allowed June to reflect on the authenticity of the film's depiction of beauty contestants at the time. A case in point was the scene in which Barbara Windsor and Margaret Nolan are fighting amongst themselves. June pondered on whether this really would happen amongst beauty queens, or whether we were shown a display of male fantasy on screen.

June was cheerfully adamant that the premise of the film really didn't do any harm. She felt that if a girl chooses to go into a beauty contest, they may do so as a route to fame. However, if a boy decides to take up boxing, do we judge them in the same way? June felt women who went into these competitions did it because they wanted to, and, ultimately, they had a choice, which was 'something to celebrate rather than criticise'. For June, a consideration of *Carry On Girls* was ultimately a consideration on changing times. 'The worst thing that ever happened to us was political correctness. It's quite ridiculous.'

June as the relentless female rights campaigner Augusta Prodworthy – a Talbot Rothwell character name worthy of Chaucer or Dickens – in *Carry On Girls*.

June in publicity for *Carry On Abroad*, her first *Carry On* assignment in thirteen and a half years: 'I clearly made a great impression in *Carry On Nurse!*' she would joke.

The time was, of course, 1973, and it's impossible to ignore that June's character was a startlingly good send up of Mary Whitehouse, the outspoken figurehead of the National Viewers and Listeners Association who, while vocalising concern about sex, violence, and profanity, had remained rather quiet on the matter of the *Carry On*s. However, upon the release of *Carry On Girls*, this situation swiftly changed, with her infamously scathing criticism of the scene depicting department store Father Christmas (Sid James) with wanton schoolgirl (Barbara Windsor). It was a moment in that season's *Carry On Christmas* television special, which was screened on Christmas Eve 1973, just a few weeks after *Carry On Girls* had gone on general release. The fact notwithstanding that Barbara is 13 going on 36 in the Christmas show, it is safe to conclude that Mary couldn't have been at all happy that her persona and beliefs had been thoroughly mocked by the *Carry On*s.

June does play the part beautifully, of course, giving us a fantastic portrayal of women at the time and how women were evolving in the 1970s. In fact, this had been part of June's armoury as an actress for years. Her performance in *Hancock*, where she plays Veronica Stillwell in 'The Succession: Son and Heir', gives us a sense of an earlier feminist, but perhaps with more redeeming features in this role. June also appeared most famously in *Hancock* as the nurse in 'The Blood Donor'. Rather wonderfully, these roles were played and broadcast just seven days apart, with the nurse followed by the feminist. A swift demonstration of June's immense versatility.

The *Carry On*s had already deployed that versatility, eighteen months before the *Hancock* series, when June made her debut with the team in *Carry On Nurse* – a far cry from her performance in *Carry On Girls*. She is always a brilliant straight woman, with a mind. She is the girlfriend of Leslie Phillips. She is glamorous and a little haughty. In this charming performance, she is

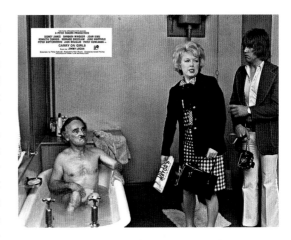

Mayor Frederick Bumble (Kenneth Connor) is interrupted in his bath by Augusta (June) and her photographer son, Larry (Robin Askwith), in this *Carry On Girls* Front of House still.

eager to get away with Leslie on their holiday, but clearly stating it will be 'separate rooms of course'. In the 1950s, women were hovering on the cusp of change. Women were facing a challenge at that time to embrace the emerging opportunities for independence. There were, however, some who clung on to the idea that marriage and home were pinnacles of aspiration. Whilst June's character is taking a step forward that perhaps her mother wouldn't have done, she is a responsible adult. This stemmed from women having a sense of dread, inherited from their own mothers' wartime fears of destitution.

Sex dominated but also restricted the freedom that women yearned for, and we see here June battling with this idea. We all know what Leslie Phillips is planning, but June's character is smart enough to say that sex before marriage risks society's judgement of her. She plays this character to perfection. It's a comedic work of fine art, balancing desire and wisdom. Something we see throughout June's career.

June's own personal favourite was as Mrs Blunt in *Carry On Abroad*, her first after thirteen

The Chelsea Pensioners visit Pinewood Studios during the making of *Carry On Abroad*, and only Bernard Bresslaw, Gail Grainger, Jimmy Logan and June seem to know which camera is snapping! Carol Hawkins, Ray Brooks, Peter Butterworth, Sally Geeson and Sidney James also take time to greet the party, while Charles Hawtrey is gleefully in a world of his own.

years. June joked that she must have made a great impression at the time, but she was thrilled to be back. You can imagine this as her marriage after a failed relationship with Leslie Phillips in *Carry On Nurse*. She's now a prude. In 1972, the year of *Carry On Abroad*'s production, marriage was deeply embedded in the culture of society. After 1972, things began to change. June's character is one which would have likely become married in the time where women took their husband's name and promised to 'obey' him. No doubt she is also economically and financially dependent on Mr Blunt (Kenneth Connor). However, from the outset we can sense this is not a happy marriage. She is clearly fed up with her husband, who

appears to do nothing right. She even admits to having led a rather sheltered life claiming that she cares not for drinking, 'I tried it once and didn't like it,' nor for smoking, 'I tried it once and didn't like it.' It's all a set-up for a gag, of course. Vic Flange (Sid James) thinks it is strange. Not at all, explains June, her daughter is just the same, which pulls the trigger on Sid's triumphant retort,

'Your only child, I presume.' Her husband may be tickled pink while desperately trying to control his laughter, but June is left, at first, looking rather embarrassed, and then annoyed. Again, this is a reflection of a time of change. Whilst in the 1960s and '70s both men and women were more ready to admit that they were in an unhappy marriage, June is more subtle in her approach. In 1969, the Divorce Reform Act had been issued and thus couples could agree mutually to a divorce without having to find fault in the other – to coin a phrase.

Thankfully though for June, her story in *Carry On Abroad* does end well. After her brief encounter with Giorgio (Ray Brooks), she is a changed woman. Maybe today this may be perceived as something of a fairy tale, and, indeed, had the story been set post-1986, when *Shirley Valentine* had been written, Talbot Rothwell may have devised a very different ending for Mrs Blunt. She is a changed woman by the end of the film and we can all cheer that she has found happiness, as well as finding some pleasure for Kenneth Connor who's probably got back the woman he once married – perhaps she really was that woman from *Carry On Nurse* after all!

So enamoured of the script, June even did her own stunt in *Carry On Abroad*. In the scene when the hotel is starting to fall apart, she is lying in bed and Kenneth Connor has to jump on the bed, for it to then crash through to the room below. Both June and Kenneth were slightly apprehensive about this particular scene, as should Kenneth have left a leg out he could have seriously hurt himself. Luckily for both of them the scene worked. June joked that she actually had the easier part as she was already in the bed.

After *Carry On Girls*, June returned for a brief scene or two in *Carry On Columbus*. Again, an echo back to her earlier relationship with Leslie Phillips. This is a nostalgic highlight of the film and she makes for a gorgeous Queen of Spain. She thought this was a rather beautiful rounding off

Gerald Thomas sets up the bra-burning scene in *Carry On Girls*. Patsy Rowlands and June Whitfield bookend the meeting. June is masking Patricia Franklin, and that's Shirley English in the black polo neck.

to her time on the series and was delighted to be working with Leslie again.

June loved being in *Carry On*, and later commented that she enjoyed the 'nudge, nudge, wink, wink' humour of the films. She felt there was something more innocent to these films compared to others that came later, in an era when sex on the screen became very 'in your face'. Despite the quick turnaround, June actually found the schedule quite easy compared to, say, working in a soap opera, which she did many times. June found everyone on the *Carry On*s to be so professional. Everyone knew their lines and enjoyed working with, and pleasing, Gerald Thomas. Indeed, the speed of production was one of the elements that June enjoyed the most. She loved the fact that she could finish filming and still have time to go and do her shopping at the end of the day! To June it was a job. The films were simply 'business'; an enjoyable business but a business all the same. The secret of the *Carry On* success was simple too: 'One would warm towards the characters and become very fond of them. The scripts were just innocent fun.'

MARIANNE STONE (1922–2009)

The omnipresent character actress of British film and television notched up literally hundreds of appearances from the late 1940s through to the early 1980s. Casting directors had her on speed dial for waitresses, pub landladies, secretaries, and distraught mothers with problem children. Her biggest role was Vivienne Darkbloom, opposite Peter Sellers, in Stanley Kubrick's *Lolita*, while she was a firm favourite of Peter Rogers. In 1971 alone, he used her as 'woman in pub' in his hard-hitting *All Coppers Are ...*; and as the bespectacled free-wheeling Maud in *Carry On At Your Convenience*. She had such a ball down in Brighton that she wrote and thanked Gerald Thomas for the experience, enclosing a copy of the newly published autobiography of actress and playwright Janet Green for him and his wife, Barbara, because she knew they were both fans.

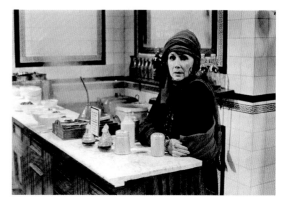

Marianne as the cynical crystal-ball gazer Madame Petra in *Carry On Laughing*: 'The Case of the Screaming Winkles', shot at Elstree Studios, for transmission on 2 November 1975.

Gerry, in turn, replied, saying that, 'I have just seen the rough cut [of *Convenience*] and must say it looks very funny. You really ought to try your gorgeous giggle out on Peter [Rogers] I am sure he would appreciate it.'

This prompted Marianne to write a cheeky missive to the producer, on 14 May 1971, explaining that:

> I enjoyed myself so much on *Carry On At Your Convenience* that my instinct was to send the money back! However, I conquered that, but want to thank you for all the nice work you are putting my way. Please keep it up. All luv Marianne.

Rogers duly did, casting her as the bonkers Mrs Putzova in *Carry On Matron* that autumn. Sadly,

Marianne on location in Brighton for her biggest *Carry On* role, as forever-giggling factory worker Maud, in *Carry On At Your Convenience*.

the role hit the cutting-room floor before the film's release. This roulette casting was nothing new. Back in 1959 she had been signed up and paid for the role of Miss Horton, only to be replaced by Lucy Griffiths. It's Marianne's voice that is dubbed in though.

Marianne's dependability as a screen actress was particularly appealing to the super-efficient schedule of Gerald Thomas. Her landlady of Dirty Dicks, in *Carry On Jack*, being a fine example. A small but juicy role, it was knocked off in just one day, on Pinewood's Stage 'F', on 18 October 1963. Over a decade later she was still a lucky talisman for the series, playing the scraggy and filthy – in every way – old crone in the Old Cock Inn in *Carry On Dick*, and the outrageous customer to butcher Windsor Davies in *Carry On Behind*.

HILDA FENEMORE (1914–2004)

A familiar face on British stage and screen for sixty years, Hilda Fenemore was a pivotal presence in the politically reactionary Unity Theatre during the war years, making her first films by the late 1940s. Although often uncredited, such roles as a mother with her baby in the Ealing comedy classic *The Titfield Thunderbolt* (1953) would become standard fare for the actress. She relished playing working-class neighbours, pub landladies and gossipy friends.

Peter Rogers was the first film producer to give Hilda really meaty roles, casting her as Tommy Steele's mum in *The Tommy Steele Story* (1957), a gloriously inexpensive biopic. At the cost of just £15,000, the film became one of the country's biggest box-office spinners thanks to its star's hit parade popularity. A real earth mother, the salt of the earth, was what Hilda's expressive face conveyed, and Rogers swiftly recruited her to play Mrs Bray, Brian Outon's wife in *Carry On Nurse*. While he is living up to the name of Bray, swanking about his property and social status, his wife innocently reveals the truth of benefiting from benefits and their 'divi from the Co-op!' He is appalled. His strangled cries of 'Rhoda!' failing to keep her quiet. She clearly loves him still though. She chuckles that she thinks he might be a snob … but graciously gives him the benefit of the doubt – along with all the other benefits. He's her Mr Bray after all.

In *Carry On, Constable*, Hilda was on location in South Ealing to play what was billed in publicity material as 'Agitated Woman'. In fact, this is one of the earliest 'caught short' gags in the series. Certainly, the first for a woman. Hilda is seen rifling through her handbag outside a public convenience when kindly Constable Charlie Constable (Kenneth Connor) spots her and asks if she needs assistance. Desperate to use the lavatory, she admits she needs a copper right enough and, ever helpful, the naive constable gives her a coin, with the hilarious coda: 'Have this one on me!' Connor immediately registers the innuendo. This is the *Carry On* universe, after all, but Hilda doesn't mind. With real relief she mutters, 'Oh, ta!' and she's off to spend that penny.

With glorious serendipity almost straight after her one day on *Constable*, Hilda was cast in police drama *Dixon of Dock Green*, as Jennie Wren. She stayed with the BBC Television series, on and

off, until 1965. In that time, she also returned to Pinewood Studios to play a typical Hilda Fenemore role, that of a railway station barmaid, for Betty Box, in *Doctor in Distress* (1963). Still, it was television that would take up much of the rest of her career, enjoying recurring roles in *Please, Sir!* as Eric Duffy's mum, and *Are You Being Served?* as various slovenly cleaners at Grace Brothers department store. Later she appeared with Kenny Everett and French and Saunders.

MARITA STANTON

The Athens-born beauty who, as Rose Harper in *Carry On Nurse*, is the charming and innocent victim of Charles Hawtrey's purloined nurse's uniform, performed in cabaret as Marita Constantinou. Indeed, she is credited as such in the Robert Mitchum film *The Angry Hill* (1959). Marita married businessman Jules Klar, in 1970, and retired to Phoenix, Arizona.

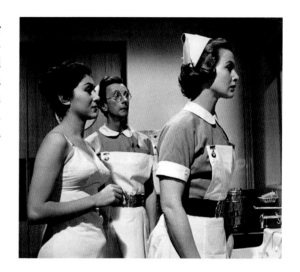

Hapless Nurse Rose Harper (Marita Stanton) has lost her uniform to patient Humphrey Hinton (Charles Hawtrey), in *Carry On Nurse*. The steely calm of Helen Lloyd (Ann Firbank) is about to resolve the situation.

ROSALIND KNIGHT (1933–2020)

Rosalind studied at the Old Vic School, from the age of 15, its last two years in existence, with repertory experience and film walk-on roles following. Most notably she plays a lady-in-waiting in Laurence Olivier's film of *Richard III*. Rosalind's talents to amuse were sharpened in revue at the Arts Theatre, and on BBC Radio in *A Life of Bliss*, followed by *Ray's a Laugh*, with Ted Ray and Kenneth Connor. Not one of the three let on when, after a successful one-take scene on *Carry On Teacher*, one of the technicians gushed how amazingly well it had been played,

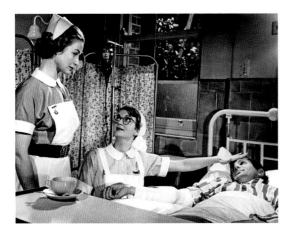

Angels of Mercy. Helen Lloyd (Ann Firbank) looks on with kind tolerance as over-keen nurse Nightingale (Rosalind Knight) tends to her patient (John Mathews). I'm sure Florence could have rustled up steak and chips!

into her performance. She is wearing glasses, but she's very wide-eyed and fresh. However, in *Carry On Teacher* we meet a very different woman, but it's the big eyes that captivate us again.

In *Teacher*, Rosalind is presented as a rather stern-faced school inspector, writing frantically on her typewriter and probably about to fail the school or, in today's terms, deem it inadequate. Interestingly, school inspectors were being phased out during the 1950s and had taken on more advisory roles. In fact, schools were looking at how they could improve their equipment and facilities so when she asks, 'Are you satisfied with your equipment Miss Allcock?' it is a very genuine look into the sort of things inspectors would say. Who knows what exactly is going into that report? It certainly isn't good. However, unlike the traditional inspector, there is a human side to

exclaiming, 'They played that so well you'd think they had worked together before!'

The daughter of distinguished actor Esmond Knight, heartbreakingly memorable in *Holiday Camp* (1947), Rosalind also had a noteworthy great-grandfather, the novelist Frank Barnett. Among his many achievements, Barnett claimed to have invented the deckchair. Rosalind certainly believed him – even having a portable one on set!

Rosalind gives two very contrasting performances in her two *Carry On* films. When we meet her in *Carry On Nurse*, she had just played medical drama on television, in *Emergency Ward 10*, and was delighted to wallow in the affectionate comedy of Student Nurse Nightingale. Asked to sit and watch a patient, with her big eyes clearly fixed on the patient – mesmerised – she is blissfully ignorant and really thinks she is making a difference. In fact, it's those eyes which draw us

A much more glamorous, romantic role for Rosalind Knight in *Carry On Teacher*, as the hard-nosed but ultimately lovesick school inspector Felicity Wheeler.

Rosalind's character, Felicity Wheeler. Her heart is melted by Mr Gregory Adams (Kenneth Connor). His attempts to woo her don't always go to plan, and she returns frustrated and frantic at her report, but eventually Mr Adams wins the day.

Forever chuffed to have been part of the *Carry On* team, Rosalind achieved both of her acting ambitions: to play Fanny Squeers in *Nicholas Nickleby* (1968) and to work with Kenneth Williams! A wonderful career, which later included unforgettable comedy roles, as Mrs Cresswell, the intimidating owner of the Villa Bella guest house in *Only Fools and Horses*, 'The Jolly Boys Outing', and 'horrible Grandma' Cynthia Goodman in *Friday Night Dinner*. Her *Carry On* performances were not only fun memories that Rosalind eagerly chatted about, but display what a fine actress she was in perfect microcosm. Rosalind remembered the *Carry Ons* as 'the happiest film set in the history of Pinewood Studios' and her affable nature and joie de vivre was no small part of that. A thoroughly good actress – and an absolute sweetheart.

CHRISTINE OZANNE

'Do you mind!' shrieks a lowly, hard-working cleaner on all fours in *Carry On Nurse* – and with that, Christine Ozanne passed into British film history. It's a look somewhere between shock and bewilderment, plus a stifled snigger from Kenneth Connor, that saw the 22-year-old get her first screen laugh … and many more were to come, from frequent roles opposite Ronnie Barker, to *The Harry Hill Movie* (2013). Christine's memoir is entitled *The Tome of the Unknown Actor*.

LUCY GRIFFITHS (1919–1982)

A perpetually anxious-looking character actress, Lucy is seen at her most fun and flustered opposite Margaret Rutherford in three of her Miss Marple adventures, and as a lady-in-waiting in *The Mouse on the Moon* (1963). Lucy is the trolley lady in *Carry On Nurse*, setting up a laugh for Kenneth Connor with his chocolate bar request prompting her response: 'I've got a sliced nut!' Connor's retort: 'Come to the right place to have it mended haven't you!'

Lucy returned to the fold to play a bookshop gossip in *Please Turn Over*; and the deliciously doom-laden Miss Horton in *Carry On, Constable*. She's Auntie in *Carry On Regardless*; a lady at the window in *Nurse on Wheels*; and Miss Morris in *Carry On Doctor*, eagerly putting her teeth back

in and desperate to be examined by Jim Dale. She is the ridiculous pay-off for Bernard Bresslaw's secret love note to Dilys Laye, of course, and she's sweetly memorable with her excited, 'Fancy someone sending me a note!' So sweet, in fact, that you kind of hope she does get one. From someone.

Lucy certainly sent a note, to her director Gerald Thomas, on 20 January 1970, after seeing the forthcoming attractions at her local cinema previewing *Carry On Again, Doctor*:

> I am delighted to find my 'bit' picked for the trailer – it happened once before too! – so now I really feel perhaps I'm doing a minute 'bit' to help sell the picture + that I belong. I do hope that you will want me more continuously + more often (perhaps bigger parts).

The bit, as the elderly hospital patient whose headphones explode during Jim Dale's drunken antics, was, Lucy noted, 'a happy experience'. As she revealed, she was 'struggling to rebuild my acting career – I'm not waiting for my agent to get cracking – I'm doing my utmost myself – I can act, I've got to act + that's it.' Her desire was to 'go forth to lift up + entertain others'. Bless her.

A few months later she was back at Pinewood, filming another bit, as a frightened old lady who calls upon Joan Sims while Sid James is in hiding there. Sadly, the scene was cut from *Carry On Loving*. Her tiny role, as a behatted audience member of Kenneth Williams's lecture in *Carry On Behind*, secured her another laugh, and she kept on trying, ultimately sparring with Peter Cook and Dudley Moore in their scattergun spoof *The Hound of the Baskervilles* (1978).

CAROL WHITE (1943–1991)

Carol is Sheila Dale, the most prominent of the *Carry On Teacher* schoolgirl saboteurs. Carol White had been gracing British film since the age of 6. She was the young Sibella (Joan Greenwood) in Ealing comedy masterwork *Kind Hearts and Coronets* (1949); a destructive pupil in *The Belles of St. Trinian's* (1954) and *Blue Murder at St. Trinian's* (1957); and a background child in three films for Betty Box and Ralph Thomas: *Doctor in the House* (1954), *Doctor at Sea* (1955) and *The 39 Steps* (1959).

Nan (Carol White) helps rescue a neglected horse from Marlow's circus in the 1956 Children's Film Foundation release, *Circus Friends*. It was the first Peter Rogers production directed by Gerald Thomas.

Peter Rogers and Gerald Thomas had already starred her in their critically acclaimed Children's Film Foundation production *Circus Friends* (1956) – a tale of two school kids, Nan (Carol) and Nicky (Alan Coleshill), who rescue an abused horse from uncaring carnies.

The 1960s were Carol's decade: playing Jackie, opposite Peter Sellers, in the gangland thriller *Never Let Go* (1960); starring as Natasha Passoti in the Eric Sykes MGM comedy *Village of Daughters* (1962); chasing the Beatles in *A Hard Day's Night* (1964); and personifying the working-class struggle in Ken Loach's influential and reform-making television plays *Up the Junction* (3 November 1965), and *Cathy Come Home* (16 November 1966). Symbolising the poverty-stricken mother of the late 1960s, Carol was cast as 18-year-old Joy in Ken Loach's first film for the cinema: the kitchen sink, seedy side of life drama *Poor Cow*.

The cumulative effect of her work with Loach led Carol to Hollywood, starring opposite Dean Martin in the light-hearted Western *Something Big* (1971). Carol occasionally returned home – to play *Dulcima* (1971) with John Mills, and to take over the role of Josie from Georgina Hale, in Nell Dunn's *Steaming*, at the Comedy Theatre in the West End.

Her life and career were in the US though. 'I came to America thinking I was at the very top and that no one could touch me. But pimps, pushers, liars and ex-husbands brought me crashing down.'

JANE WHITE (1945–2014)

Carol's fellow female saboteurs at Maudlin Street School include her sister Jane White, who plays Irene Ambrose. Jane's career in British film also began in the 1950s, with appearances including *Mad About Men*, for Betty Box, and *A Town Like Alice* (1956), for producer Joseph Janni.

JACQUELINE LEWIS

Jacqueline Lewis is Pat Gordon, a deliciously mouthy, opinionated saboteur, gleefully undermining the English lesson of Kenneth Williams, and throwing herself into the maelstrom purely designed to stop beloved headmaster William Wakefield (Ted Ray) from leaving the school in *Carry On Teacher*.

DIANA BEEVERS

Diana Beevers is bespectacled saboteur Penelope Lee, memorably assigned the role of Juliet in the school's production of Shakespeare. A Corona Academy of Stage Training student, Diana had also been a problem pupil in *Blue Murder at* *St. Trinian's*, and would enjoy television success as 'Mitch' Donnelly in Hazel Adair's *Compact*, the BBC drama series based in the swanky offices of a women's magazine.

Games mistress Sarah Allcock (Joan Sims) valiantly attempts to pull her pupils off jobsworth caretaker Alf (Cyril Chamberlain) in this publicity still for the American release of *Carry On Teacher*. Anne Chapman is top left, while that's Irene French with her hands on Cyril's broom. Bespectacled Diana Beevers flanks Jacqueline Lewis, with Julia Atkinson mirroring them immediately above Cyril in the scrum.

SANDRA BRYANT

That final scene of triumph in *Carry On Teacher*, as 'Wakie' reveals he is staying on, required a playground full of kids. Some familiar faces are among them. Uncredited, but destined for great things. Sandra Bryant went on to become one of the classiest clippies *On the Buses*, appearing as, yes, Sandra in the television series as well as the Hammer Films smash hit *Holiday On the Buses* (1973). Other sitcom successes include *Whatever Happened to the Likely Lads?*: 'I'll Never Forget Whatshername' (6 February 1973) and *Not On Your Nellie*: 'A-Haunting We Will Go' (15 August 1975). For six years from 1969 she had been Dawn Digby in *Coronation Street*.

PATRICIA GARWOOD (1941–2019)

Patricia Garwood was a near permanent fixture on British screens, cropping up as a flirty WREN in the Charlie Drake film *Petticoat Pirates*; appearing alongside Donald Sinden in ITV sitcom *Our Man at St. Mark's*; and starring as Beryl Crabtree, alongside William Gaunt, in the BBC sitcom *No Place Like Home* (1983–88).

FRANCESCA ANNIS

As well as embodying the dogged, unflappable heroines of Agatha Christie as Frankie Derwent in *Why Didn't They Ask Evans?* and 'Tuppence' Beresford in *Partners in Crime*, Francesca Annis played Lady Macbeth opposite Jon Finch, in 1971, and Lillie Langtry alongside Timothy West's *Edward the Seventh*, in 1975. For the spin-off series, *Lillie*, in 1978, Francesca donned over 200 specially designed outfits.

DIANE LANGTON

Diane was one *Carry On Teacher* schoolgirl who returned to the franchise in the 1970s. Barbara Windsor's film career had started similarly, in the crowd as a snotty lass in *The Belles of St. Trinian's* and Diane was destined to be modelled as 'the new Barbara Windsor' when she properly joined the *Carry On* team with the ATV *Carry On Laughing* series. She played buxom Tzana in the very first episode 'The Prisoner of Zenda' and Griselda in 'The Baron Outlook', as well as Isolde in the Battle of Hastings romp 'One in the Eye for Harold'. The series aired over the first couple of months of 1975 and almost immediately after Diane was eagerly embracing the world of the 1970s sex comedy, teaming up with Linda Regan as the singing duo the Climax Sisters in *Confessions of a Pop Performer*.

Nothing says 'New Barbara Windsor' like a comic routine centred on the bust, and here Diane Langton steps up to the plate, opposite Kenneth Connor as Captain S. Melly, in *Carry On England*.

After nearly taking Kenneth Connor's eye out on parade for *Carry On England*, Diane was given more of the same when she was cast as Katy in London Weekend Television's revival of Ronald Wolfe and Ronald Chesney's *The Rag Trade*. Diane's casting was simple shorthand for the big-busted, continually hit on, and often brilliantly self-protective factory floor dolly bird, the function Barbara Windsor had fulfilled in the 1960s original. The revival was broadcast across two series from September 1977 through to October 1978.

In later years, Diane appeared in *Only Fools and Horses* as one of Del's 1960s squeezes in 'Happy Returns', a double-edged sword title, not only referring to the imminent birthday of her character's daughter but also the first episode back since the death of Grandad actor Lennard Pearce. As was scriptwriter John Sullivan's wont, he neatly weaved Diane's character back in, in the Christmas Day 1986 episode 'Royal Flush', in order to commit social faux pas at the opera and gloriously embarrass Rodney – almost spilling out of her posh frock and slurping her drink in the auditorium.

Another maternal force of nature, she played Ruby Rowan, mum to Nick Rowan (Nick Berry)

An out-of-character, April 1976 publicity call for Diane Langton during the making of *Carry On England*.

in *Heartbeat*, supporting her son and helping bring up baby Katie after he tragically loses his wife.

JILL ADAMS (1930–2008)

Jill Adams is purely in *Carry On, Constable* as a frosty, then slightly flirtatious tease for PC Tom Potter, none hotter (Leslie Phillips). His desperate attempts to find out Policewoman Harrison's forename fall on stony ground. 'I can't keep on calling you that, it's such a mouthful!' he pleads. 'What do your friends call you?' 'Policewoman

Harrison!' comes back Jill's pitch-perfect reply. Ouch! Still, our moustachioed Romeo does get the green light: she gives him a lusty wink and a cheery smile but, disaster, she also gives a sweet little sneeze. It's a signal to the audience that she has caught the dreadful influenza that has brought down the workforce and necessitated the

use of our hopeless boys in blue in the first place. After that moment, we see nothing more of Jill's Police Woman Passworthy. Pity.

Jill had already proved herself a fine light comedienne and clearly 'game on' for the scantily clad antics of the *Carry On* style of comedy. As early as 1956, she had stripped down to her black basque for the black comedy *The Green Man*, a frantic farce that sees her caught up with the true but tall tale of a hired assassin to whom door-to-door salesman George Cole peddles his vacuum cleaners, while Jill's husband – owl-faced prig Colin Gordon – reads blank verse and misery over the airwaves of the BBC.

Jill was the daughter of silent screen star Molly Adair. Marrying Jim Adams in 1951, Jill joined Anthony Newley in the cabaret revue show *On With The New*; and started her film career with decorative roles opposite Arthur Askey in *The Love Match* (1954) and Dirk Bogarde in *Doctor at Sea* (1955). Producer Guido Coen offered her a substantial role in the thriller *One Jump Ahead* (1955). That same year, Frank Launder and Sidney Gilliat signed her up as one of Rex Harrison's seven wives in their romantic comedy *The Constant Husband*.

Jill enjoyed a jaunt to Australia resulting in a starring role as Julie Kirkbride in Chips Rafferty's

A Greek goddess for British screen comedy: Jill Adams on location in Athens – and not a Pinewood Studios set! – during the making of *Doctor at Sea*.

thriller *Dust in the Sun* and as Mary Meredith in the Associated British Television series *The Flying Doctor*.

Peter Rogers's wife, Betty Box, employed her once more, this time as Genevieve in *Doctor in Distress* (1963). Her last role, the 1965 comedy film *Promise Her Anything*, went uncredited, and in 1971 she moved her family to the Algarve where she ran a small hotel. In peaceful retirement, Jill concentrated on her painting and fun with her granddaughter and great-granddaughter.

JOAN YOUNG (1900–1984)

Joan Young had been playing prim and proper secretaries, hard-faced wives, and bombastic shoppers since the 1930s. Her one and only *Carry On* role was as the typically affronted customer accused of shoplifting by our cops in frocks, Kenneth Williams and Charles Hawtrey, in *Carry On, Constable*. One of those wonderful 'I know the face but not the name' character actresses, students of Joan's work are advised to watch out for her as Maggie in the Sid Field comedy *Cardboard Cavalier*; Mrs Round in *Time Gentlemen, Please!*; and as a frosty-faced competitor in *An Alligator*

Named Daisy. On television she was Ethel in *The Grove Family*, and Madge in the Sid James comedy drama *Taxi!* Also lost but most certainly not forgotten is her performance as Catherine de Medici in the *Doctor Who* serial 'The Massacre', opposite William Hartnell.

NOEL DYSON (1916–1995)

A mainstay of British comedy for nearly half a century, Noel Dyson graduated from the Royal Academy of Dramatic Art in 1938, and enjoyed stints with repertory companies in Birmingham, Oxford and Windsor. During the war, she enlisted as a nurse with the Voluntary Aid Detachment, alongside Hattie Jacques, and returned to stage and screen following the conflict, usually playing a rather flustered middle-class lady in a bewitching state of befuddlement. Noel is certainly in such a condition in her first *Carry On* film, *Carry On, Constable*, in which her naughty cat, Fluff, has got stuck up a tree. That nice policeman, Charles Hawtrey, mistakenly thinks he is addressing Miss Fluff but rather than give him a scowl, Noel is coquettish, even flirtatious. It's a lovely mistake that she rectifies. While tiny, the supporting turn is a delight. Indeed, Peter Rogers had already capitalised on her beguiling charms, when he had cast her as Mrs Brent in *Please Turn Over* (1959). Noel returned to the series one final time, as the charmingly controlled district nurse who comes to the aid of driver Sid James and nut of an expectant dad, Jim Dale, in *Carry On Cabby*.

Television would provide Noel with her defining roles: the maternal Ida Barlow in the original cast of *Coronation Street*, from 1960, and the practically perfect Nanny in *Father, Dear Father*, from 1968. An always welcome face on screen.

ESMA CANNON (1905–1972)

In a long career that ranged from opera in *Madame Butterfly* to a dazed lovesick reaction to Norman Wisdom singing *Don't Laugh at Me Cos I'm a Fool*, via playful pantomime at the Victoria Palace, Esma Cannon will be forever remembered as that mad little pixie that melted our hearts in *Carry On Cruising*, taking to the trip with full gusto. She is an unexpected *Carry On* girl, perhaps one people forget, but she certainly brought her share of the fun to the gang across her four appearances.

She is an international woman, having been born in Australia. One can certainly hear a hint of her accent in *Carry On Cabby*. Although always having an air of the dotty eccentric about her, there is certainly versatility and diversity within

'I'm Glad.' 'So am I, dear!': Cruising chums Glad Trimble (Liz Fraser) and Bridget Madderley (Esma Cannon) get merrily tanked, thanks to barman Sam Turner (Jimmy Thompson), in *Carry On Cruising*.

each of her *Carry On* roles. With her first, as a deaf lady trying to cross the road in *Carry On, Constable*, there is certainly a slight foreshadowing of what is to come later in her defining role in *Carry On Cruising*. Most memorably with a delightful whirl and twirl and giggling collapse as she struggles to do up the zip of her posh frock. The fact that Esma conveys just the right amount of sadness – she is travelling alone and has no partner to aid her – this back story is subtle enough to add real truth and humanity to the hilarious antics.

In *Carry On Regardless* though, we see her portray a slightly more calm character in her performance as Miss Cooling, a rather apt name in true *Carry On* fashion. She is the secretary we

all know and love, who has a joke with the staff, but is forever loyal to her boss, Bert Handy (Sid James). A practical woman, but not in a way that is derogatory to women, she is the rather charming and loveable lady that we can all relate to, one we might have worked with in our own careers. While very much part of the *Carry On* gang, there is an intriguing and effective sense of otherness about her. Super-efficient, and detached from the core team, Esma keeps the Helping Hands in line throughout. Esma effortlessly takes charge of the team, twittering with nerves at the

gobbledegook of their landlord (Stanley Unwin) and keeping well out of the destructive climax as the established team wreck his property. Esma stands on her own tiny two feet amongst those larger-than-life characters.

It was a talent that attracted other producers to offer Esma bigger and better roles. While Peter Rogers happily signed her up as the deaf old landlady in *Raising the Wind*, a role harkening back to her dithering cameo in *Constable*, Monty Berman had given her the plum eccentric role of bonkers Aunt Emily in *What a Carve Up!* From October 1961, she starred on television as feisty Lily Swann in *The Rag Trade*, a hit sitcom role that undoubtedly secured her that meatiest of *Carry On* gigs, in *Carry On Cruising*, which was filmed from January 1962.

Here Esma is very much part of the team. She is the spinster everyone wants to meet on a cruise; she's fun, entertaining and up for a jolly good time – be it taking part in the fitness activity, or playing ping-pong as a novice, to holding her own in the bar. Yet again, women come out on top as they break the rules and prove they can do twice as much as the men can, or in her case, drink twice as much as her friends and most of the men. Even to the extent that the ship's resident drunk (Ronnie Stevens) gurgles, 'What a woman!' The beauty of Esma's character is that although she is a spinster, everyone on board the ship welcomes her into their circles, including Glad and Flo (Liz Fraser and Dilys Laye). Although she is never going to be a threat to the two girls, who are already at loggerheads over the fitness instructor (Vincent Ball), this doesn't stop Esma throwing herself into the fun of the cruise. Indeed, the character of Bridget is the cement between the two young lasses and she enjoys just as much pleasure as the girls. Never vicariously but by getting on with it and mucking in. Let's face it, if there were to be an Esma Cannon cocktail, why not call it Two Flo Dears and sail away into the sunset with her?

One too many Two Flo Dears, as Bridget (Esma Cannon) is helped by First Officer Leonard Marjoribanks (Kenneth Williams), Flo Castle (Dilys Laye), Captain Wellington Crowther (Sidney James), and Doctor Arthur Binn (Kenneth Connor). Esma was delighted at her high position and prominent place in the publicity for *Carry On Cruising*.

Cruising not only displayed her endearing charm as a comic actress, the production also showed what a real trouper Esma was: she revealed during the filming schedule that she could not swim! Desperate not to let anyone down, she admitted the fact to Gerald Thomas on the day she had to put on her dainty Victorian bathing costume and submerge herself in the studio swimming pool. Gerry, ever caring and conscientious, placed an expert swimmer, just off camera, just in case Esma needed assistance. However, the 4ft 9in professional took the plunge, quite literally, and emerged, scene completed, and was greeted with a huge round of applause from the surrounding cast and crew. None cheered this gallant actress louder than Gerald Thomas.

Little wonder she went straight into another Gerald Thomas film, playing the delightfully absent-minded and telephone-phobic mother of Juliet Mills in *Nurse on Wheels*. The film was released in January 1963, at a time when Esma

was starring in *The Rag Trade* stage show, at the Piccadilly Theatre in London's glittering West End.

Never downhearted, the show closed in the February of 1963, as Esma was preparing to rejoin the gang for *Carry On Cabby*, a film where she is now very much one of the team, notably forming a wickedly funny and cunning partnership with Hattie Jacques. Indeed, for a little lady of a certain age, when we meet her in this film, she embodies women of the 1960s. Women had been used to doing the work of men during the Second World War, and it is clear that as a result of this, in *Carry On Cabby* we see how women now want to be treated as equals. Whilst Hattie is the leader of Glamcabs, it's dear Esma who is the real rally-crying leader of the workforce. Without her they would not be able to service their cabs, or play havoc with the boys. Hattie may be the protective influence on her tantalising taxi drivers, but it is Esma who is the forthright warrior: never letting the men take an inch and never showing remorse or pity or weakness. She's a fighter for the female cause.

It's all the more the pity then that Esma would make just one more film, *Hide and Seek*, rather disappointingly as a tea lady, and thus a return to the coughs and spits of her past. A decade of quiet retirement followed. Very much Esma's choice, and very fitting for such a self-contained lady. Still, the *Carry On*s would, and intended to, have her back. Indeed, in one of Norman Hudis's aborted draft scripts for *Carry On Spying*, initially discussed as the next *Carry On* in the spring and summer of 1963, he had written the feisty secretarial character of Amelia Barley especially for her.

It was very different from the film that was eventually made, and the *Carry On* history could have been very different if Esma Cannon had carried on acting. One can reflect on her being cast as Frankie Howerd's deaf assistant played by Joan Sims in *Carry On Doctor* – as we have seen, Esma did deaf extremely well – or even the contrary maternal influence of Renée Houston's character in *Carry On At Your Convenience*.

It was certainly not in her mind to exit stage left at the time of publicising *Carry On Cabby*, with Esma delighted with her character. 'Until now,' she reflected, 'I've always played fluttery parts. My height made it difficult to play anything else. But as Flo I really do get a chance to show that little women can be a character to reckon with.' Amen to that.

After decades of fun bit parts and uncredited screen assignments, Esma Cannon finally became a star character actress in the early 1960s. Her glee fair pulses off of the page.

DIANE AUBREY

Just 19 when she appeared as Lily Rankin, one of Boris Karloff's victims in *Grip of the Strangler* (1958), Diane Aubrey was still waxing lyrical about the experience some sixty-five years later for the documentary film *Boris Karloff: The Man Behind the Monster* (2021). In between she had married film director Troy Kennedy Martin, got caught up in the classic *Scotland Yard* short, 'The Ghost Train Murder', played Sandra in eleven episodes of the Sid James comedy drama *Taxi!*, and given her all as Honoria in *Carry On, Constable*. Potty Poos! Fellow constable on the beat Kenneth Connor has less joy with Janetta Lake and her naughty dog!

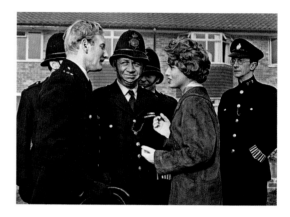

PCs Kenneth Williams, Kenneth Connor and Charles Hawtrey look on as Police Sergeant Frank Wilkins (Sidney James) breaks up the upper-class catch-up of Potty-Poos (Leslie Phillips) and his Hornia Old Thing (Diane Aubrey), in *Carry On, Constable*.

DORINDA STEVENS (1932–2012)

A bubbling blonde with real acting ability was just the sort of actress the *Carry On*s required, although only rarely was she used to the maximum of her potential. A whiz at elocution, she had joined the Southampton Repertory Company and made her London debut by the age of 17. At 19 she was married to actor Peter Wyngarde, a union that lasted five years and ended in 1957 when Dorinda was playing a handful of roles in the television series *African Patrol*, on location, and fell for dashing Canadian director of photography William Michael Boultbee.

At the time, she was in several successful British comedy films, including *Not Wanted on Voyage* (1957), with Brian Rix and Ronald Shiner, and appearing with Donald Sinden and

Barbara Murray in *Operation Bullshine*. Released in the summer of 1959, the Sinden connection led directly to Peter Rogers, who cast her as Young Woman in *Carry On, Constable*. She is the glamour girl, wearing only a towel and a worried expression, who is innocently listening to a tense crime drama on the radio. Cue devil-may-care Leslie Phillips, on duty and, at the sight of Dorinda, on heat. It was a small role, but a stand-out. Unsurprisingly, Peter Rogers gave her an even bigger part in the music academy comedy *Raising the Wind*, in which she catches the eye of publisher and jingles-writer Sid James. Thereafter, Dorinda would pop up in untaxing television roles, for the Danzigers (*The Cheaters*, 'The Safe Way', 24 February 1962) and

Robert Baker and Monty Berman (*The Saint*, 'The Careful Terrorist', 18 October 1962), before rejoining the gang as one of Marianne Stone's Dirty Dicks girls in *Carry On Jack*.

Although Dorinda's screen career was over by the mid-1960s, she went out with a bang, notching up powerful roles opposite Hugh Lloyd and Terry Scott in *Hugh and I*: 'Emergency Ward' (7 March 1964) and Patrick MacGoohan in *Danger Man*: 'Such Men Are Dangerous' (12 January 1965), and, with fellow *Carry On* girl Edina Ronay providing the glamour alongside Hollywood icon Leslie Nielsen and *Carry On Spying*'s Fat Man, Eric Pohlmann, in the rollicking, critically acclaimed espionage thriller film *Night Train to Paris*. En route there's mystery, intrigue, murder … Oh, yes!

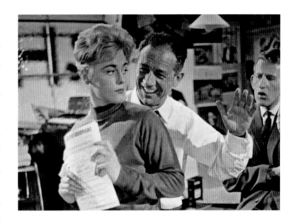

It's not all Popsey Crisps and Bubble Flakes at the advertising jingle offices of Sidney James and Lance Percival, in the Peter Rogers production *Raising the Wind*. Their curvaceous secretary, Dorinda Stevens, is on hand to brighten the place up. As Sid says of her, 'She takes up some room!'

CARMEN DILLON (1908–2000)

Born to a large Irish family in Hendon, North-West London, Carmen's siblings were split asunder early in her life: a brother was killed in action during the Great War; another emigrated to Australia; while one sister became a nun and another, Una, founded Dillons Booksellers.

Trained as an architect and designer, Carmen joined the British film industry as an art director in 1934 working on such pre-war quota quickie classics as Manning Haynes's *The Claydon Treasure Mystery*, and Alex Bryce's *The Last Barricade* (both 1938). The war years saw Carmen collaborate with actor-director Leslie Howard on the heart-warming war romance *The Gentle Sex* (1943), and enjoy regular work with directors Harold French (the contemporary espionage thriller *Secret Mission*, and the guilty past comedy

Flo Castle (Dilys Laye), Glad Trimble (Liz Fraser), and Doctor Arthur Binn (Kenneth Connor) magnificently supported by Carmen Dillon's set designs for *Carry On Cruising*. Jill Mai Meredith and Jan Williams are also on board to bring extra glamour.

Talk About Jacqueline (both 1942)) and Anthony Asquith (ranging from romantic comedy *Quiet Wedding* (1940) to patriotic flag-waver *The Way to the Stars* (1945)). It was alongside Asquith, on the Russo-Anglo comedy *The Demi-Paradise*, that she met Laurence Olivier. So impressed was he that, at the earliest opportunity, he assigned her a film project, his epic, influential screen versions of Shakespeare's *Henry V* and later *Richard III*, and his 1948 presentation of *Hamlet*. Nominated for seven Academy Awards, it won four, including Best Picture and Best Art Direction.

It was comedy that Carmen seemed to gravitate towards, however, working with Peter Ustinov (*Vice Versa*, 1948), Walter Forde (*Cardboard Cavalier*, 1949); and John Paddy Carstairs (*One Good Turn*, 1955). She had enjoyed a prolific association with the British-based arm of Walt Disney Productions for *The Story of Robin Hood* (1952), *The Sword and the Rose* and *Rob Roy* (both 1953); reunited with Anthony Asquith for *The Importance of Being Earnest* (1952), and worked

with Betty Box and Ralph Thomas on *Doctor in the House* (1954), *Doctor at Sea* (1955), and *The Iron Petticoat* (1956).

In an association that simply enforces the fact that Peter Rogers used the very best technicians in the business, this Oscar-winning art director worked on no less than seven of the film comedies he produced between 1959 and 1962, from *Please Turn Over* to *The Iron Maiden*.

Carmen really let rip on the colourful nautical romp *Carry On Cruising*, designing a swimming pool which was realised as a water tank set into the floor of sound stage 'A'. It was a stunning tiled design, backed by a large mural depicting Neptune and the denizens of his underwater world. With a depth of 6ft 6in at one end and 4ft at the other, it was 24ft long and 17ft 6in wide and contained 50,000 gallons of chlorinated water heated to 86°F.

This pioneering woman of British film retired in the late 1970s, settling to a comfortable life by the sea in Hove, East Sussex, in a flat she shared with her sister.

LIZ FRASER (1930–2018)

If Shirley Eaton is the Grace Kelly of the *Carry Ons* then Liz Fraser is the Judy Holliday: bubbling, forthright, fearless, occasionally ditzy, but that rare commodity in British comedy – a truly hilarious comedy actress who looked knock-out in a bikini. Her earliest screen comedies, with glorious bits and bobs, include the Ealing comedy *Touch and Go* with Jack Hawkins, and as a snogging cinema-audience member in *The Smallest Show on Earth*.

'I actually auditioned for the role of Miss Hogg, the daughter of the character Sid [James]

played,' Liz remembered. 'That would have been nice, wouldn't it?' Nice indeed, for Liz and Sid would be practically joined at the hip for much of the early 1960s. She bewitched Tony Hancock with her pithy attitude and severe stares so much that he insisted that writers Ray Galton and Alan Simpson use her in bigger and more bolshy roles. Hancock's persona benefited from strong figures to work against, and he knew it, and the female foils of Liz were hilariously savage in the extreme. The more she insulted him in the show, the more the star of the show liked it. Invariably, Hancock

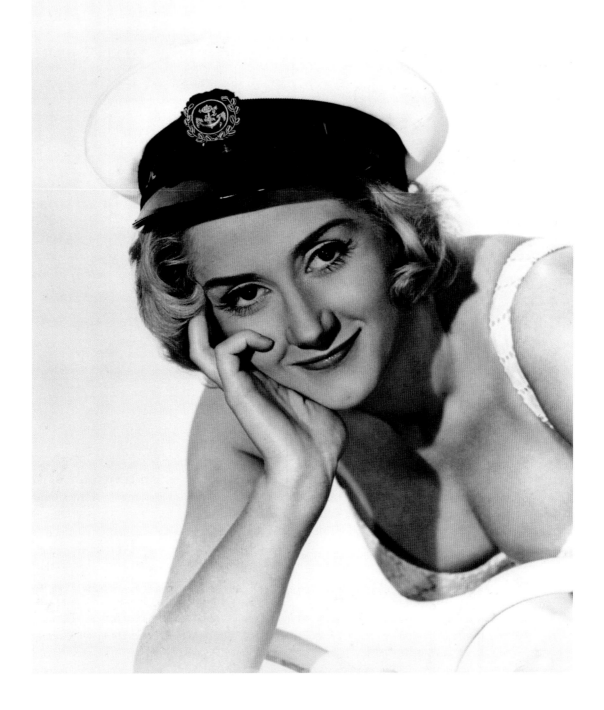

All the nice girls love a sailor. Liz as Glad Trimble, for *Carry On Cruising* publicity.

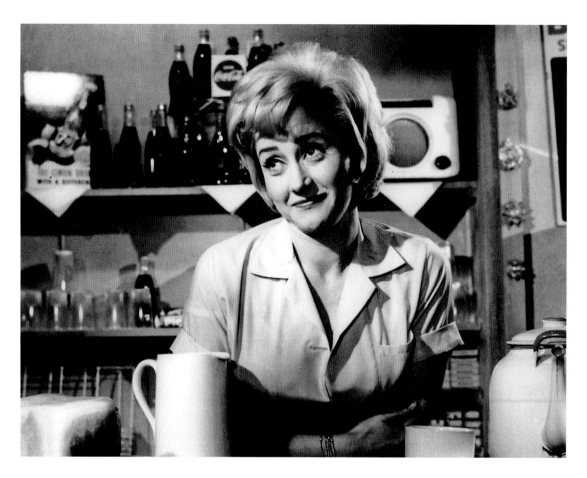

Liz as the careworn but loyal canteen girl Sally in *Carry On Cabby*.

would lose out to his best chum, Sid James, which, in turn, meant that Liz and Sid enjoyed a warm chemistry.

Liz found herself in the unique position of working with both Hancock and Sid when the much-publicised breakdown of the partnership happened. Liz was insistent on serving her coffee shop coffee with froth in *The Rebel*, while enjoying a barge holiday with Sid in *Double Bunk* – the favourite of all her film roles. Having written the film for Hancock, Galton and Simpson felt morally obliged to write a little something for Sid too. This was the BBC Television sitcom *Citizen James*. Ostensibly *Hancock's Half-Hour* without Hancock, the first series cast Liz as Sid's no-nonsense girlfriend, Liz, the owner of a cosy Soho drinking establishment, who was forever forking out money for Sid's latest scheme, and forever waiting for him to name the day for their wedding.

By the time the show was transmitted, Liz had been signed up for *Carry On Regardless*:

Sid was in that too, of course, so he was always a reassuring presence, not that I needed anyone to look after me, but Sid looked out for you. That's a very different thing. He was a great mate. He used to call me Lizzle. A happy man and a happy film set.

The role of Delia King was swiftly written, out of thin air, to cover over the cracks left by Hattie Jacques's unavailability for the whole schedule (although she readily agreed to support Matron Joan Hickson in the medical vignette). With Joan Sims well aware that Liz 'won on points' in terms of vital statistics, much of the overweight jibing was written into Joan's character, while all the wolf-whistle worthy sexiness was given to Liz. And then some!

Liz Fraser really put the I in Independent, both in life and in character. Liz had a glorious career, and it's no surprise that Sid James was the man to champion her comic attributes. Liz could play soft and feminine as well as tough and bold. In *Carry On Regardless* we fall head over heels for her, as our blonde bombshell. She had a figure to die for and very quickly became part of the team.

It had been producer Roy Boulting who had been instrumental in creating that Liz Fraser image of blonde bombshell in a tight sweater when he cast her as Cynthia Kite, daughter to Peter Sellers and Irene Handl, in *I'm All Right Jack* (1959). In *Two-Way Stretch* (1960) she was Sellers's girlfriend. While just a few months after wrapping on *Carry On Regardless* she was preparing to return to Pinewood Studios and the Peter Rogers comedies, as sexy cellist Miranda Kennaway, in *Raising the Wind*. Liz took fame, and the requirement for revealing scenes and photo shoots all in her stride:

> The *Carry On*s weren't unique in asking us ladies to wear bikinis or revealing dresses or whatever it was, but it's only the *Carry On*s that people remember, so they are always held up as the barometer for those days. All I can assure you is that there was never anything horrid or unpleasant on the *Carry On*s. Never! We were getting paid to make people laugh. That was it. And the people are still laughing. That we had such great fun doing it is a lovely bonus.

Exuberant carefreeness, as gentlemen's club stripper Leonora, in promotion of *Doctor in Love*, in cinemas for the summer of 1960.

Liz worked well with Dilys Laye, whom she greatly respected as an actress. As best friends in *Carry On Cruising* they really provide the Yin and the Yang. Liz really is every girl's favourite best friend, although you know she will give you a hard time, and pull you straight back into reality. Then again, we all need a friend like Liz. Despite competing with Dilys over the gym instructor on board the ship, she is really caring towards her friend. Glad is on hand to help Flo when Flo drinks too much. However, it is the moment when she hears Kenneth Connor singing 'Bella Flo' that marks her out as a real girlfriend. Suddenly we see a side of Liz that she would have relished playing more on film. She is genuinely touched by the romance of the moment. She's not jealous, she's not an angry feminist, she just sits and thinks. A thoughtful moment, looking across to Flo. She knows ultimately this is Flo's moment, and she will help her to open her eyes. Perhaps almost a sense of sadness, because deep down that's what she really wants. Remember this is a time when women ultimately wanted to find a husband. Glad sees the potential and, through her boldness, takes action.

In *Carry On Cabby*, Liz is much the same, a sensible girl, trying to help Hattie Jacques find a way forward through the stubborn pig-headedness of her husband (Sid James) and his workforce of male taxi drivers. Liz strikes the balance between loyal girlfriend and feminist here. Her character reflects women of the time, those women who wouldn't work once they got married, happy that their sole purpose was to look after the house and the children once they were wed. Liz looks at Hattie, almost with a sense of concern that she may end up being pushed into this role; a role for which Liz initially feels she is not ready. Therefore, when Liz supports the establishment of Glamcabs one almost feels this is going to be her last hurrah, her final moment of rebellion before she has to settle down. Remember, post-Second World War, when women had been doing the jobs of men, they felt a sudden redundancy once they returned home to domesticity. Whilst the back story is engrained within the performances of Liz and Hattie and Esma, the men spell this connection out loud and clear. If an out-of-work driver with a war record approaches Sid for a job he will invariably give him one, even cack-handed lunatic Charles Hawtrey. As Kenneth Connor makes clear, Sid's character likes to look after the boys who saw action in the conflict. Eighteen years since the end of the war, 1963 had seen the feminist revolution started with a vengeance. For Liz too, the *Carry On*s and British cinema in general was her route to independence. During the promotion of *Carry On Cabby* she explained that film won over on theatre because, 'I like to have my evening's free … besides I like the money in films.'

Indeed, despite the theatre providing Liz with her most satisfying roles, including Mrs Lovett in *Sweeney Todd*, and Mrs Bumble in *Oliver!*, she happily threw herself into the lucrative sex comedy film market of the mid-1970s, romping with Robin Askwith (*Confessions of a Driving*

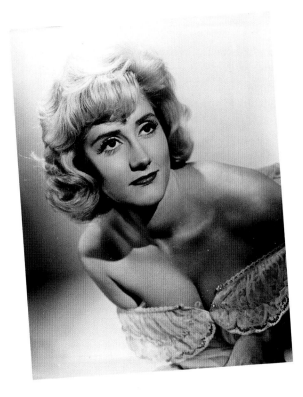

Born to *Carry On*: Liz Fraser in a stunning portrait study for her debut as part of the series, as Delia King, Miss, in *Carry On Regardless*.

Instructor and *Confessions from a Holiday Camp*) and Barry Evans (*Adventures of a Taxi Driver* and *Under the Doctor*) and, rather more sedately, making a belated return to the *Carry On* franchise, as a suspicious wife on both film, *Carry On Behind*, and stage, *Carry On Laughing*. That, within the *Carry On*s, Liz had matured from scatty sexpot to nagging matriarch is a given, but her suspicions are certainly not unfounded. Despite the double negative, she takes to the self-protective housewife role with ease. And at the end of the caravanning film, she is nicely tucked up, with her loving husband (Windsor Davies) getting quite misty-eyed and nostalgic at the reunion. His girl-chasing days over, he's settled back to wedded bliss. That the role had been written especially for Sid James is so right, it hurts. It would have seen Liz finally making an honest

man of Sid some fifteen years since *Citizen James*. Ho Hum.

Never one to mince her words, Liz herself would get frustrated when journalists insisted on overshadowing her varied and vast body of work with the *Carry On* label, seemingly forgetting her sensational serious roles such as the fading model in *She*: 'Sight Unseen', the distraught cancer patient in *Eskimos Do It* and the alcoholic, grieving mother in *Miss Marple*: 'Nemesis'. Still, Liz happily regaled fans on the signing circuit, celebrated at reunion parties – and even walked the corridors and sound stages of Pinewood Studios one final time for the retrospective documentary series *Carry On Forever*.

Looking back on her long life, Liz realised she was a part of social history and appreciated that her *Carry On* characters allowed her to fly the flag for the young free-thinking feminists amongst us in the 1950s and 1960s.

FENELLA FIELDING OBE (1927–2018)

The theatrical phrase 'Vamp until Ready' – meaning to pout, express, do anything while awaiting your cue during an unexpected pause – could have been coined expressly for Fenella Fielding. After half a dozen years on the stage she had become an overnight sensation in Sandy Wilson's musical *Valmouth*, in 1958, stopping the show, and stealing the plaudits as Lady Parvula de Panzoust, with her solo numbers 'Only a Passing Phase', and 'Just Once More'. The following year, she was headlining, alongside Kenneth Williams, in the hip and happening revue *Pieces of Eight*, at the Apollo Theatre. During the run, her beautifully bizarre qualities were fully utilised by Ray Galton and Alan Simpson for the *Hancock's Half-Hour* episode 'The Poetry Society'. Her bewitchingly pretentious Greta purrs out such lines as 'I can only tolerate Bartok and Weber …', while she is described by Hancock as 'the weirdest one here tonight …' She is delighted. It's Fenella's career mission statement in a nutshell.

That voice was used to bewilder Anthony Newley too, when Fenella was cast as Caroline the Cow in the third episode of the abstract and hugely influential *The Strange World of Gurney Slade*. On film she had bamboozled Norman Wisdom, as Lady Finchington, in *Follow a Star* (1959), and, still at Pinewood Studios, would join the repertory companies of Peter Rogers and Betty Box in 1960. It was all happening. Still, Fenella's magnum opus of screen comedy would come a little over five years later and was blood-curdling indeed.

The performance as the sultry vamp has been ingrained in our minds forever. That dress, those lips and her silky-smooth voice from *Carry On Screaming!* left us all with a long-lasting impression. If she had been in just this one film, Fenella would still be remembered as a *Carry On* legend.

However, when Fenella first joined the team, she played the illustrious Miss Penny Panting ('No, that's the way I always breathe!') in *Carry On Regardless*. Supposedly looking for a babysitter, and getting poor Kenneth Connor hot under the collar. It was only one day's work, completed on 12 January 1961, but she sure left an impression on the screen. She simply oozed the siren! Fenella wasn't so much nervous as incredulous. 'When I

received my script, with my one scene, I thought to myself, "My God, we will never get all this done in one day!" It seemed to go on for hours, and was very complex.' Her scene, in fact, was a whopping twelve pages of script:

> I got the impression that if we didn't get it finished then they would just cut the end of it. Dear Kenny Connor was just so good, and so relaxed, we did it. And our director was such a whiz. An incredibly clever man. We actually got the scene shot … with time to spare. I was astonished.

Fenella effortlessly matched the true professionalism of the team. It was a tight schedule but never rushed and for Fenella, like Joan Sims, she approached the *Carry On*s with the same energy as she would a Restoration comedy on stage. 'You knew instinctively what the part required, and how they wanted you to play it, I suppose. It was hard work but fun. That's exactly how this business should be.'

Fenella had certainly proved herself speedy, efficient and clever, and went on to enjoy a supporting role, of Miss Fordyce, opposite Leslie Phillips in Earl St John's Pinewood-based veterinary comedy *In the Doghouse*, as well as a couple of featured roles in the *Doctor* series: as a flustered passenger on a train in *Doctor in Distress*, and, most spectacularly of all, the flamboyant ballerina Tatiana Rubikov in *Doctor in Clover*. Although Peter Rogers had been disappointed when Fenella had turned down the role of Anthea in *Carry On Cabby*, no one was replaced forever (she was appalled that the role 'was obsessed with my bust!', a pass that gave 'totally flat-chested' Amanda Barrie her *Carry On* break, while Hattie's

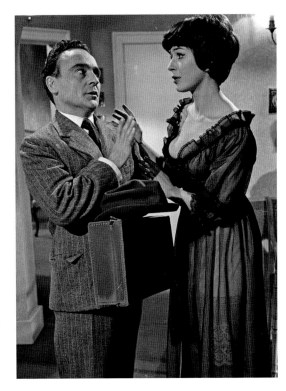

Siblings Valeria and Orlando Watt (Fenella Fielding and Kenneth Williams) up to some ghoulish goings-on in *Carry On Screaming!*

Mrs Glam phone voice was a loving pastiche of Fenella's husky tones).

When it came to planning *Carry On Screaming!*, at the end of 1965, Rogers knew that Fenella was the only actress in the country that could do his comic vamp justice. She had convincingly turned on the twisted titters over at Hammer Films, playing the weird and wonderfully bonkers Morgana Femm in American showman William Castle's boisterous reimagining of *The Old Dark House* (1963). The ultimate British horror spoof was a shoo-in:

> Even though the Hammer films were not made quite as quickly as the *Carry On*s, I was asked to play the role of Valeria Watt, I read

Fenella Fielding in her defining role: as the ultimate Hammer Glamour pastiche Valeria Watt in *Carry On Screaming!*, in cinemas across Britain for Halloween 1966.

the script, and loved the character so much I just had to say 'Yes!'

That instinctiveness of interpreting *Carry On* was very much down to the performer, and Fenella remembered that her first day on set, with Bernard Bresslaw, was the first time director Gerald Thomas was witnessing how Fenella would play it. 'He suddenly gave me a sharp look, and with that single glance, it was clear to me that he was very pleased!'

The shorter schedule also meant less money but it was an issue that never bothered Fenella. She would giggle:

> I never thought about it. For me, being in a *Carry On* film meant I was going to have a lot of fun. And what's more, one knew they were popular, and knew they would be shown.

For a jobbing actress, the *Carry On*s at the time proved an excellent exposure to get more work. They were well-distributed showcases.

Over the years, many fans and interviewers would ask Fenella, 'Whatever happened to the dress?' She honestly didn't know, and with hindsight felt she should have kept it, but at the time many actors didn't think like that. In fact, the only costume item Fenella did keep was the blood-red ring that she wears in the film. Prior to filming, she had met with the costume designer (Emma Selby-Walker) who took Fenella off to buy some earrings. Fenella saw the ring and asked if her character could wear it. 'It was £9 and I was told that the budget was too tight for that, but if I wanted it, my character could wear it. The only thing was, I would have to buy it myself!' Fenella did just that. And she kept it. Quite right too! As for the dress, it was so incredibly tight that Fenella needed to use a leaning board on set in order to relax between takes. The dress became so iconic that many women copied its style for their own wedding dresses. Fenella always felt that

Valeria Watt (Fenella Fielding) seduces Detective Sergeant Sidney Bung (Harry H. Corbett), in *Carry On Screaming!* The actress had to similarly warm up her co-star during the making of the film, in January 1966.

the money had gone in the right direction when making *Carry On Screaming!* 'I only had that one costume, but I never felt that was anything personal. It's all I needed. Unforgettable.'

It's certainly enough to set the heart of Harry H. Corbett racing. The two are simply sublime on screen together. Although the role of Detective Sergeant Sidney Bung had been written for Sid James, Corbett's brilliantly straight reading of the part really allows the outlandish and exaggerated performance of Fenella to shine. Both seasoned Shakespearian actors happily play the gloriously silly dialogue with total conviction. Fenella loved working with Harry and it shows:

> He was a darling man, although he was very serious. I was a bit cheeky and actually asked

for a second take on the scene where I had to kiss Harry. He was being sort of mild, shying away from it, so I got my way and we did it again.

That second take is the one in the finished film.

Fenella fit beautifully into the team. She owns *Screaming!* Her iconic presence brings a new dimension to the *Carry On* girl. She is incredibly sexy, sharp witted, and is not afraid of being in control of her own desires and needs as a woman. She is canny enough to play all the men off against each other, and that includes her own brother (played by Kenneth Williams). Even the deathly pale Sockett (Bernard Bresslaw) falls under her spell. Fenella is the ultimate vixen.

As a result, she was rather miffed when the film proved only a fleeting success at the British box office. 'We laughed and laughed when we made it, but when it came to the press screening everyone was sort of silent.' It was television

that really made it a cult classic, 'And I for one am very grateful to all those television showings of the film.' Apart from the exposure and the work it continued to bring in decades after she made it, it reminded people just how good the film was. 'Without television I honestly think we would have all been forgotten about by now.'

During the film's production, from January 1966, Fenella had been launched in the bizarre *Izeena*: part Africa safari, part acid trip. Fenella starred as Izeena, a 200-year-old mystic who lived in a magical treehouse in Animal Land and watched the animals through her telescope. Fenella being beautifully Anglian studio-bound; the animals being in the Serengeti. It was pure Fenella. Mind you, everything she touched became pure Fenella: that voice! – as the tannoy system in *The Prisoner*; as the essence of Blue in *Dougal and the Blue Cat*; presenting the 'Carnival of Monsters' section for BBC Television's *Doctor Who* night.

She was often invited back to the *Carry On*s. 'I would have loved to have done more, but thank God, I was very busy in the theatre.'

Carry On Screaming! never went away, of course, not that Fenella minded in the slightest. 'Oh, darling. I'm thrilled.' People were forever stopping her in the street and asking her to say, 'Oh, OdBodd.' 'I don't mind one bit.'

And when she finally sat down to write her memoirs, the title was *Do You Mind if I Smoke?* Of course it was:

You know I questioned that line at the time. I felt it was corny. Gerald Thomas said, 'Don't worry darling, the children will love it.' And he was right. That's the secret of the *Carry On*s. It's important to still be able to laugh like when we were children.

Fenella as the temperamental and lovesick ballerina Tatiana Rubikov, in *Doctor in Clover*.

AMBROSINE PHILLPOTTS (1912–1980)

Cinematic shorthand for dotty dowagers and out-raged aristocrats, the small but beautifully formed *Carry On* contribution of Ambrosine Phillpotts began as the flu-stricken chimpanzee owner in *Carry On Regardless*. The beast is called Koki but her cold in the nose convinces Helping Hand Kenneth Williams that it is Yoki. With hilarious results. She is the haughty Mrs Featherstone in *Raising the Wind*, while taxi driver Sid James hurls insults at her stiff features and prim and proper manner which resembles a disapproving corpse. 'Watch out, mate,' our main man bellows to chauffeur Frank Forsyth, 'she's got out of the box!' Betty Box had also cast Ambrosine as the severe wife of Sir Lancelot Spratt (James Robertson Justice) in *Doctor in Love* (1960) – looking on with similar disapproval at the medical antics of Leslie Phillips and Michael Craig.

Devotees of Ambrosine's unique screen snob-bishness should also refer to two minor gems in the Sid James canon: as Nurse Pynegar in *Father's Doing Fine* (1952) and Sylvia Levington in *Aunt Clara* (1954). Peter Rogers had cast her as the duchess Cynthia Whitecliffe in his dual Tommy Steele comedy musical *The Duke Wore Jeans*. It's a perfect encapsulation of Ambrosine at her best, and it was a performance she effortlessly continued to give until her last days, support-ing Dick Emery, as Lady Missenden Green, in *Ooh … You Are Awful* (1972), and Mrs Mowbray, opposite Sheila Hancock in *The Wildcats of St. Trinian's* (1980).

MOLLY WEIR (1910–2004)

The archetypal Scots fusspot, from her house-keeper Aggie McDonald in *Life with the Lyons* to the dazzling Hazel McWitch in *Rentaghost*. Perhaps best remembered as the figurehead for the advertising campaign for cleaning fluid Flash, Molly was a bestselling author of a series of memoirs, beginning with *Shoes Were For Sunday*, in 1970.

Her British film appearances include two very different school teachers, in *What a Whopper* (1961) and *The Prime of Miss Jean Brodie* (1969), while Peter Rogers cast her as the parrot-loving client of the Helping Hands agency in *Carry On Regardless* where Bill Owen is mistakenly sent to her aid while fey Charles Hawtrey is assigned the job of bouncer at a strip club! A mix-up over birds, you see. A decade later, she was recalled to the fold to play the mother of Mary (Patricia Franklin) in the film presentation of *Bless This House*. In 1975, Molly joined a lovely *Carry On*-centric supporting cast – including Bernard Bresslaw, Joan Sims, Jon Pertwee, and Amanda Barrie – in Walt Disney's *One of Our Dinosaurs is Missing*. In a natural piece of casting, Molly played a Scots nanny. John Benham (1918–81) is very Ambrosine and a might Molly is a dazed dinner guest in *Carry On Emmannuelle*.

BETTY MARSDEN (1919–1998)

Liverpudlian firecracker and woman of many voices – many, many voices – Betty Marsden proved her dependability and versatility in both her *Carry On* roles: as the heavy-lidded lady of mystery in *The 39 Steps*-themed escapade for Kenneth Connor in *Carry On Regardless*, and as Harriet Potter, the braying-laughed, ever-eager wife of Terry Scott, in *Carry On Camping*.

Her *Carry On* assignments sat comfortably alongside long-standing commitment to BBC radio sketch comedy, joining Kenneth Williams and titular totem pole Kenneth Horne, as part of the repertory company for *Beyond Our Ken* and *Round the Horne*. Betty's galaxy of grotesques ranged from throaty culinary expert Daphne Whitethigh to scenery-chewing theatrical deity Dame Celia Molestrangler. For the 1958/59 pantomime season, she had also joined Kenneth Williams in the lavish London Coliseum production of Rodgers and Hammerstein's *Cinderella*;

Williams was one of the Ugly Sisters, Betty the Fairy Godmother. Naturally.

In a delightful slice of bookending, Betty reunited with her first *Carry On* co-star, Kenneth Connor, when they played Mr and Mrs Warren in *The Memoirs of Sherlock Holmes*: 'The Red Circle' (28 March 1994).

Betty attended the fortieth anniversary *Carry On* party at Pinewood Studios in 1998. Earlier that year she had taken up residence at Denville Hall, the retirement home for actors, though she never actively retired! The end came while she was regaling fellow pros with theatrical anecdotes, with a large fruity alcoholic drink in hand.

If you are ever tempted to question just how inclement the filming conditions for *Carry On Camping* were, here's Betty Marsden and Terry Scott, in character as Harriet and Peter Potter, and in camera rehearsal.

JULIA ARNALL (1928–2018)

Born in Munich, and spending most of her childhood in Berlin where her father was an army officer, after the war Julia married a British serviceman, and relocated to Britain in 1950. She was signed up by the Rank Organisation, appearing in the Norman Wisdom comedy *Man of the Moment* (1955), and the Michael Craig crime thriller *House of Secrets* (1956). In 1960, Julia made her one and only appearance for Peter Rogers, as the hot-headed wife to Terence Alexander in *Carry On Regardless*. The tears of sentimental Helping Hand Kenneth Williams encourage her to return from her native German to English, thus allowing her raffish husband to know exactly what the argument is all about.

Television briefly capitalised on her exotic charms, casting her as Hilda in *The Avengers*: 'Intercrime' (5 January 1963) and Ingrid in *The Saint*: 'Locate and Destroy' (16 December 1966), before she drifted into semi-retirement by the late 1960s, to live a fulsome life by the sea in Brighton.

Julia Arnall bringing continental intrigue and mysterious glamour to British cinema since the mid-1950s.

JUDITH FURSE (1912–1974)

Furious battleaxe on screen, charming companion off, Judith Furse typifies the outsized, belligerent figure of pompous authority that would get the goat of Kenneth Williams and Sid James. In *Carry On Regardless* she is the outraged school mistress in charge of the party of young girls at the railway station which Williams mistakes for his Chinese clients, and in *Carry On Cabby* she's the butt of yet another crack from our cheeky cabby Sid,

when her real cow-hide suitcase clearly belongs to a real cow … Naughty!

Last but by no means least, Judith was the asexual criminal mastermind Doctor Crow in *Carry On Spying*. Although her other-worldly vocal mannerisms were provided by John Bluthal on dubbing duties, Judith's heavyweight, sub-James Bond villain employs her scariest scowls and her most chilling smiles. This is a genius clearly fit

to take on the very least of British espionage! A favourite of film-maker Michael Powell, she was cast as Dorothy Bird in *A Canterbury Tale* (1944) and Sister Briony in *Black Narcissus* (1947), and there was always an air of respect and reverence when she was on a Betty Box or Peter Rogers production – whether it was a burst of bombast in the romantic comedy of *Marry Me!* (1949), or the forthright Mrs Webb in *The Iron Maiden* (1962). Judith was all good comic value.

At Hammer Films she was the hatchet-faced Chief WREN with Frankie Howerd in *Further Up*

the Creek (1958), and Madame Bon-Bon with Bob Monkhouse in *A Weekend with Lulu* (1961).

On television she cropped up as Lady Sybil Popham in a trilogy of episodes of *Hugh and I*, and as Miss Vera Sipperley alongside Ian Carmichael and Dennis Price in *The World of Wooster*: 'Jeeves and the Stand-In for Sippy' (13 October 1967). Judith's final role was in Bruce Beresford's outrageous Australian comedy *The Adventures of Barry McKenzie* (1972).

CAROLE SHELLEY (1939–2018)

In films as early as her late teens, Carole was Peggy opposite affable music teacher John Mills, in *It's Great to Be Young* (1956), and by the early 1960s had appeared for Betty Box, in *No, My Darling Daughter*, and Michael Winner, in *The Cool Mikado*. In the latter she is Mrs Smith – married to the venerable C. Denier Warren – while Frankie Howerd and Tommy Cooper see who can crack the corniest gags.

Carole's *Carry On* roles are brief but unforgettable: playing the absent-minded wife, Helen Delling, in *Carry On Regardless*; and the delightfully silly and giggling Glamcabs driver in *Carry On Cabby*. She's clearly tickled at the thought of a man starting something in her cab, before Esma Cannon puts paid to that. The solution is a starting handle. Nothing better for stopping something! While Pinewood delighted in Carole as an amusing posh bit of totty, Hollywood and Broadway saw her as an English lady and an actress of infinite range. Indeed, she made her debut at the very top, as Gwendolyn Pigeon in the original 1965 production of Neil Simon's *The Odd*

Advised to always have a starting handle to hand because there's nothing better for stopping something, giggling Glamcabs driver (Carole Shelley) lines up for duty alongside Anthea (Amanda Barrie), in *Carry On Cabby*.

Couple. Carole and Monica Evans (who played her sister Cecily) transferred to the 1968 film version, and the initial run on television.

Bored of the same role, Carole once again reinvented herself, eagerly accepting an offer to play Rosalind in the 1972 Stratford Festival production of *As You Like It*, in Ontario, Canada.

Carole enjoyed a long association with the Walt Disney Studios too: lending her voice to Amelia Gabble the Goose in *The Aristocats* (1970) and another fine fowl, Lady Kluck, in *Robin Hood* (1973).

Back in New York, she starred as Jane in Alan Ayckbourn's *Absurd Person Singular*, for which she was nominated for a Tony Award, and won one for her performance as Mrs Kendal in *The Elephant Man*.

She guest-starred as Helen Moskowitz in the 1998 Emmy-winning *Frasier* episode 'Merry Christmas, Mrs. Moskowitz', by which time she was preparing for Fraulein Schneider in the 1999 revival of *Cabaret*. She created the role of Madame Morrible in *Wicked* (2003), and was once more nominated for a Tony for her role as Grandma in *Billy Elliot*, at the Imperial Theatre. From 2014, she played Miss Shingle in Freedman and Lutvak's *A Gentleman's Guide to Love and Murder*.

SALLY GEESON

Sally Geeson appeared in her first *Carry On* film as a child actor in *Regardless*. She is seen to be laughing within the crowd at the antics of Kenneth Williams in the department store. Twelve years later she would make a brief but starry cameo as Jimmy Logan's TV production assistant in *Carry On Girls* – an intrepid and resourceful independent woman amongst the beauty queens.

However, it is in *Carry On Abroad* we really get to see Sally as a fully fledged member of the team. Whilst Sally was often cast as the gorgeous girl next door, in this role she is feisty. Alongside her friend, played by Carol Hawkins, they are the girls who are looking for that holiday romance.

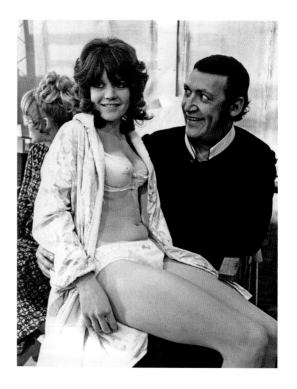

Brother Bernard! Sally Geeson sits on the knee of Bernard Bresslaw, during the making of her first grown-up *Carry On* appearance, as Lily, in *Carry On Abroad*.

A fascinating behind-the-scenes peek of Sally Geeson on Stage 'J', Pinewood Studios, shooting *Carry On Abroad*, in spring 1972.

However, Sally plays her character as another strong and independent woman. This theme towards the girls is really shining through. Sally brings a new generation of women into the fold.

Sally represents the girls of the 1970s. We see short skirts and hot pants, a more obvious approach to looking for a man, nicely compared and contrasted with Liz Fraser and Dilys Laye in *Cruising*. It's almost like a modern reprise of those characters. It's obvious from the outset she is looking for a guy, but – perhaps more obvious – that it's only for fun. Her run-ins continue throughout the film with Brother Bernard (Bernard Bresslaw). Whilst Sally is sassy, she isn't prepared to give it all away. That look of shock when he first sees her in his wardrobe with just her smalls on says it all. Sally merely brushes it off later with, 'I hope you enjoyed what you saw,' but she is trying to be a tough cookie. Underneath we get a sense of her embarrassment, her innocence even. As Scottish

rogue on the razzle Jimmy Logan notes early on, she's something of a Daddy's Girl. She puts down Bernard Bresslaw as a 'big nit' and as Carol Hawkins falls for his clumsy charms, Sally retorts, 'I don't know what you see in him.' Perhaps for her character, he makes her uneasy. After all, he is a monk, who represents wholesomeness and chastity, and Sally is up for a man who's going to give her a good time. Attitudes had changed by this point historically, and women had the pill, so why not go on holiday, have a fling and not worry about the future. Men could do it, so why couldn't the ladies?

It is lovely to see Sally's role diversify from her role in *Bless This House*. Sid James, who was starring as her father in the television series, was

very protective. 'Sid nicknamed me Salary,' Sally recalls, 'and really was like a dad to me. He was my way in with the *Carry On* people.' In the television sitcom, and the film version which went into production soon after *Carry On Abroad* had wrapped, Sally is still the virginal teenager. In *Carry On Abroad* she's become a woman, independent and in control.

Sally had already proved her strengths as a screen actress, playing everything from a terrorised servant girl to Vincent Price (*The Oblong Box*) to a sexually liberated teenager with Norman Wisdom (*What's Good for the Goose*). In her breath of fresh, 1970s air, in *Carry On Abroad*, Sally's vitality and vivaciousness was perfect for the more daring, open, and fundamentally empowered direction the films were going. It's no small thanks to Sally's performance that *Carry On Abroad* is one of the best-loved feel-good comedies in the British film canon. A glorious break indeed.

DILYS LAYE (1934–2009)

With a tilt of the head, a beaming smile, and a breezy confidence, Dilys Laye's early forays into British film comedy are eye-catching indeed: she's a leggy scheming schoolgirl in *Blue Murder at St. Trinian's*, and a knowingly sexualised secretary in *Doctor at Large*. It's an attitude born of Dilys's Broadway debut, when she played Dulcie in Sandy Wilson's *The Boyfriend* (1954). After a year on Broadway she was offered an extension to her run on the Great White Way or a return to London to star in the West End revue *For Amusement Only*. She opted to return home.

Dilys had trained at the Aida Foster School, making her stage debut, as Moritz, in *The Burning Bush*, at the New Lindsey Theatre in 1948. The following year, she chalked up her first film appearance, opposite Jean Kent in the riotous hymn to old time music-hall, *Trottie True*.

Canvas Chuckles. Dilys Laye and Joan Sims were stage cohorts and firm friends, who brought their natural warmth and playfulness to holiday chums Anthea Meeks and Joan Fussey in *Carry On Camping*.

She came into *Carry On Cruising* to replace her friend Joan Sims: Dilys had starred alongside Joan in the Hippodrome Theatre revue *High Spirits*, from 1953, and *Intimacy at 8:30*, at the Criterion Theatre in 1954.

Her character joins the cruise looking for a man with her sassy friend Glad (Liz Fraser): 'big head!' Dilys is fun, she is open to experience and wants to have a good time, although competition soon sets in when the girls see the hunky gym

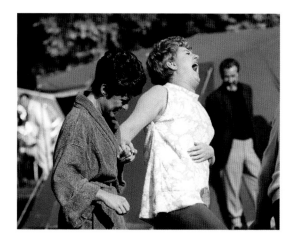

Double Agent Lila (Dilys Laye) does what it takes to get the secret formula from Desmond Simkins (Kenneth Williams), in *Carry On Spying*. It's either a bang or S.N.O.G.

instructor (Vincent Ball) and Glad is now back on a mission to finding a man. As Glad says, 'for him I'll make an exception!' While in this maelstrom of lovesick cabin fever, Dilys even gets a touch of 'Dad fad!' and makes a play for Sid James. Before his *Carry On* character developed into the one doing the chasing, Dilys is happy to chase after Sid, and throws herself at him. This leaves poor Sid feeling very uncomfortable. Whilst in the past, Sid's characters have had romantic connections with Hattie Jacques, in particular in his first film *Carry On, Constable*, this is much more subtle. In *Carry On Cruising* we really see a woman fling herself at a man. It's rather nice to see Sid feeling a little out of his sexual comfort zone, and both actors play the scene to perfection.

Unsurprisingly with her theatrical background, the *Carry On*s would utilise the versatility of Dilys, and when she returned to the series for *Carry On Spying*, this little lady was a huge presence as the seductive and duplicitous Lila. There are certainly shades of things to come, in the performances of Joan Sims and Angela Douglas in *Carry On Cowboy*. We see a darker performance here – for the plot has real death and intrigue at its heart – still Dilys embraces the never-never

land of James Bond fantasy with that sparkle of fun in the eyes.

Her later *Carry On* films present her as more sweet and demure. However, her character in *Carry On Doctor* makes a twist on this. We first see her as a sweet, innocent girl sitting in bed, recovering from an appendix operation. She makes coquettish eyes towards Bernard Bresslaw's character and enjoys his cheeky visit to see her. There's a real depth to this lonely female patient. We feel sorry for her, wondering why such a lovely girl is without someone to visit her. However, there's real backbone to this demure waif. She's not that quiet wallflower we first perceive her to be, for she rallies the other ladies to get revenge on Matron, by giving her a nasty bed bath. She is manipulative and gets her way in the end. A sterling role for Dilys.

Her final *Carry On* appearance is in *Camping*, playing Anthea Meeks, and, again, she starts out as a quiet, sheepish young lady. As the name suggests, she is meek. Scared of her own shadow, and a far cry from the role of Lila in *Spying*. Her small stature against Bernard Bresslaw's towering one adds comedic value. This time her partner in crime is Joan Sims, reflecting back to her *Cruising*

partnership with Liz Fraser. Dilys works well in a partnership in these roles, similar to her friend Joan in acting styles, working together to tempt their boyfriends away from the attractive schoolgirls. Still, while Joan is determined to hold on to her chastity, Dilys is the first to crack. She even shocks her friend when Mrs Fussey's postcard makes reference to lusty farmhands and the like. Dilys perks up. 'Chance would be a fine thing,' she muses. It's Dilys too who gets her own back on Joan's overbearing mother. Her innocent 'Oh dear, the ram's loose' is fooling no one. It isn't supposed to. We cheer her action – all designed for a moment of passion with her man, in a tent. Even Joan gives in. And even breaks the fourth wall to address us. It's all part and parcel of the loving and free-wheeling joy of the *Carry On*s.

The *Carry On* characters of Dilys always suggest a subtle feel of sexual independence, but her sweet and innocent nature leaves us guessing as to how far she really will go with her men. Ultimately, she plays a one-man woman and is in love with love.

Dilys was forever courted for a 1970s return to the *Carry On*s, but found theatrical commitments more appealing and, 'As I got older, I just couldn't imagine doing a film during the day and a play during the evening like I used to.' These stage commitments included playing Joan, opposite Leslie Phillips, in *The Man Most Likely …*; Theresa Diego in *The Bewitched*, at the Aldwych; Hattie in a nationwide tour of Hugh Williams's *The Grass is Greener*; Golde in *Fiddler on the Roof*, in Coventry; and Brenda in the Hong Kong Festival presentation of *A Bedfull of Foreigners*. For Dilys, 'The most satisfying time of my professional life,' was joining the Royal Shakespeare Company, where she played everything from Maria in *Twelfth Night* to the Nurse in *Romeo and Juliet* to First Witch in *Macbeth*.

Dilys remained a key champion of the *Carry On*s though, happily recording audio

Raising temperatures since 1957! Dilys Laye was cast as flirtatious doctor's wife Jasmine Hatchet in *Doctor at Large*, here in a stunning promotional pose.

commentary tracks for three of her films. 'Whatever I do, wherever I go, people ask me about the *Carry On*s. I love being associated with something that gives so many people so much pleasure.' Always a pleasure, it was wonderful to see one of her last television performances playing Frankie Howerd's mum in *Frankie Howerd: Rather You Than Me* in 2008. A wonderful, gentle nod to her career and love of the films.

MARIAN COLLINS

While still in her teens, Marian's pretty face was popping up all over British film and television: comedy credentials include the Crazy Gang romp *Life is a Circus* (1960), in which she played the role of a girl in a bookshop; *Dentist on the Job* (1961) as one of Bob Monkhouse's patient patients; and Michael Relph's hymn to the silent screen *The Smallest Show on Earth* (1957).

Her roles as part of the *Carry On* team were suitably decorative: as Evan David's Bride in *Cruising*; Peter Byrne's Bride in *Cabby*; one of the Dirty Dicks girls in *Jack*; and one of Doctor Crow's Guards in *Spying*. All eye-catchingly garish.

Marion Horton, one of the *Carry On Cabby* Glamcabs Girls, swaps her Ford Consul Cortina for a Douglas Vespa Sportique to cuddle up with Kenneth Connor, in spring 1963. Marion was back with Connor later that year, at the Strand Theatre, playing one of the Gemini Twins, in *A Funny Thing Happened on the Way to the Forum*. Her husband, Johnnie Spence, was the show's musical director.

Marian Collins as one of the seductive Glamazons guarding the S.T.E.N.C.H. headquarters in *Carry On Spying*. That's the Society for the Total Extinction of Non-Conforming Humans, to you. Peter Rogers and costume designer Yvonne Caffin stated the look should be sexy and sinister, hence: 'a sort of black elasticated siren suit straining at the seams ... with calf-length black kinky boots, black gun belt and a holster with a lethal Luger.'

RENÉE HOUSTON (1902–1980)

A cabaret and music-hall star, forming the Houston Sisters with younger sibling Billie, by the 1950s Renée had established herself as a dependable, larger-than-life character actress in British film. She is particularly memorable as the slightly sozzled school mistress, Miss Brimmer, in *The Belles of St. Trinian's* (1954). Peter Rogers first employed her, as Mrs Beacon, in late 1962, for *Nurse on Wheels*, and loved dropping her Scottish brogue into the most incongruous of settings; she was back at Pinewood Studios in the spring of 1963 to play the rather grouchy taxi rank cafe owner in *Carry On Cabby*; and a year later, was the Madame of Hakim's Funhouse in *Carry On Spying*.

Her favourite was Agatha Spanner in *Carry On At Your Convenience*: a multifaceted

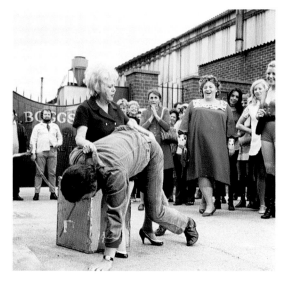

Lenny Piper, Robert Ramsey, Marianne Stone, Hattie Jacques, Gloria McGuire, Tina Hart, Margaret Nolan and the Boggs girls look on as Agatha Spanner (Renée Houston) teaches her son Vic (Kenneth Cope) a lesson, in *Carry On At Your Convenience*.

battleaxe role, sharp of tongue towards her son Vic (Kenneth Cope) and sweetly accommodating to her lodger Charles Coote (Charles Hawtrey). All the best food and all the secret games of cards are reserved for him – until he turns up drunk on her doorstep. Then it's full-on rant mode: tearing him off a strip, publicly humiliating her son by giving him a thoroughly good smack on the bottom, and leading the women's revolt against the striking fraternity.

It would have been a joy to see Renée go full-on eccentric, as was the intention with her original

Charles Coote (Charles Hawtrey) is as drunk as a newt, much to the disgust of Agatha Spanner (Renée Houston), in *Carry On At Your Convenience*.

casting as Mrs Dukes in *Carry On Girls*. Joan Hickson stepped into the breach and made the role her own, while Renée would make just one more film appearance. A familiar face in British horror too, she was the aggressive, no-nonsense travelling entertainer Chou-Chou, an ageing and forthright woman of the road, in *Legend of the Werewolf*. What a performer!

AMANDA BARRIE

Amanda made her stage debut at the age of 4, treading the boards of the Theatre Royal, Ashton-under-Lyne, which her grandfather owned. She had a right royal laugh with beloved, bearded James Robertson Justice in the 1963 Betty Box production *Doctor in Distress*, and shortly afterwards made her debut for Peter Rogers, as the cheeky Anthea in *Carry On Cabby*. Still, immortality within the series was hers when cabaret co-star Barbara Windsor baulked at the role of a lifetime. For it's Amanda Barrie who is the British Queen of the Nile! Who can forget those beautiful big eyes staring through the screen at you? Despite soap stardom and celebrity, her portrayal of Cleopatra in *Carry On Cleo* is still her best-loved performance. Even her co-star Julie Stevens joked that she made a better Cleo than Elizabeth Taylor.

It was 1964, the film *Cleopatra* had upped sticks and left Pinewood, so those cheeky chappies from the *Carry On* team thought they would make good use of the sets, costumes and props – thank goodness they did.

Amanda was lucky enough to wear some of the costumes that had belonged to Elizabeth Taylor. She recalls that a couple of pairs of shoes were

Elizabeth Taylor's and so were her headdresses. In recent times, she wished she had kept the items. She even threw her script away, because the idea of this becoming classic memorabilia had never really occurred to her.

Despite wearing such beautiful costumes in the film, she was put through some horrors with the wardrobe department. During one of her

Amanda applying her own distinctive make-up, for her legendary role as the Queen of the Nile in *Carry On Cleo*.

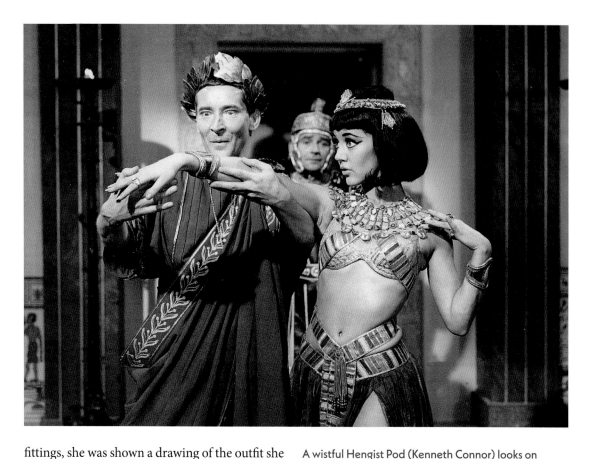

A wistful Hengist Pod (Kenneth Connor) looks on as Julius Caesar (Kenneth Williams) and Cleopatra (Amanda Barrie) get acquainted, in *Carry On Cleo*.

fittings, she was shown a drawing of the outfit she was going to wear. She turned to the fitter and explained she didn't have much to push up. The fitter disagreed with her, so she resorted to taking her clothes off and showing him. At which point she heard the fitter run to the phone and overheard some comments of 'plastic surgery' and 'there's not enough time to operate'. For Amanda this was quite distressing, as it was a time when many women in film had big breasts and led to her being in tears as she didn't fit the fashion trend. However, she is so stunning in the film and, in fact, had she had big breasts this would have distracted from her natural beauty. Thank goodness for Amanda showing that women come in all shapes and sizes.

For Amanda, looking back, she never thought the film would stand the test of time. In those days, she didn't really want to admit to doing a *Carry On* film, at least not with any pride. But television work was thin on the ground in 1964, so unless you were in theatre this was the alternative. However, this was an opportunity to work with some of the greats, and on reflection she feels unkind for not talking about the film more. Now with the cult status of the film she has fond memories and is proud to have been a part of it.

When we meet Amanda in *Carry On Cabby*, she presents a leggy powerhouse that will stop at nothing to get a ride (pun intended). She's sassy, in control, and she knows how to use her feminine charm. What is most interesting about this

particular film are the styles of the uniforms that the Glamcabs girls wear. It was 1963, and fashion was dominating. It was an obvious sign of shifting attitudes, as women chose, very publicly, to start looking different from what had been the norm. This is exactly where we find Amanda, her cute little uniform reflecting the time. The skirt pieces which were created in the 1960s are very much part of the film. The miniskirt, in particular, earned its place as the decade's most iconic look, and of course we saw evidence of it throughout the *Carry On* films. It is fitting really that the Glamcabs ladies wore miniskirts as this was the time that women enjoyed the chance to 'dare to bare'. Even Mary Quant, the British designer of the miniskirt, claimed that this fashion was a way for women to rebel. Therefore, a young Amanda Barrie, and the tribe of girls she leads, stretched over a new Ford Cortina in a short dress was an absolute symbol of women evolving. It certainly helped sell the film too.

Amanda's role in the film does not present her as a vacuous woman though, in fact she's quite the opposite. She even dares to say to Hattie, 'Are you sure this is really going to work?' in response to them starting the new cab company. Her character knows that it's a male-dominated world at this point, women simply didn't drive taxis. Amanda too is well aware of the power she has over men. When she gets a flat tyre, she can happily relax, sitting on the bonnet filing her nails, while her male passenger changes the tyre for her. Kenneth Connor is at first impressed, then disgusted, by his brother-in-arms falling for her charms. Of course, it is a male joke against men. Connor would react in exactly the same way. And we, the audience, know Amanda could change her own tyre. She's a street-wise, road-savvy cab driver. Just why would she? Feminine charm as empowerment.

Obviously, Amanda's Cleo oozes feminine charm too, but in a very different, quite subversive way. Queen Cleopatra was celebrated

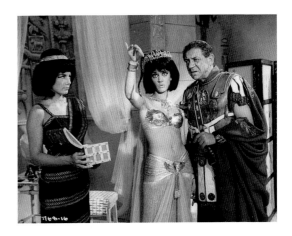

Cleo (Amanda Barrie) and Mark Antony (Sidney James) finally control their glorious giggles and nail the asp scene. The handmaiden is Virginia Tyler, who also plays one of the Hakim Fun House Girls in *Carry On Spying*, and a decorative member of the alien race of Thals opposite Peter Cushing's time traveller in *Dr. Who and the Daleks*.

throughout the world for her strength and beauty. Amanda may portray her as more dizzy, but she's still charming. It could be argued that it may have been strange or even daunting for Amanda to be rejoining a year later, in a leading role, with such an established team, but it wasn't. Amanda had been no stranger to revue and had worked with many of the cast already, so everything was cross connected. Gerald Thomas and Peter Rogers were very welcoming towards her. In particular, she enjoyed working with Gerald as the film was done at an enormous pace, which she thrived on as it 'cut out all the pointlessness of filming and allowed us just to get on with it'. Everyone just knew their lines, and to Amanda, reflecting today, she sees how this is very similar to working in a soap like *Coronation Street*. 'It put me in good stead for those later roles.'

In fact, when Amanda got the role, her agent had muddled the dates so she found herself starting filming on the same day she was due to make her West End debut that evening, in *She Loves*

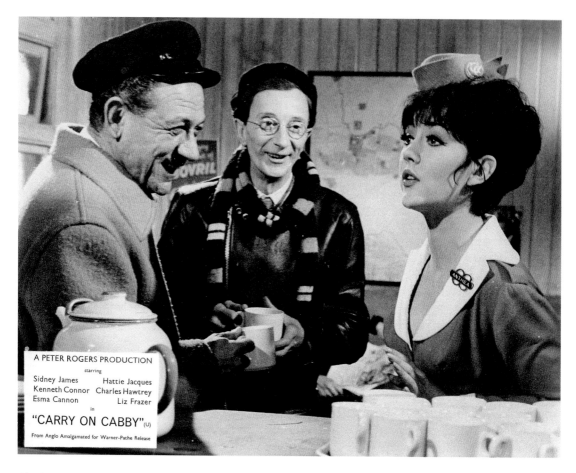

A PETER ROGERS PRODUCTION

starring

Sidney James Hattie Jacques
Kenneth Connor Charles Hawtrey
Esma Cannon Liz Frazer

in

"CARRY ON CABBY" (U)

From Anglo Amalgamated for Warner-Pathe Release

Charlie Hawkins (Sidney James) and 'Pintpot' (Charles Hawtrey) get little interest from the 'smashing bit of over-time' Anthea (Amanda Barrie), in *Carry On Cabby*.

Me, at the Lyric Theatre. 'I would finish on set, rip my wig off in the back of the car, and be taking my studio make-up off just before arriving at the stage door.' This is certainly not a woman who's shy of hard work.

Her leading man was a joy too. For Amanda, Sid James was one of the kindest cast members on set, and was also her partner in crime:

> We giggled so much one day that we got in so much trouble that we were both sent home!

I think the producers were quite cross with us. I just found it incredibly funny. ... Sid was having trouble with one of his lines, he kept saying Shakespeare instead of Caesar ... You can see in the films that poor darling Sid's eyes are red from laughing so much. Somehow we managed to get through it, but it's a lovely personal memory when I catch the film on television these days.

Amanda also enjoyed being on set with Sid as she would place his bets for him. 'It would happen between every shot! I loved it. I was Sid's bookies runner. And he would do rather well. He knew exactly what he was doing when it came to the gee-gees.'

Sid also protected her modesty when the outrageous Kenneth Williams playfully ran up to her after she emerged from the milk bath, and stole the towel she was wearing. Amanda felt a little humiliated, and it was Sid who saved her from embarrassment by throwing her another towel.

That scene was very daring for the time. 'The milk was real, and not only did it stink but I spent a long time in there. My fingers would go all wrinkly! I didn't have anything on either!' The scene as Amanda emerges and is wrapped in the towel, while Sid's character growls, proved a headache for the censors. Amanda recalls, 'Apart from Kenny Williams larking about, I didn't mind not having anything on, I'd done cabaret. It was nothing. My, how things have changed.'

Amanda did have a stand-in and one day, the stand-in refused to go into the bath as it was too hot. It was for the last shot of the film and it had been warmed up too much. Amanda is a woman of guts, so she offered to do the shot herself and walked straight in not realising quite how hot it was. The crew said to Amanda, 'You've got to do it,' and in her words, 'Twit face did it and ended up looking like a lobster. Thinking back, it was really dangerous – silly old me.'

There was also a second accident which happened on set. When Amanda is supposed to roll out of the carpet, and crash into the table, the stunt girl hadn't turned up in time. Amanda, bravely as ever, offered to do it. Thankfully though the stunt girl did arrive, just in the nick of time, but when she was rolled out of the carpet the table collapsed on her, and she ended up injuring herself. Amanda was glad in hindsight it didn't happen to her, not because of any personal danger, but simply because it would have meant her being unable to go on stage that night.

Despite the rigours of film-making, Amanda was distraught at the stage drama *Cleo, Camping, Emmannuelle and Dick*:

That play didn't represent my memories at all. For one thing it made Sid look miserable, and he was the jolliest of people. I would leave the studio every day with chronic rib ache from laughing so much. I would like to put it on record Sid James is the funniest and silliest man.

Amanda also loved Charles Hawtrey. He was incredibly kind towards her, especially knowing that she would be rushing off to the West End in the evenings. To help her, he would give her food, and would tell her how worried he was about her having to do eight shows a week:

One time Charlie gave me some fish to take to the theatre so I would have something to eat that evening. Of course, silly me never got round to eating it, so the fish left a terrible smell in the dressing room!

Amanda is very proud to be part of the *Carry On*s and loves that she still gets fan mail to this day. She is grateful to see them still being shown on television, because when she's not working and sees them she often feels nostalgic. She does, however, agree the pay should have been there in later years for those that made them what they are. She doesn't feel she personally needs that verification but her dear friends Charles Hawtrey and Joan Sims did need help in later years. That being said, Amanda agreed that on set everyone was a team and nobody ever brought up any issues of money on set. In Amanda's words, 'You say the line, get the laugh and get off.' Amanda even jokes that she's spent her whole career not knowing who the producers were (on *Carry On* or elsewhere). With tongue-in-cheek, Amanda says she hopes she is 'the last one left, so I can do all the interviews!' We bow down to her majesty Queen Cleo, our Amanda Barrie.

VALERIE VAN OST (1944–2019)

Valerie made her debut in the series as one of Hattie's Glamcabs drivers in *Carry On Cabby*:

> At the audition they asked if I could drive. I said of course, but I'd never been behind a steering wheel in my life. I was delighted when I got the part, but then had a nerve-wracking fortnight in which to learn to drive. It was filmed in a carpark at Pinewood, so local motorists were safe. I was only a danger to the cameramen. I missed one by a hair's breadth.

The producers certainly weren't put off from employing Valerie again, and she delighted in being part of the gaggle of bewigged and beauty-spotted lovelies chatted up by Charles Hawtrey in *Don't Lose Your Head*. Valerie reflected, 'My father, who had been a major in the army and was a mature 50-year-old when I had been born, was always quite bemused by my *Carry On* antics!'

It was her mother who was chief inspiration for a life in show business, having been a singer in Ivor Novello musicals in the West End. Valerie went off to drama school at the age of 16, and would become the youngest adult dancer at the London Palladium. Her mother acted as chaperone on television and film work.

Valerie's best-loved *Carry On* appearance was in *Carry On Doctor*. Indeed, she was delighted to have a meta joke within the bed-pan humour. In a reference to *Carry On Nurse*'s trailblazing and much-loved daffodil joke, nurse Valerie approaches the hospital bed of patient Frankie Howerd with a vase of the flowers. 'Oh no you don't,' mutters Frank, 'I saw that film!' 'I had seen the film too, as a teenager, so I got the joke, and to be part of this joke within a joke in the *Carry On*s, and with Frankie Howerd too, was a real treat.'

You can take your medicine! Charlie Roper (Sidney James) gets to grips with Nurse Valerie Van Ost, in an unforgettable encounter that was oft-utilised upon the film's initial release ... and ever since!

Valerie goes on to say:

> The *Carry On*s were the happiest of places to be. Sid James and I appeared together in what must be the most famous nurse/patient photo of all time. It's a still from *Carry On Doctor* and it's been reproduced thousands of times. It was on a billboard in Leicester Square when the film opened. I've got a copy hanging in my loo. I play a blonde nurse with lots of bright lipstick and a very nipped-in uniform, and I'm tucking up Sid in bed and telling him he's a naughty boy because he has been smoking. Sid has got his arms around me. He was just great fun and very easy-going.

So much fun that she returned, in nurse's uniform, for *Carry On Again, Doctor*.

Having retired from screen acting, Valerie and her husband, Andrew Millington, ran their own casting company. Still, she always looked back with fond memories to her days as a *Carry On*

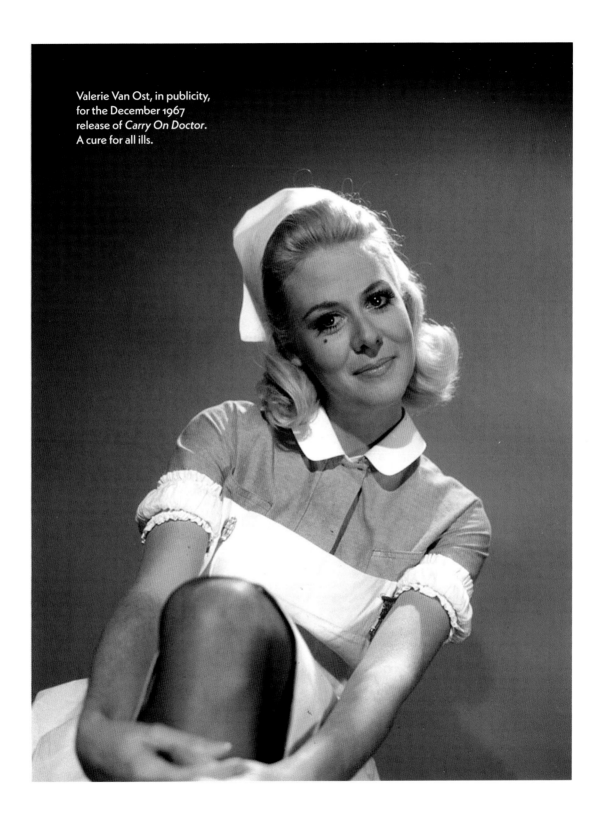

Valerie Van Ost, in publicity, for the December 1967 release of *Carry On Doctor*. A cure for all ills.

girl. 'It was hilarious and ridiculous. We were all these nice young girls with rather plummy voices, delivering these awful crotch jokes. It was such a hoot.' Perceptive about her role in the team, Valerie explained, 'The *Carry On* glamour girls were certain types: we all had that saucy look and expressive eyes. We had to make a definite impact in a couple of seconds.'

JULIET MILLS

Born to British film icon John Mills and noted novelist Hayley Bell, it was only natural that young Juliet would find herself in front of a movie camera early in her life … and few have made it big as early as Juliet Mills, cast as the baby daughter of her dad's character in Noël Coward's flag-waving naval adventure *In Which We Serve* (1942), when she was just a babe-in-arms. Still, as part of the *Carry On* team in the early 1960s, Juliet was adamant that her distinguished theatrical lineage made no difference to her success:

> I don't think that simply being John Mills's daughter has helped me get on. If it could help at all it could only be right at the beginning and then if you weren't a good enough actress no one would keep you, no matter whose daughter you were.

In 1958, she created the role of Pamela Harrington in Peter Shaffer's *Five Finger Exercise*. Staged at the Comedy Theatre, it concerned a music teacher who calmed a feuding family, and 16-year-old Juliet caused a sensation as the daughter. She stayed with the company when the play transferred to the Music Box Theatre in New York and, at the end of 1960 when she was still only 18, Juliet was nominated for a Tony Award.

That pantomime season she was back in the West End, at the Scala Theatre, to star as Wendy Darling in *Peter Pan*, with Margaret Lockwood's daughter Julia Lockwood (who herself would star for Peter Rogers in *Please Turn Over*) as the Boy Who Never Grew Up.

Betty Box had cast Juliet in the pivotal lead role of troublesome teenager Tansy Carr in *No, My Darling Daughter*, where the generation gap was ever widening alongside her screen father Michael Redgrave. Having been knighted for his theatre work in 1959 it was an added layer of intertextuality to cast Sir Michael Redgrave as Sir Michael Carr

Sally (Juliet Mills) tempts Albert (Bernard Cribbins) into a state of naive gullibility in this Front of House still for *Carry On Jack*.

A PETERS ROGERS PRODUCTION
"CARRY ON JACK" Ⓐ
starring
KENNETH WILLIAMS · BERNARD CRIBBINS
JULIET MILLS · CHARLES HAWTREY
DONALD HOUSTON
and GUEST STAR—CECIL PARKER
EASTMAN COLOUR
FROM ANGLO-AMALGAMATED FOR WARNER PATHE RELEASE

in this screen adaptation of the play *Handful of Tansy*, by Kay Bannerman and Harold Brooke. The film opened to good reviews in the August of 1961, and Peter Rogers had already welcomed Juliet to the team, as Nurse Catty in *Twice Round the Daffodils*. Based on the play *Ring for Catty*, which had already inspired *Carry On Nurse*, Juliet was so convincing and popular in uniform that in 1962 she played district nurse Joanna Jones in *Nurse on Wheels*.

The village location of Little Missenden, in Buckinghamshire, was very familiar to Juliet. She had been born in Great Missenden, in Buckinghamshire! Celebrating her twenty-first birthday during the making of the film, Juliet grabbed the opportunity of introducing another

Sally (Juliet Mills), Walter Sweetley (Charles Hawtrey) and Midshipman Albert Poop-Decker RN (Bernard Cribbins) take on a desk job on Captain Fearless (Kenneth Williams) in *Carry On Jack*.

member of the Mills family to British screens. Juliet's own cat, Luca, plays Puffball, the furry friend to elderly spinster Athene Seyler.

It was out of a nurse's uniform and into naval officer's dress for her next film for Peter Rogers, her only official *Carry On* romp, *Carry On Jack*.

Interestingly, Juliette was one of the earliest members to dress up as a man during the filming of *Carry On Jack*. Here she is in disguise. There's nothing new in this: it's something which women had been doing for centuries to access battlefields,

either as journalists or to avoid capture. However, underneath her uniform is a beautiful woman and it must have been tough for her to be cast as the glamour for the film. During her promotion of the film she said, 'I know that people will judge me not only as an actor but as a Mills. You can't come from the sort of family as I do without being compared – especially with my sister.'

The publicity department were certainly in no doubt, with the film's trailer presenting 'Juliet Mills as Sally, the loveliest lass that ever loved a sailor.'

While she relished her membership of the *Carry On* team, Juliet's theatre commitments kept her more and more busy, with distinguished roles ranging from Titania in *A Midsummer Night's Dream*, with the Royal Shakespeare Company, to Kate Hardcastle in *She Stoops to Conquer*, at the Garrick Theatre.

Other notable stage assignments include Gilda in *Alfie!* at the Morosco Theatre on Broadway; Fanny Kemble in *The Elephant Man*, at the Royal Poinciana Playhouse; the acidic Ruth in Noël Coward's *Blithe Spirit* at the Lauren K. Woods Theatre, and Miss Froy in the 2019 British tour of *The Lady Vanishes*.

Juliet had always been happy to return home, although by 1970 she had settled in America, where, from January through to December 1971, on ABC, she bewitched the entire nation as the British Nanny Phoebe Figalilly in the 20th Century Fox television sitcom *The Professor and the Nanny*. While her magical abilities were always hinted at rather than displayed, a knowing look, that demure attitude and a tinkling musical sting gave her more than a nod to Mary Poppins.

The exposure and popularity did Juliet no harm at all, and Billy Wilder cast her opposite Jack Lemmon in *Avanti!* (1972), her favourite film and one that saw her nominated for a Golden

Juliet Mills, in character as Joanna Jones, in conference with her *Nurse on Wheels* producer Peter Rogers. Director Gerald Thomas is on hand with 'the Bible': his name for the script. It was a very rare day indeed when he allowed any line of dialogue into the film that wasn't in the script.

Globe Award. Her role as Samantha Cady in the Holocaust television drama *QB VII* won her a Primetime Emmy Award for Outstanding Supporting Actress.

Even so, Juliet holds dear her association with *Carry On*, reuniting with Bernard Cribbins, back on location at Frensham Ponds, for *Carry On Forever*; and setting sail once more, for the sixtieth anniversary *Carry On* cruise aboard the Cruise & Maritime Voyages vessel the *Magellan* in 2018:

Who would have thought that fifty odd years since I had been mucking about on the waters of Frensham Ponds with the *Carry On* team, that I'd be setting sail, for real. I will never not be amazed at the longevity of those films, and the love people have for them. I'm so delighted to have been part of such a happy company.

VIVIANNE VENTURA

There had been B.B.: Brigitte Bardot; C.C.: Claudia Cardinale; D.D.: Diana Dors; M.M.: Marilyn Monroe, and then there was V.V.: Vivianne Ventura. Variously billed as Vivienne and Vivian, this Colombian British beauty had already appeared on television with Michael Bentine and Dickie Henderson, before being cast, at the age of 17, as the Spanish Secretary to the raffish Patrick Cargill, in *Carry On Jack*.

Her other screen credits ranged from Alexander Mackendrick's *A High Wind in Jamaica* (1965) to *The Persuaders!* episode 'Nuisance Value' (14 January 1972). A model and author and so much more, there's always a little bit of saucy, private personal assistant about our V.V.

Vivianne Ventura displaying the effortless effervescence that Peter Rogers spotted and utilised, briefly, in *Carry On Jack*.

SALLY DOUGLAS (1941–2001)

For a decade from 1960, pert and pretty Sally Douglas continually cropped up in uncredited glamour girl roles in British screen comedy, from a dancer in the *Doctor in Love* strip club to Marlene, the erotic dancer in *Doctor in the House*: 'Take Your Clothes Off and Hide' (24 April 1970).

Sally wasn't really called upon to do much more than dress scantily and look gorgeous. Which she did with aplomb. Her *Carry On* career started as one of the lustful girls at the Dirty Dicks tavern in *Carry On Jack*, and continued six months later with a role as one of Doctor Crow's Amazonian henchwomen in *Carry On Spying*.

Sally's purple patch with the *Carry On*s came from the spring of 1964 in *Carry On Cleo* when she played what was credited in publicity as a dusky maiden – a role in which she really shone as a wordless, bikini-clad slave girl – one of Mark Antony's purchases, with 'M.A. fetching' stamped on her arm. A mild bit of flirtation with Kenneth Connor and Jim Dale results. It all builds up to the scene of lavatorial interplay around the stamped initials of ownership W.C. and the ill-fated stamp of the King of the Jungle: 'you'll be going to the lions, mate!' Beautifully played by Sally with doe-eyed innocence and pouty charm.

The following year, she was back for *Carry On Cowboy*, playing another wordless beauty, Kitakata, alongside Charles Hawtrey's Indian chief, Big Heap. As the publicity declared, she is

'It's a good job it wasn't Frank Antony!': Hengist Pod (Kenneth Connor) cuddles up to Mark Antony's branded slave (Sally Douglas), in *Carry On Cleo*.

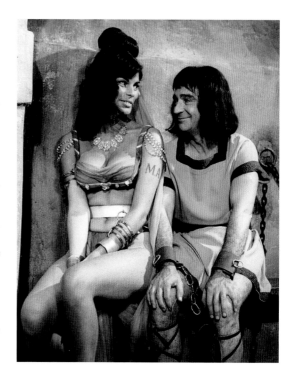

'the answer to every redskin's prayer!' It's Sally's legacy that Prudence Solomon echoes this role, as American native Ha Ha, in *Carry On Columbus*. The 1965 releases of *Cleo* and *Cowboy* broke box-office records internationally. And Sally was back, to be petrified in the name of laughter, in January 1966, for *Carry On Screaming!*

Sally's last *Carry On* assignment was as a harem girl in *Follow That Camel*, a role she had been used to performing from the very first year of her screen career, supporting Charlie Drake in *Sands of the Desert* (1960), and Cecil Parker in *The Pure Hell of St. Trinian's* (1960). She was one of Dennis Price's groupies in the Tony Hancock film *The Rebel* (1961); an extra dose of glamour in two films with Morecambe and Wise (*The Intelligence Men* (1965), and *That Riviera Touch* (1966)); Blodwen in *Dad's Army*: 'War Dance' (6 November 1969) and, unsurprisingly, Titta in the feature-length presentation of *Up Pompeii!*, with Frankie Howerd.

In her final film role, Sally went out on top and out in front, much to Frank's mock chagrin. On set he took one look at buxom Sally and turned to his director Bob Kellett, exclaiming, 'Will I be all right here? Looks to me as though she's tittering on the brink!'

Although nowhere to be seen in the opening credits, the Glamazons were heavily exploited in the marketing campaign for *Carry On Spying*. Here Sally Douglas is to the fore, in an advertising poster available for cinema managers to order from the distribution press brochure.

DAME BARBARA WINDSOR (1937–2020)

The epitome of the saucy seaside postcard, bubbly Barbara Windsor was an effervescent spark who wiggled her way through some of the best-loved *Carry On*s. Barbara galvanised the buxom blonde creation of Liz Fraser and added an essence of carnivalesque cheekiness.

In her early career, Barbara appeared in *No Love for Judy* (staying with the show from the age of 14 and retaining her youthful physique by cleverly strapping down her ever-increasing bust). She was also an extra, as one of the school girls in *The Belles of St. Trinian's*. Just you try and spot her!

However, it was Joan Littlewood who gave Barbara her breakthrough in the film *Sparrows Can't Sing* (1963). The film's release came just as Barbara was making her first big break into television comedy, in the BBC sitcom *The Rag Trade*. She had flirted in and out of the Fenner Fashions shop floor in the earlier episodes before she was cast as Judy and elevated to a leading role for the third and final series for the BBC run, broadcast from January through to March 1963. As a result of her small screen comedy stardom, Barbara was cast as the giggling sexpot Bikini in *Crooks in Cloisters* (1964). The film's publicity department was eager to make the connection and so this bright and breezy crime caper put Barbara's bright and breezy personality to the fore, with the caption 'She's in the Lag Trade now!' The film also introduced her to co-star Bernard Cribbins, who would be a dream on the set of her first *Carry On*.

Barbara is something of the lone female wolf in *Spying*. Daphne Honeybutt may be a vision in a

pith helmet but she's much more than the dumb blonde of the espionage operation. For one thing her not-so-secret talent – a photographic memory – proves pivotal in saving the day, although a passion for her boyfriend (Bernard Cribbins) and a sparkling champagne cocktail can distract her from the assignment in hand. As the publicity brochure for *Carry On Spying* stated, 'This tiny five-feet-nothing blonde with startling 38-22-35 statistics is indeed a welcome newcomer to the 'Carry On' team …'

The scriptwriters, Talbot Rothwell and Sid Colin, may have had one foot very much in the past of Hollywood Film Noir and British thriller *The Third Man*, but the contemporary brief was to send up James Bond. A fledgling franchise

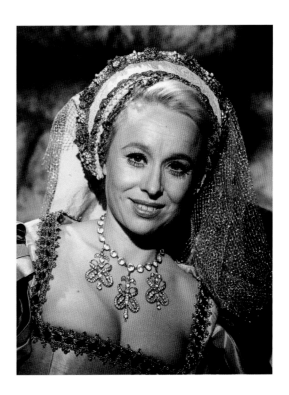

You were never lovelier: Under the lighting direction of Alan Hume, Barbara Windsor poses as court favourite Bettina, for her *Carry On Henry* publicity session.

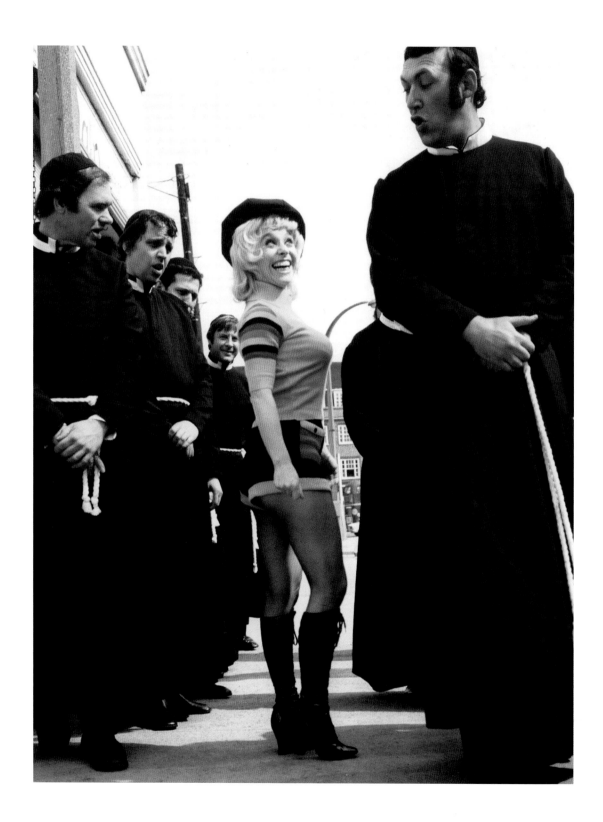

at the time, Barbara's secret agent, Daphne Honeybutt, is a clear and cheeky reference to the first Bond Girl, Honey Ryder, as played by Ursula Andress in *Dr. No*. Released in October 1962, the Bond girls immediately set out their stalls as provocative, sexual characters, with innuendo-fuelled names to match. Indeed, the Bond that followed *Carry On Spying* into cinemas – only the third – was *Goldfinger*, by which stage Honor Blackman was basking in a name that already went well beyond what even *Carry On* dared: Pussy Galore.

Carry On Spying was filmed in the spring of 1964; Barbara really hit the floor running, and her marquee value to the film's success was clear. She earned £4,000, only £1,000 less than her co-stars Williams and Cribbins, and £1,000 more than Charles Hawtrey. All worked on the film for the full thirty-day schedule. For many fans of the series, she remains <u>the</u> *Carry On* Girl.

She went on to rejoin the cast for *Carry On Doctor*, as cheeky Nurse Sandra May, who sent doctors' and patients' pulses running. At the time of filming, in September 1967, she was also appearing in *The Beggar's Opera*, at the Connaught Theatre, Worthing. Like many of the team, Barbara continued to relish theatre in the evening and filming in the day: while shooting *Carry On Abroad*, in the spring of 1972, she was at the Piccadilly Theatre, performing in *The Threepenny Opera* until 23 September.

A beloved member of the family, and a naturally bubbling, cheerful colleague, Barbara would fearlessly take on the nudity that the *Carry On* scripts would often call on her to perform. In point of fact, she never found these scenes easy:

Barbara Windsor, as saucy holidaymaker Miss Sadie Tomkins, is more than enough temptation for Bernard Bresslaw and his fellow religious order brothers Tony Allen, Harry Fielder, Peter Dukes and Mike Stevens, although Mike seems to be enjoying the view more than most! Spring 1972 publicity for *Carry On Abroad*.

There's something wise and slightly weary about this scrumptious, demure, scantily clad publicity pose of Barbara Windsor, as Nurse Susan Ball, for the May 1972 release of *Carry On Matron*.

Nobody ever believes me but I was quite shy. I'm this little bird, with 38-22-35 statistics. Kenny Williams also said he could never see what the fuss was all about, which is fair enough I suppose! But Gerry Thomas really made me into a sex symbol because of those *Carry Ons*, and then everyone thought I was this cheeky, confident *Carry On* girl. I would be so nervous about the little bits of nudity on the *Carry Ons*. I was never difficult at all, please God, I don't think I was, but I would ask for a closed set. I would ask, very nicely, that only the people who really, really had to be there, were there. Gerry and Peter were always careful about that, and I really appreciated it.

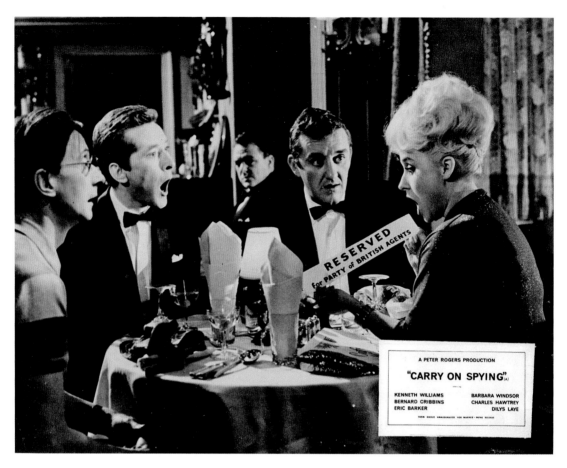

A PETER ROGERS PRODUCTION

"CARRY ON SPYING"(A)

KENNETH WILLIAMS	BARBARA WINDSOR
BERNARD CRIBBINS	CHARLES HAWTREY
ERIC BARKER	DILYS LAYE

FROM ANGLO AMALGAMATED FOR WARNER - PATHE RELEASE

It must have been difficult for a young actress to bare almost everything and of course they didn't stop at just one film, she was continually either losing a bra here, or baring her bottom there; however, she was a true professional and was respected for her wishes. Barbara was very nervous doing the famous *Carry On Camping* scene where she loses her bra. She comments:

> I remember just before shooting <u>that</u> scene in *Camping*, getting really het up about it, and Gerry calming me down, saying that he had cleared the location as much as he could but that it was a public space at the studios. 'Then close the field!' I said, laughing my way through it.

'Ooh, do you think they're on to us?': Charlie Bind (Charles Hawtrey), Desmond Simpkins (Kenneth Williams), Harold Crump (Bernard Cribbins), and Daphne Honeybutt (Barbara Windsor), in the exhilarating James Bond pastiche, *Carry On Spying*.

No matter who you are, it must be hard to show off your body. Of course, we all see her as the beautiful bubbly blonde, and think she's super confident, but underneath she is just a girl from the East End, playing a part. Nothing is ever that straightforward, but she always shot her scenes with conviction and professionalism. In fact, whilst censorship was often a problem the films would encounter, a public tolerance increased in the sweeping social change of the 1960s, and we

saw films becoming more explicit. The British Board of Film Classification still requested cuts on the basis of verbal and visual 'indecency', and even *Carry On Camping* had to be trimmed for it to be granted an A category – standing for 'Adult' and signifying that children under a certain age had to be accompanied by an adult, as the film might contain some material which was unsuitable for children. This was replaced by PG in 1982.

Barbara did, however, turn down *Carry On At Your Convenience*. It was during the time of filming *Carry On Henry* that Barbara met Ken Russell. He was filming *The Devils* at the same time and the two ended up becoming great friends. Ken had heard about Barbara insisting on a closed set and exploded, 'Wait a minute! You get a closed set for half a bum and one tit! You wait 'til you see what we're getting up to!' Despite this though, Barbara recalls that Ken was in awe of the team at the time, although he was to get snooty about the *Carry Ons* in later years. Barbara said, 'He couldn't believe that we could do what we did in such a short time and with such a small budget. And make a whopping great profit!' Through Barbara's friendship and professionalism, Russell would cast her as Hortense in *The Boy Friend*, which was shot early in 1971. As she really wanted to work with Russell, it meant she had to turn down *Carry On At Your Convenience* That didn't stop her though, she of course came back for *Carry On Matron*.

Carry On Dick is often cited as Barbara's final contribution to the *Carry Ons*. It was hardly that! After the film wrapped at Pinewood Studios, Barbara was still playing twice nightly at the Victoria Palace in the stage revue *Carry On London!* During this time, she had a very short period of being absent through ill health. In true *Carry On* fashion, the rest of the cast rallied round, and the press took photographs of their leading lady surrounded by well-wishers' bouquets of flowers. All the team felt her absence

A scrumptious and rare colour shot of Barbara, as Daphne Honeybutt, in her first foray with the team, *Carry On Spying*.

keenly. Somehow, the *Carry On* team didn't function at full-pelt without her on stage. And her popularity with the audiences was clear. Her return provided a blip up in ticket sales!

When *Carry On Dick* hit the cinemas for the Christmas of 1974, the *Carry On* team was gearing up to fully launch the franchise as a television series too. ATV presented the first batch of self-contained *Carry On Laughing* episodes in January and February 1975. As the *TV Times* cover screamed: 'laughter is a new year *Carry On*'.

In spring 1975 she was touring *Carry On Barbara*, with the blessing of Peter Rogers, while later in the year reconvened for the second batch of *Carry On Laughing* shows. Throughout the series,

Barbara had yearned to play something other than the blonde bombshell, but audiences still loved her in those roles. The final show, *Lamp-posts of the Empire*, did at least cast her as a refined traveller, Lady Mary Airey-Fairey, although she still enjoyed cheeky dialogue. When the intrepid jungle adventurer (Jack Douglas) is mentioned with, 'They don't call him Elephant Dick for nothing, do they?' Barbara smirks, 'They do actually!'

In July 1977, Barbara was back at Pinewood Studios, joining her old mate Kenneth Williams to film the linking scenes for *That's Carry On*, in just two days, and picking up a nice grand pay cheque for her efforts. Barbara was tickled pink to have been asked; it was a natural move, for alongside Williams, she was the most visible 'personality' from the core team. She penned a note of thanks to Peter Rogers, in which she also dropped a hefty hint that she would be very willing to return to the series if he were planning on making another one. On 1 August, Rogers replied. 'My dear Barbara. Thank you for your very kind note. Naturally we are planning another *Carry On* but what form it will take is anybody's guess …'

The form, as it turned out, was a very shapely one. *Carry On Emmannuelle* was in pre-production before the year was out, and Peter Rogers, with a heavy hand in the script that was credited to Lance Peters, and severely reworked by Vince Powell, orchestrated a handful of tasty cameos for Barbara Windsor.

With the production set for the spring of 1978 it had been agreed that Barbara would receive prominent on-screen and publicity billing of 'odd appearances by Barbara Windsor', and be paid £500 per day for a four-day commitment to the film: one day per week over the four-week filming schedule. The first three weeks were all fine and dandy, and would have seen Barbara as the objects of the sexual fantasies of the downstairs *Carry On* staff – so she would have been a sexier memory for Kenneth Connor, as opposed to the

That moment before British cinema immortality. Barbara waits patiently, in the mud, while the light is gauged during the filming of *Carry On Camping*.

big and brassy Claire Davenport; she would have been a saucier French wench for the wartime stories of Peter Butterworth, eventually played by Deborah Brayshaw; and she would have been a more mature zoo-conquest for Jack Douglas, in the role subsequently cast with Louise Burton.

The problem arose with the fourth role. Due to changes in the schedule, director Gerald Thomas had to shift the filming day for the final cameo, that of the nurse who has the closing line of dialogue: 'don't they look like their father …' in a hospital ward set with Emmannuelle surrounded by practically every male in the cast. As Barbara's agent at Richard Stone wrote to Peter Rogers on 19 April 1978, the fact that this scene 'would now be shot during the week of April 24th during which time you have known for two weeks that

she will be on holiday' made the whole project impossible. 'At that time,' the missive continues, 'I talked to Barbara and she felt that without the nurse at the end of the film she would not be able to appear in the film and negotiations fell through.'

Indeed, despite a sweet performance by Marianne Maskell as the nurse, the fact that Barbara Windsor would deliver the punchline and have played interesting little wisps of sexual fluff within the body of the film, would have been both gratifying for fans of the *Carry On*s, and satisfying in terms of narrative. Alas it was not to be. The press got wind of the on again/off again casting of Barbara Windsor and fabricated a story that she had walked off the set. In disgust, mind.

Not true.

And not the end of the story, of course, for with the British film industry changing out of all recognition, the *Carry On* cast found gainful employment on television and stage, while Peter Rogers and Gerald Thomas turned to their vault of past glories. The *Carry On* compilation shows for the small screen initially plundered the films from the decade between 1966 and 1976. They had resulted from a bumper audience tuning into the television debut for *That's Carry On*, in December 1981. Philip Jones, Head of Light Entertainment at Thames, suggested a series. Bingo. The ratings were huge. So huge, in fact, that a *Carry On Laughing's Christmas Classics* was pulled together in 1983, with, as with the film compilation, Kenneth Williams and Barbara Windsor being cast as the hosts.

By 1987, interest in the film series, and plans for new ones, were rife, and it was another compilation series for television – *Best of British* – which resulted in the gathering of the great and good of cinema being interviewed for *Wogan's Film Fun*.

Attention! Barbara puts a visiting troop of squaddies through their paces in a wonderfully weird publicity opportunity during the production of *Carry On Camping*.

Kenneth Williams and Kenneth Connor, Bernard Bresslaw and Barbara represented the *Carry On*s. Barbara spoke for them all when she said, 'We are very proud to be a part of this …'

So proud, in fact, that Barbara kept the British end up when, in 1989, Harry Enfield invited her to play the *Carry On* girl in the hilarious 'Carry On Banging' scene for his spoof of the British film industry *Norbert Smith – A Life*. Kenneth Connor and Jack Douglas joined in too and for Barbara twenty years simply evaporated. 'The day we shot it the temperature went down to 2 degrees. It started to sleet and snow. It was *Carry On Camping* all over again!'

As Peggy Mitchell in *EastEnders*, Barbara added another aspect to her status as National Treasure, while utilising nostalgia for her *Carry On* image as the Queen of Bingo in a series of giggling commercials for JackpotJoy.com, celebrating the series' fortieth anniversary with interviews for the ITV documentary *What's a*

Carry On? and fronting Channel 4's *Carry On* weekend. That same year, Barbara fully endorsed Terry Johnson's take on the making of the series, *Cleo, Camping, Emmanuelle and Dick*, opening at the National Theatre, with Samantha Spiro as Barbara. The television film version, *Cor Blimey*, retained the original stage cast, with Sam Spiro even morphing into the real Barbara Windsor at the very end. An emotional 'reunion' with Kenneth Williams, as played by Adam Godley.

With the twenty-first century having dawned, the appeal and popularity of the *Carry On*s was unwavering. So much so that Peter Rogers, once again, launched the idea of a brand-new film. *Carry On London!* would tell the hilarious tale of Lenny Love and his car-hire firm, specialising in those glittering, celebrity-heavy, awards ceremonies that occasionally invigorate the capital city. The reinvention of the *Carry On* girl was to have included Swedish model Victoria Silvstedt who was cast as a sun-bleached, transatlantic answer to the towering, statuesque men-devourers of Valerie Leon; Valerie's confident, posh vibes were to have been shaded in by Lady Isabella Hervey.

Barbara's *EastEnders* chum and co-star, tabloid babe Daniella Westbrook, was earmarked as the leading lady, the latest *Carry On* girl, and was photographed in a session of various shots inspired by Barbara Windsor's iconic roles in the series: from scantily clad spy to sexy nurse and, of course, in *Carry On Camping* bikini.

The film was still in pre-production five years later when, in March 2008, a rather muted fracas broke out over that iconic bra-flinging scene being censored on YouTube. Thirty-five-year-old *Carry On* fan Gary Williams was quoted as saying, 'It's crazy. YouTube have made a right boob with this!' The scene, filmed nearly fifty years before, had enjoyed over 4,000 views in a matter of weeks since it was posted. YouTube considered it broke the guidelines of 'explicit films …' The nationwide incongruity was exploited by the *Daily Star Sunday*, when they gainfully employed glamour model Malene Espensen, who was dutifully squeezed into a similar bikini for a typically cheeky 'Cheesecake' photograph session of the era and even filmed in a detailed reconstruction of the scene. Malene chuckled, 'It's funny, not rude. Some people just take some things far too seriously!' Well, quite.

With persistent rumours of the new film going before the cameras, Barbara was philosophical:

> Everybody asks me whether I'm going to be in it or not, darling. I mean, everyone thinks I did every bleeding *Carry On* film in any case, so I might as well be in this one. I'll give them a giggle and a wiggle. For old times' sake.

Quite rightly she became a Dame in the New Year Honours in 2016, and continued her tireless charity work right until the end, in particular with the Alzheimer's Society. A baton readily taken up by her husband, Scott Mitchell.

Barbara was always thankful to her *Carry On* career. As far as she was concerned, the films gave 'all of us a national identity' and she felt there should have been more recognition given to them saying, 'I always thought it was a disgrace that they were never given that acknowledgement. An award of some kind. The Queen's Awards to Industry. Something like that.' She knew though these were the films she will be best loved for and said:

> You know, that picture of me in *Carry On Camping*, with me clasping my boobs. I've lost count of the times I've signed that for people. And that gratitude and, yes, love, for what we did. It's lovely. Even though that bloody photograph will be with me to the end!

Sure enough, following Dame Barbara's wishes, Scott Mitchell included that photograph on the back of the funeral service. 'Yep!!! Rest in peace my darling Bar, my love forever Scott xx'

The summer of 2003 saw the launch of the new Peter Rogers film *Carry On London!* Daniella Westbrook was signed up to play the female lead, and gamely recreated a few iconic poses of her *EastEnders* co-star Barbara Windsor. Here, it's that scene from *Carry On Camping* ...

... and in the unforgettable heart-sized bikini in homage to *Carry On Again, Doctor*. Daniella happily did the interview circuit and all the press junkets, and received Barbara's blessing. 'Daniella is a darling,' she said, 'and she's a bloody good little actress. She'll fit in with the *Carry On*s perfectly. She has the guts and the heart for it.'

Claire Davenport (1933–2002) was a good-to-over-ripe comedy blonde notching up sitcoms such as *Fawlty Towers*, *On the Buses*, and *George & Mildred*; as well as a threatening masseuse opposite Peter Sellers in *The Return of the Pink Panther*. Here she takes one of Barbara's relinquished roles in *Carry On Emmannuelle* and goes large with it, much to the amusement of Kenneth Connor.

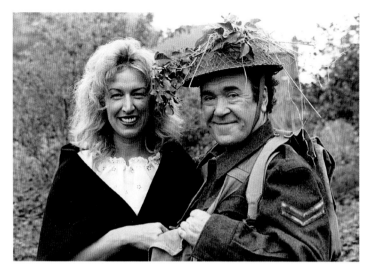

Down on the Call Sheet as 'French Buxom Blonde', Deborah Brayshaw (1946–2022) gamely stepped into Barbara's shoes at the eleventh hour, to join Peter Butterworth in the Second World War flashback sexual memoir in *Carry On Emmannuelle*. Deborah had hot-wheeled it from playing a sexy Go-Karter in *Confessions From a Holiday Camp*.

Marianne Maskell, next to Kenneth Williams here, played the pivotal role of the nurse at the end of *Carry On Emmannuelle*. It would have given Barbara Windsor the last line of *Carry On Emmannuelle*, surrounded by all the likely suspects, including the Arabian (Steve Plytas), the American (Bruce Boa), the Admiral (Jack Lynn), the Prime Minister (Robert Dorning), Leyland the Chauffeur (Kenneth Connor), Lyons the butler (Jack Douglas), Richmond the Bootboy (Peter Butterworth), and an entire football team!

THE CARRY ON
AND THE WOMEN OF THE NHS

Throughout the course of the *Carry On* series we see wonderful tributes to the National Health Service: our NHS. As early on as the second film, the nurses of the NHS are honoured. We see a historical social commentary on our British nurses, learning of the different roles within the profession. From the uniform that the nurses wear, and the importance of Matron, there is a social hierarchy presented within *Nurse*, which has changed, in reality, as now the NHS is more holistic in its care. Still, it was very fitting for the time, when staff nurses would spend a lot of their training time in the sluice room. It was, and still is, a joy to see Nurse Stella Dawson (Joan Sims) messing up in there. We also see the caring side of nursing, with Rosalind Knight sitting beside the bed of a patient. Alongside the nervousness and awkwardness of the men's ward humour, the nursing staff are efficient, proficient, and reassuring. These all stemming from genuine anecdotes and the sheer verve of nurse Rita Hudis, wife of original *Carry On* scriptwriter Norman Hudis.

Matron (Hattie Jacques), whilst a fierce character, often feared not only by the nurses but also the patients and even doctors, has remained much loved in the nation's hearts. Whenever there is a crisis in the NHS, time and time again we often see an image of Hattie as Matron with news headlines such as 'What would Matron do?' or 'Bring back Matron'. A discussion with an NHS worker who works on a dementia ward reveals

that patients of a certain age often call for Matron. They are harking back to a safer time; a place of stability for them. The NHS has changed; there is no longer one Matron in a hospital, but several Matrons. When a Matron is brought to the patient they often get upset as it's not Hattie Jacques, and even more so if they see a male Matron, as times have certainly changed. However, it's amazing how Hattie holds a place in people's hearts as the epitome of what, or perhaps who, Matron should be. An interesting thing to note is that, unlike other cinematic and television interpretations of the NHS, *Carry On* still hangs on today as an anachronistic but indelible representation.

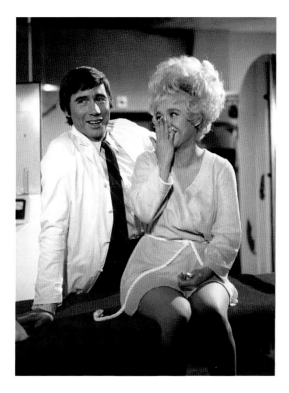

According to Jim Dale, 'Barbara [Windsor] never put on that sparkle. That bubbly personality. That was her. It wasn't manufactured. That was just there. Always. Lovely.' Here the two series favourites share a joke during the making of *Carry On Again, Doctor*.

Iconic lines such as those of Kenneth Williams in *Carry On Again, Doctor*, who, arriving at the hospital and upon hearing the screams, looks up and says, 'They've started early today.' A line which an NHS worker in today's hospitals says they often still quote. Perhaps one of the real reasons these films are still held with such warmth in our hearts is that at some time or other we all experience a hospital, and in the moments of suffering in our lives, we turn to humour. Sometimes the darkest of humour.

The nurses within the films are always portrayed as sweet, caring and as working incredibly hard. When Frankie Howerd's character enters the hospital in *Carry On Doctor*, we can only feel sympathy for Anita Harris, the young nurse trying her best to make her patient comfortable. The line 'If this is the National Health Service, take me back to the leeches' makes us laugh, as we can all empathise from either being patients ourselves, or as visitors, but we also feel compassion for Anita, who is only trying to do her job.

By *Carry On Doctor* we see how nurses became more sexualised. Barbara Windsor as the cheeky Nurse May, with her little wiggle, walking up to the hospital in her first scene of the film, sends hearts racing. We also see the two ambulance drivers (Peter Gilmore and Harry Locke) taken aback with 'Cor!' and 'Get a load of that!' but Barbara as always has the last laugh. She knows she can handle herself and adds to their embarrassment by blowing them a kiss.

It is fascinating to observe in all of these films the strict rules on uniform. The ladies are often presented straightening their white caps. Although, perhaps one piece of uniform that wasn't presented so well, is the footwear of the ladies. From Shirley Eaton to Barbara Windsor, all the ladies are wearing high heels. Not very practical for women who would spend their days on their feet. Whilst nurses did have a small heel

The inspiration for *Carry On Nurse*, and the loving life partner of the original *Carry On* scribe. Nurse Rita Hudis with husband Norman Hudis.

to their white shoes, they were certainly not wearing black stilettos!

By *Carry On Again, Doctor*, we see the development in medical needs. Gone are the central stories of plain illnesses of *Doctor*, with the likes of Sid James in hospital for goodness knows what, Bernard Bresslaw with a broken foot and Peter Butterworth with a possible vasectomy. This film details the advancement in medicine to help ladies with weight loss. At the time a rather suitably ridiculous premise, thinking that ladies would take a miracle pill to lose weight, although now in the twenty-first century, this is definitely something many are seeking. This film was ahead of its time! Whilst the final joke is women waking up with beards, to a modern audience this is actually something quite sensitive. Most disturbingly, the joke in this film is often against women. Whether they are overweight or they end up with a hormone-induced drug to enable facial hair,

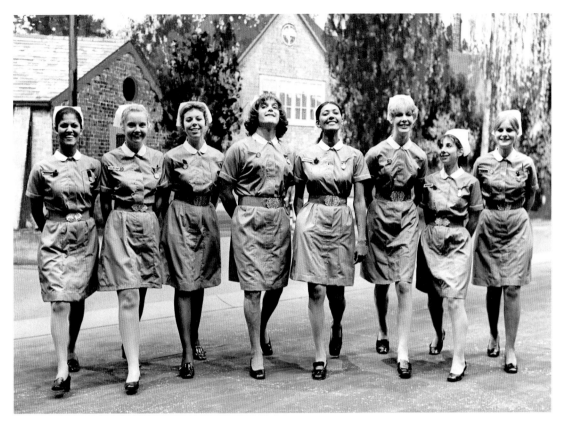

Life's a drag for Nurse Kenneth Cope, lining up with some of the real-life nurses on duty at the Heatherwood Maternity Hospital, Ascot, in Berkshire, during a break from filming *Carry On Matron*.

these are two areas most women are extremely embarrassed and self-conscious about.

Reassuringly, we returned to the hospital with *Carry On Matron*. Matron is back at full throttle and we find ourselves in a maternity ward. The nurses are still sweet and caring; however, the sexiness is toned down somewhat. Jacki Piper is clearly our caring Sister on the ward, sensibly dressed and ever the professional. Even Barbara Windsor's character is a little more mature – to being a more dedicated nurse – although she still keeps her hint of provocativeness, with sexy stockings and suspenders. She is also eager to

... and in retreat! Kenneth remembers that 'the click, click, click of those heels aroused male interest. Immediately. I came to know exactly what life as a woman was like!'

help Kenneth Cope's character and not give away his secret male identity.

Naturally, the patients are all ladies and we see a wealth of different characters. Joan Sims playing a more mature mother-to-be who's quite happy to relax and enjoy her pregnancy, embracing one of the few times in a woman's life where she feels she can eat as much as she pleases. It may be crass to have Joan cast in this role, but you can forgive her character for being pregnant and thinking, 'well why not?' We also see the young Madeline Smith, who represents a naive new mother who's worried about her boy's 'little thing'. The joke is there, of course for innuendo, but Madeline is so cute and naive that we allow her to be a concerned young mum. Finally, there is the gorgeous Valerie Leon, giving birth to triplets in the back of an ambulance. A ridiculously far-fetched scene, of course, this is a lovely *Carry On* after all, but it works and of course she is beautiful and just what all women would love to look like after giving birth – especially to triplets! Valerie is Jane Darling indeed!

Even the sexual predator of Dr Prodd (Terry Scott) is put in his place for, thankfully, we have Matron, who, despite being a disciplinarian, valiantly protects her nurses from Prodd's advances. Matron may fall under the spell of Kenneth Williams – yet again – but in her duty she is the

Matron: in reality and screen fantasy. Hattie Jacques chats over the daily grind, on location at the Heatherwood Maternity Hospital, during the production of *Carry On Matron*, in October 1971.

personification of care and consideration. Indeed, the only 'nurse' who seems impressed by Prodd's conquests is Kenneth Cope, and he's a fellow, you know! The male – albeit in feminine garb – admires the prowess of another chap. Ultimately, even Cope's character notes the desperation of Prodd, finally seeing things through the eyes of a woman and having the last laugh on the randy medic. Kenneth Williams is the one who sums up Dr Prodd's character as 'You idiot'. Prodd is idiotic, the other nurses know it within the narrative, the audience knows it while watching, and as the character is played by beloved team

Some appropriate reading for a couple of expectant mother extras during the making of *Carry On Matron*.

member Terry Scott, this 'idiot' is redeemed through humour.

All the nursing films have a love story attached. It's the cliché of nurses in love with doctors and vice versa – from Shirley Eaton falling for the young doctor, to even poor Matron's unrequited love for Kenneth Williams as Dr Tinkle. We also see a repetition of patients falling in love with their nurses, from Terence Longdon to Sid James. Ultimately though, these ladies keep a respectable bedside manner, and it's just another day at the hospital.

JUNE JAGO (1926–2010)

A distinguished actress of the Australian stage, June created the role of Olive Leech in *Summer of the Seventeenth Doll*, playwright Ray Lawler's pivotal and poignant reflection of normal Australian life. Opening in Melbourne in November 1955, June stayed with the company through a residency in Sydney, a thirteen-week tour across Australia, and ultimately Nottingham, Liverpool, Edinburgh and the West End.

June journeyed to New York, for a month-long run on Broadway, and swiftly returned to Britain to pick up on television and film interest. The most interested film producer was Peter Rogers, who cast her as Gladys Worth in *Please Turn Over* (1959).

Most tellingly, Rogers saw June in a medical situation: she was the strict but fair Matron in the Leslie Phillips film *No Kidding* (1960), and gave a hint of her softer side as the nurse opposite Joan Hickson's aghast Matron in *Carry On Regardless* (1961). Incredibly, she didn't make another film until *Carry On Doctor* (1967), when she was promoted to Sister Hoggett, alongside a disgruntled Frankie Howerd.

June captures the spirit of the Ward Sister beautifully. Ward Sisters were very much feared by the nurses as they had a lot of power. Her classic line

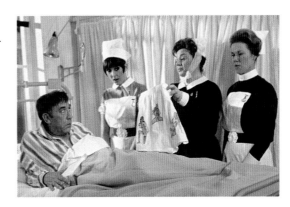

Francis Bigger (Frankie Howerd) reluctantly parts with his underpants. The *Carry On Doctor* nursing staff are Nurse Clarke (Anita Harris), Matron (Hattie Jacques) and Sister Hoggett (June Jago).

about lying in our nice comfortable bed with our nasty old pants on offers an insight into the power these Ward Sisters had. She is efficient and cool. She is also protecting Nurse Clarke (Anita Harris) from embarrassment and wants her ward to maintain its high standards and efficiency.

Always more at home on stage, June appeared with the Royal Shakespeare Company and the Royal Court Theatre, before returning to Australia in the late 1970s and joining the Melbourne Theatre Company.

GWENDOLYN WATTS (1937–2000)

One of the bright young things of British screen and stage, Gwendolyn's 1960s credits include such diverse fare as playing Rita in John Schlesinger's *Billy Liar* (1963); the cook in George Cukor's *My Fair Lady* (1964); and Gloria, in Silvio Narizzano's gorgeously gruesome Hammer horror *Fanatic* (1965). Ray Galton and Alan Simpson also gifted Gwendolyn a couple of prize television parts: as the naive and stunning French au pair Monique in *Steptoe and Son*: 'Steptoe a la Cart' (28 January 1964) and Edie Hentill in *The Galton & Simpson Comedy*: 'Pity Poor Edie Married to Him' (17 May 1969). The 'him' was bone idle Milo O'Shea, who had been one of Sid's drivers in *Carry On Cabby*. In reality, Gwendolyn had married frantically busy actor Gertan Klauber in 1959, another firm favourite of producer Peter Rogers, who cropped up as everything from slave-trader Markus in *Carry On Cleo* to a seller of naughty postcards in *Carry On Abroad*.

Gwendolyn's *Carry On* career was exclusively confined to the medical success of the late 1960s and early 1970s: *Doctor*, *Again, Doctor*, and *Matron*:

I have stimulating memories of acting with Sid James, Hattie Jacques and Barbara Windsor.

Sid Carter (Sidney James) puts on the charm with Frances Kemp (Gwendolyn Watts), the receptionist of Finisham Maternity Hospital, in *Carry On Matron*.

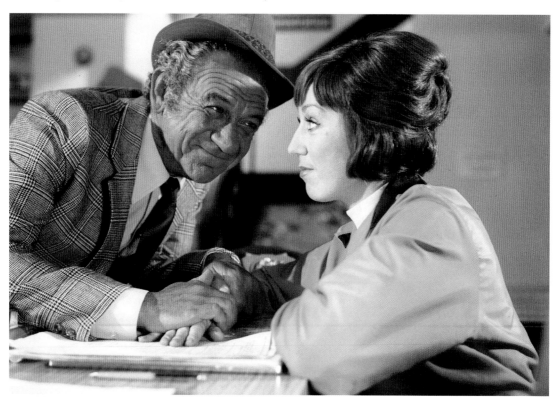

They were all so lovely. And good. My fondest memory is of playing Charles Hawtrey's pregnant wife in *Carry On Doctor*. I had the baby – he had the labour pains!

Despite this, she is the dutiful wife: never once do we see her complain, and even when her baby is coming she just casually walks off to the delivery room on her own. It's quite daunting for many women who have had a baby alone, although back then men were not allowed in the delivery room, so it wouldn't have been anything out of the ordinary. She is never judgemental towards her husband, in fact you almost wonder if she's glad he's in the hospital and she can just get on with things. It's the classic man-flu situation with labour pains! They are actually a loving couple; unlike the other men's wives she is happy to go along with things because she is just so kind and sweet. A beautiful performance.

JEAN ST CLAIR (1920–1973)

The Dublin-born actress popped up fairly frequently in British film and television throughout the 1950s and 1960s; memorably as a charlady (*Doctor at Large*); and schoolteacher (*The Great St. Trinian's Train Robbery*), usually playing a fusspot, as often as not slightly tipsy. She is a chatty, ultimately contemptuous wife to Mr Smith (Peter Butterworth) in *Carry On Doctor*, eating the unwanted gift of grapes and presenting a perfect vignette of incompatibility.

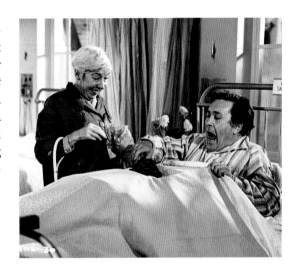

Mrs Smith (Jean St Clair) brings the clichéd bunch of grapes to her disinterested husband (Peter Butterworth), in *Carry On Doctor*.

PAT COOMBS (1926–2002)

A beloved and brilliant foil for such comedians as Bob Monkhouse, Ted Ray, and Frankie Howerd, being particularly hilarious as the barking-mad and up-staging Tarta the Sorceress in *Up Pompeii!*: 'The Legacy' (14 September 1970).

At that stage Pat's *Carry On* career was done and dusted; she is the typically timid and shy patient, who 'nurse' Bernard Bresslaw provides a

male bottle for in *Carry On Doctor* – well he is dressed up as a female nurse at the time, so his mind is on Dilys Laye rather than clinical care. It's another joyous 'caught short' joke.

The gag proved so popular and worked so well that Peter Rogers made sure every effort was contrived to bring Pat back for the semi-sequel, *Carry On Again, Doctor*, two years later. She had originally been offered the role of the fraught Miss Armitage (ultimately played by Ann Lancaster, 1920–70), although the filming dates did not work out. So Pat was offered the consolation role of the new Matron, who gives the bedraggled Frederick Carver (Kenneth Williams) short shrift. Pat is severe indeed, looking down her nose at this supposed down and out. The insult of vagrant is so harsh that the good doctor fails to register it at first, with his look of jolly amusement collapsing into outrage.

By the summer of 1974, Pat was playing Dorothy Blake, sister to Stephen Lewis in his *On the Buses* spin-off in the sun sitcom *Don't Drink the Water*. Her comedy career reached its zenith when she teamed with Peggy Mount for Yorkshire Television's retirement home sitcom, *You're Only Young Twice*, from 1977 to 1981. In 1989, Pat joined the cast of *EastEnders*, gaining a new generation of fans, as the charmingly bewildered Marge Green, Brown Owl of the Walford Brownies. A lovely lady in every way, she carried on working until the end.

FAITH KENT (1925–2008)

New Yorker Faith Kent enjoyed a string of British screen credits ranging from *Dixon of Dock Green* to *Little Britain* via the recurring role of Helen Eacott in *Emmerdale Farm*. Her one and only association with the *Carry On*s, as the Nursing Home Matron in *Carry On Again, Doctor*, went uncredited at the time and remains largely unheralded ever since. She had such a great time on the *Carry On* that she put pen to paper to producer Peter Rogers, reflecting on her most recent appearance, as Sheila Fordyce in the BBC television series *Dr Finlay's Casebook*, having 'given my airy Aberdonian wife in two episodes in London' and hoping for another *Carry On*. 'Next time, if there is a next time, could I be funny? You're bound to *Carry On again up the Khyber* so may I say Knickers in Afghan?' The world of comedy is still waiting …

JULIE STEVENS

Julie Stevens is best known as the original *The Avengers* girl – the blonde-bobbed Venus Smith, alongside Patrick Macnee as John Steed, and alternating with Honor Blackman as Cathy Gale. Venus was a nightclub singer, featured in six episodes, each of which would include an interlude for Julie to sing a song. She later went on to be one of the best-loved presenters on *Play School*: 'I actually gave my mouse chatting with a giraffe business from that programme for my *Carry On* audition!'

When Julie joined the *Carry On* team she was utterly thrilled; for one thing, the money was terrific. 'I went from £15 a day on television work to £50 a day for *Carry On Cleo*. That was a lot of money, it was very good stuff.' Moreover, Julie was delighted to be working with what she calls the 'crème de la crème' of British comedy. At the time, although she had just given birth and she was still carrying her post-baby weight, Julie was self-conscious that her breasts were not big enough. Indeed, the costume department had to pad her out. Looking back she doesn't understand what she was worried about: 'My figure looks gorgeous.'

When she went up for the role, she attended the audition not really knowing what it was about. She simply delivered her line and giggled. Thinking how lovely Pinewood Studios was, she left. When she was offered the role, she couldn't believe her luck. In fact, she told her agent, 'You're kidding, I'm a midget with stumpy legs.' To aid her with her concerns, they put her in high heels and a big blonde wig so she could be taller. 'It's hilarious,' Julie remembers, 'whenever I went up for a part and had dyed my hair blonde, I never got it. I kept my dark hair for the *Carry On*, and got the part!'

Julie had the most fun on set, particularly with Amanda Barrie ('We would giggle all the time, and just enjoy the silliness of it all'), and Sid James:

Sid only lived around the corner from the studio, so he would go straight home after

Rome Antics for Ancient Britons in Egypt: Horsa (Jim Dale) and Gloria (Julie Stevens) are reunited at the end of hysterical historical *Carry On Cleo*.

filming, so although they did provide Sid with a Dressing Room at the studios, he never used it. He was such a sweetheart. When I'd finished one day and was really in need of a shower, Sid threw me his keys with 'I'm off home, so help yourself.' I was so touched by his kindness. Sid was a true gentleman.

When Julie began filming, she wanted her character of Bristolian Gloria to have a Bristol accent. After her first scene:

Gerald Thomas pulled me to one side to say 'What's with the accent?' I said, 'Well, it says in the script she's from Bristol …' Gerry smiled and said, 'Don't worry about that,' so I dropped it from there on in. It's still in the film. Just. Right near the end, when I escape with Jim Dale, which was my first scene to be filmed.

For Julie, everyone was professional on the set, and she felt it was about as luxurious as her career could ever be. It was fast and it was fun: 'No one ever changed the script. You had it, you came to work, and got on with it. It was a joy. They were all naughty boys in the nicest possible way.'

DAME SHEILA HANCOCK

Just before starring as the dipsy Carole in *The Rag Trade*, from October 1961 through to June 1962, Sheila had originally been cast in the role Ambrosine Phillpotts plays in *Carry On Regardless*. With the chimp! However, Sheila did join the team in *Carry On Cleo*. She played Senna Pod the domestic ogress who becomes the affectionate mother and sexually eager wife to Hengist Pod (Kenneth Connor). A few months after completing her role, in October 1964, Sheila appeared in BBC2's *Thursday Theatre* production of *The Summer of the Seventeenth Doll*. She was cast as Olive Leech, the role created by June Jago. *Carry On* wheels within wheels …

Horsa (Jim Dale) is welcomed by his new next-door neighbours Hengist and Senna Pod (Kenneth Connor and Sheila Hancock): a snarling ancient Briton, 'without a lick of woad on!'

TANYA BINNING

The buxom Chief Vestal Virgin, Virginia, in *Carry On Cleo*, Tanya was a statuesque model and showgirl who was paid in cash from the kitty for her three days' work on the film. Part of the assignment was a prestigious publicity photograph session in London in August 1964. These photos were circulated in the press as an advance coming attraction for the Christmas 1964 launch of the film.

A reflective moment for Tanya Binning, being fitted for her *Carry On Cleo* part at theatrical costumers Bermans. The Australian-born beauty would follow the film up with an appearance in the musical comedy film *Funny Things Happen Down Under*.

THELMA TAYLOR

Thelma Taylor was the beautiful blonde servant to Seneca (Charles Hawtrey) in *Carry On Cleo*. Something of a secretary, the aged sage is teaching her to write; after all, Thelma has little to do but look lovely. She does it beautifully. Of course.

Thelma Taylor's performance in *Carry On Cleo* was too funny for words, and she blended perfectly with the ancient Rome decor (even in sixties kinky boots): a gloriously haphazard assortment of sets left over from 20th Century Fox's epic production of *Cleopatra*, and from a production of *Caligula* rented out from fellow *Carry On* player Victor Maddern. Vic had played Helicon in the stage play so 'those sets were very familiar to me!'

WANDA VENTHAM

Chalking up two very different, decidedly strong *Carry On* girls, Wanda Ventham is the determined auction bidder at the Marcus & Spencius slave market, trying to pick up the handsome hunk Horsa (Jim Dale), in *Carry On Cleo*. She is outbid by Peggy Ann Clifford (1921–86), the rotund character actress who specialised in those over-fed, overly affectionate roles. Wanda's sheepish shake of the head to the hirsute slave as she is outbid is delightful indeed, and not even Jim's desperate plea, that he'll pay her back should she go higher, does any good. He's destined to be Willa Claudia's 'pampered pet of an old Roman bag'. W.C. Oh, no!

Wanda returned four years later, for *Carry On … Up the Khyber*. Here, as the number one wife of the Khasi of Kalibar (Kenneth Williams) she

brings a serene sensitivity to the role. She is part of the package deal that Sir Sidney Ruff-Diamond (Sid James) insists upon bedding, thanks to the Khasi, supposedly, seducing Sid's good lady wife, Lady Joan (Joan Sims). While the scene is played in the broadest of strokes by the *Carry On* regulars, this was common practice during the days of the British in India, and Wanda's subtle playing adds just the right touch of authenticity to this right old *Carry On*.

A frequent face on British screens, Wanda's first break in Pinewood Studios comedy was opposite Norman Wisdom, in uncredited roles as a debutante in *On the Beat* (1962), and as a nurse in *A Stitch in Time* (1963). In between romps with the *Carry On* team, she played sophisticated Priscilla

Blunstone-Smythe, opposite Mark Burns, in the glamorous thriller *Death is a Woman* (1966); and demure Clare Mallinger in the Tigon horror film *The Blood Beast Terror* (1968), where Inspector Peter Cushing is on the trail of a murderous moth. Oh, yes. Spoiler alert here: it turns out to be Wanda, the pretty daughter of mad doctor Robert Flemying.

Wanda's sitcom credentials are high, most notably playing Pamela Parry, wife of Alan (Denis Lill) in *Only Fools and Horses*, from 1989 through to 1992. Along with second husband, Timothy Carlton, she joined the cast of *Sherlock*, playing the parents of Sherlock Holmes – the couple being the actual parents of *Sherlock* star Benedict Cumberbatch.

Sid James, in character as Sir Sidney Ruff-Diamond, was whisked into *Carry On … Up the Khyber* publicity mode, and snapped on the Pinewood Studios village set for concurrent production *Chitty Chitty Bang Bang*, with gorgeous Vicki Woolf and Wanda Ventham, as the Khasi's wives, the last and first to 'right the wrong'.

JULIE HARRIS (1921–2015)

Carry On Cleo was the only *Carry On* assignment for Julie Harris but one of splendour to be sure. Julie, who had graduated from the Chelsea School of Art, was something of the go-to designer for swinging sixties British film. Indeed, she worked on The Beatles films *A Hard Day's Night* and *Help!* Soon after completing work on *Cleo*, she was employed by director John Schlesinger for *Darling*. Julie recalled that star Julie Christie 'badgered me to make the skirts shorter. And she was right.' Harris was presented with the Academy Award for her designs. The wealth of Victoriana required by Bryan Forbes for *The Wrong Box* pocketed Julie a BAFTA. She designed

the elaborate, flowing threads for former Bond girl Ursula Andress in the James Bond spoof *Casino Royale*, and later worked on the official film series, creating the wardrobe for *Live and Let Die*, Roger Moore's first outing as 007, and designing that easily removed dress worn by former *Carry On* girl Madeline Smith.

For *Cleo*'s leading ladies it was something of an embarrassment to stand in front of Julie Harris. Neither Julie Stevens nor Cleo herself felt their bodies were good enough; Amanda Barrie said:

Oh my God. I was mortified. Julie Harris was fantastic … but all the jokes were about my

cleavage, and I didn't have one. Zero. I spent most of my time apologising to Julie, but she worked wonders. Those *Cleo* dresses are to die for.

Julie Stevens felt the same:

My problem was my legs. Julie Harris was horrified by my short sturdy functional legs! She promptly put me into high-heeled shoes, which as you can imagine were perfectly in keeping with the Roman costumes! She made no bones about the rotten job the casting people had done … choosing such legs. I felt like a horse having his fetlocks examined!!

A thoroughly stylish creator of style: Julie Harris was a BAFTA winner, an Oscar winner, and, thanks to a lengthy association with Pinewood Studios, is a *Carry On* girl and a Bond girl!

ANGELA DOUGLAS

The epitome of the *Carry On* glamour girl for the hysterical historicals, Angela Douglas joined the Worthing Repertory Company while still in her teens. She made her West End debut in *The Anniversary Waltz* (1959) before making her first film, *The Shakedown*, that same year. Her breakthrough role came on television, starring opposite Alfred Lynch in *A Smashing Day* (17 August 1963). She was the leading lady to Peter Rogers favourite Tommy Steele, in *It's All Happening* (1963), which also featured Bernard Bresslaw as a window cleaner.

Just a month before filming began on *Carry On … Up the Khyber*, Angela married Kenneth More, whom she had met during the making of the film *Some People* (1962).

Later roles included a guest spot in the Leslie Phillips espionage thriller *Maroc 7* (1968); a reunion with *Carry On* heartthrob Jim Dale in *Digby, the Biggest Dog in the World* (1973); and a role in the

Kenneth More television serial *Father Brown*: 'The Arrow of Heaven' (12 December 1964). Following More's death in July 1982 Angela returned to acting, memorably playing Doris, the Brigadier's long-suffering wife in *Doctor Who*: 'Battlefield', in 1989.

Angela is the beautiful girl next door who looks fabulous in a cowgirl hat, toting a gun! As Annie Oakley in *Carry On Cowboy*, she slotted into the team without falter. Angela fondly remembers her time:

I loved being part of the *Carry On* team. They were all so brilliant. And I swiftly got the measure of Kenneth Williams who would actively test newcomers to what he considered his set! The darling. He overheard me mock-complaining one day about all the outrageous innuendo I was having to say. I pulled myself up to my full height and said: 'It's not right you know. I'm a lady!' and quick as a flash

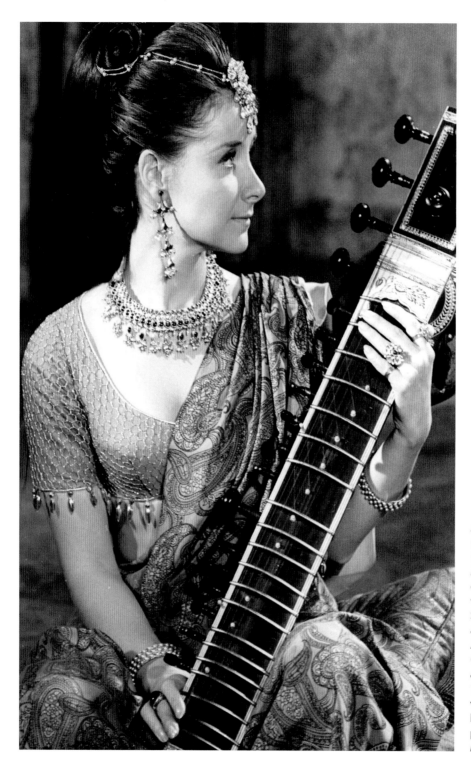

A contemplative pose for *Carry On ... Up the Khyber*. The costume designer was Emma Selby-Walker, who also worked with Angela on *Carry On Screaming!* and *Follow That Camel*; as well as another Peter Rogers production, *Don't Lose Your Head*.

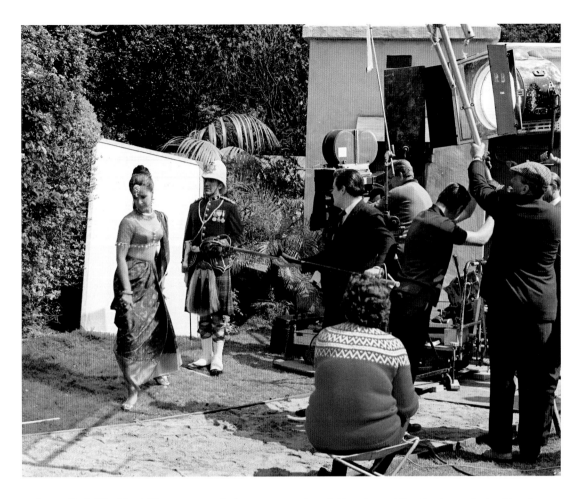

Angela Douglas and Roy Castle, on the backlot of Pinewood Studios, filming *Carry On ... Up the Khyber*, in spring 1968.

he replied: 'Darling! If you were a lady, you wouldn't be doing *Carry On* films!' He was right, of course. It was a dream job!

What an entrance she made on to our screens for her very first *Carry On*! None of us will ever forget her walking down the stairs dressed as a showgirl, singing 'This is the Night for Love'. Although we can't help but notice she's slapped on the bottom by the drunken cowboys, she recovers well by shooting a look that only Angela can add such fire to. Of course, we have to understand this is a period piece, and no doubt pretty normal behaviour of that era. She continues to sing and tease the men, by throwing a ball into the roulette wheel and sitting on the lap of lip-licking cowboy (Simon Cain), leaning in for a kiss. A very tough scene for such a young actress, but she does it flawlessly, despite, in her own words, being 'so terribly nervous'.

Of course, she has one man in her sights: Sid James as the Rumpo Kid! Actually, when she embraces him, you notice how Sid's hand is gently on her arm, and his fingers come off her arm from time to time, clearly trying to make her feel comfortable and taking care of her, despite playing a

role which asks him to be lecherous. It's actually very sweet to watch, as there is a genuine care in Sid's face. When she kisses him on the nose, he is beaming, with a look of reassurance for Angela and pleased that she managed to get through that scene with such style and grace.

During the film, we learn there's so much more to Annie Oakley, who teases the Rumpo Kid by getting him up to her bedroom and then tries to assassinate him. Three cheers for Angela for pulling off the sweet and innocent look, but being a fighter for women!

Her leading man and love interest is Jim Dale. The two of them make for an ideal couple; as the juveniles of the *Carry On* team, they're quite the dynamic duo. In the *Carry On* universe you really believe they are an item.

After gelling with the cast and crew on *Cowboy* she hoped she would be asked back. 'And it happened. I was thrilled!' Angela was cast as Doris Mann in *Carry On Screaming!* She really felt part of the team. As she recalls, 'We were a mad lot, we had a sort of shorthand for the regular lot, you could say.' Angela felt that everyone on the team had their place, and they all slotted in as part of the ensemble.

In fact, of all of Angela's work in the films, it's *Carry On Screaming!* she is always asked to quote to her fans. Angela says, 'People always say, please say – "There is something in those bushes", she laughs. Of course, we know what's just come before this, one of the best blood-curdling screams of British cinema. Jim Dale is still recovering from that scene even today, although the sweet romantic screen kiss has even fonder memories. However, Angela felt a real sense of trust with Jim; she knew if she had to faint, he would always catch her, so it made the job much easier.

Angela has a great love for Joan Sims, and felt sorry for her in *Carry On Screaming!* Even more so, since following *Cowboy* when Joan was at her most stunning as Belle, she landed the

A rollicking series debut for Angela Douglas, as the fast-shooting, no-nonsense Annie Oakley, in *Carry On Cowboy*.

role of nagging wife Emily. Angela recalls, 'Joan was really unhappy to be cast as these moaning women, she was such a wonderful actress.' The two ladies bonded closely during the creation of the plaster casting for the film. Both women had a mould made of their body. Angela said Joan had found the process of a body plaster cast quite difficult as it can be a claustrophobic experience; however, the one thing both women were thrilled about was that it made their skin beautifully soft: 'it was like our own private skin treatment.' The whole process took a couple of hours, but Angela wasn't happy with the end result. She found that the casts:

made both our necks look too big. Because we had to lie down in the plaster of Paris and

that's how the models turned out! Whatever happened to the models, no one really knows.

But Angela certainly wasn't going to keep it. However, her male co-stars were rather naughty with the dummies. The dummies would often be just lying on the floor on set, so the naughty boys would draw arrows with pens: 'the boys were outrageous,' remembers Angela. 'I would go home exhausted from laughing all day long.'

Having had her porthole checked in *Follow That Camel*, Angela then went *Up the Khyber*. Her favourite co-star of all was Peter Butterworth. 'I simply love that man,' she says. She recalled that during the filming, they travelled to Wales for the shooting of the Khyber Pass. It was so freezing that they had to wear thermals under their costumes. Peter would joke and lark about with Angela. As they both felt so cold, he would try to take her mind off it by making her laugh by saying, 'My old willy wouldn't come out for a piece of lettuce.' Angela said the joke carried on for years and years, and every so often she would send Peter a little piece of lettuce!

Angela loved being part of the *Carry On* team and was sad not to continue. She did get the call back but had to decline because of other work commitments. She feels that they stand up for themselves as films. She enjoyed the pace of the *Carry On*s, and said there were other films which were made in just two days and for which 'you would only get paid £7 a day', so to be on a *Carry On* film and be paid ten times that was a real treat. Angela was quick-witted and assured as an actress, and knew exactly what the *Carry On* people required. 'I would never ask for another take, I took the money and went home.' However, there will always be a fondness in her heart for the films. In recent years, she has received fan mail from all over the world, including from a gentleman in prison in America. 'He wrote to tell me that the *Carry On* films are the only thing that keeps him going. Fancy that!'

EDINA RONAY

The daughter of Hungarian restaurant critic Egon Ronay, like many a fellow *Carry On* girl Edina made her screen debut as a schoolgirl: one of the riotous students in *The Pure Hell of St. Trinian's* (1960), when she was just sweet 16. On television she was cast as an escapologist who uses her skill to break into a nuclear fall-out shelter in *The Avengers* episode 'The Nutshell' (19 October 1963). She can be spotted bopping at the discotheque with Ringo Starr in The Beatles film *A Hard Day's Night* (1964), and went on to spend the following year being the victim of lunatics in British film: as

an ill-fated nurse at the hands of Terence Stamp in William Wyler's *The Collector*; and as streetwalker Mary Jane Kelly in the Sherlock Holmes vs. Jack the Ripper thriller *A Study in Terror*. Barbara Windsor was Annie Chapman, another one of the Ripper's victims.

Peter Rogers first spotted Edina as a newspaper pin-up. It was more than enough to convince him to cast Edina in the principal role of Sally Gamely, the Lolita-like flirting teenage daughter of landlady Joan Sims in *The Big Job*. Her intended beau is the clumsy copper of Jim Dale, but she certainly

piques the interest of bungling burglars Dick Emery and Lance Percival. For once, Sid James is more concerned about the stolen loot.

Peter Rogers was delighted with his new 'discovery'. 'At the time I called Edina Ronay "the next Brigitte Bardot". The camera adored her. She looked exquisite; and her charming personality radiates off of the screen.' He cast her in *Carry On Cowboy*, which he gleefully called 'the Western to end all Westerns!' A good girl gone West, Edina's role of Doreen adds comic clout to the cliched fishnet-stocking-wearing saloon beauty of many a television Western, a staple diet on British screens at the time. The hackneyed dialogue of these horse operas is skilfully sent-up by scriptwriter Talbot Rothwell: the wanton women, all with ulterior motives, run through a gamut of similes for love: strawberries and cream, ham and eggs … Jim Dale, in desperation, cries, 'doesn't anybody go together like man and woman,' with Edina's seductive, 'Now you're talking my kind of language, honey?' Boom!

Hammer Films whisked her back in time and stuck her in a fur bikini for *Slave Girls*. Filmed in 1966 and not released in Britain until two years later, Edina is both prehistoric woman Saria and prim socialite Sarah. Confused? You soon will be. *Carry On Teacher*'s Carol White is also in the heady mix, as loin-cloth-clad Gido.

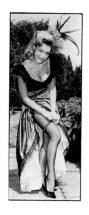

Selling *Carry On Cowboy*: the publicity brochure gave great exposure to the glamorous *Carry On* girls, with these cheesecake poses available to order as part of a cinema's promotion of the film. Vicki Smith plays Polly, 'a 'naughty nineties' saloon girl', Sally Douglas, as the Indian squaw, enjoying her biggest *Carry On* role so far, while it was noted Edina Ronay, centre, 'is steadily rising to the top of her profession in Britain'.

Edina retired from acting in the mid-1970s; going into fashion, and specialising in knitwear, she launched her own company in 1984, and has been honoured as a Fellow of the Royal Society of Arts. Edina delights in happy memories of her film-star past, occasionally appearing at signing conventions, much to the delight of *Carry On* and Hammer fans.

MARGARET NOLAN (1943–2020)

Glamour model and activist theatre-maker Margaret Nolan left an indelible mark on cult British film of the 1960s and 1970s. Indeed, it was Maggie and not fellow *Carry On* golden girl Shirley Eaton who featured in the opening credits of pivotal James Bond escapade *Goldfinger* – with scenes from the forthcoming attraction being projected over her body. She was also cast as Dink in the film. Her comedy co-stars range from Groucho Marx (in the Doncella Cigars advert) to

that perennial dirty old man Wilfrid Brambell; she plays a gorgeous blonde in a casino in *A Hard Day's Night* and puts on the pout as an amateur drama queen in the 1972 *Steptoe and Son* episode 'A Star is Born'.

Maggie first joined the team in *Carry On Cowboy* at the tender age of 21. She played the role with an American accent, as Miss Jones, the blonde and bountiful secretary to the governor. This is no simpleton though. She knows her boss expects favours, and she's clearly given them in the past. It's all part of her job. The following year, Maggie was readily signed up as the stripteasing art teacher in *The Great St. Trinian's Train Robbery*, and appeared in a dazzlingly low-cut gown in the *Hugh and I* episode 'Goodbye Dolly' (24 January 1966).

She returned to the *Carry On* series for *Carry On Henry*, in October 1970, playing the Buxom Lass with her infamous royal roll in the hay remark when King Sid offers her a coin. 'Oh, I haven't got any change …' She went on to appear in four more *Carry On*s, playing a naive factory worker in *Carry On At Your Convenience*; a haughty lady in *Carry On Dick*; super-confident beauty queen in *Carry On Girls*; and super-confident expectant mother in *Carry On Matron*. Her

Bernard Bresslaw looks on with glee during a cheeky publicity opportunity in the House of Mirrors, during the making of *Carry On At Your Convenience*.

role here has that same wide-eyed sexuality as her *Cowboy* secretary. Maggie's saucy misunderstanding of the comic situation – her elderly husband has got her and the female lodger pregnant – is played with bold acceptance of the situation. Sex does not daunt her. She revels in it; enjoys it. In between these treasured *Carry On* antics, Maggie also found time to join Valerie Leon in an outrageous seduction of little Ronnie Corbett in *No Sex Please, We're British* (1973).

A stunning pin-up pose for Margaret Nolan, taken on the end of the Palace Pier, Brighton, on the first day of location shooting for *Carry On At Your Convenience*, on Monday, 3 May 1971.

Fitting then that her best-loved *Carry On* role, Dawn Breaks in *Carry On Girls*, had come just a few months before and in company of her good friend Valerie Leon. Maggie, as The Dairy Queen beauty pageant contestant, has some real beef with Barbara's 'Miss Easy Rider'. The two women really go for each other in that scene. The comedic value comes in with their difference in height. It was a *Carry On* battle royale between firm friends which gleefully took the series' naughtiness to the limits.

After her *Carry On* days, Maggie deployed her strong acting techniques once more, as Denise Paget in *Crossroads*, and in 1983 she retired from acting to settle in Spain. The last few years of her life were spent back in Britain, pursuing her career as an avant-garde artist, creating stunning montages from multiple repeated images from her old glamour shoots. Quite literally chopping up her past in the name of art. Maggie happily promoted her work along with appearances on the cult film signing convention circuit, with *Carry On* and James Bond fans delighted to meet her. Her final film role perfectly bookended her career: it was a cameo at the Sage Barmaid in

What the Butler Saw!: Margaret Nolan plays up to her previous professional life as Vicki Kennedy, on the Palace Pier, during Brighton location filming for *Carry On At Your Convenience*.

Edgar Wright's poem to the seedy and seductive London of the 1960s, *Last Night in Soho* (2021).

DANY ROBIN (1927–1995)

Don't Lose Your Head benefits hugely from the genuine Gallic charm of Dany Robin. The actress, born in Clamart, France, had received the first prize at the 'conservatoire', entering the Paris Opera thereafter. Immediately after the war, Dany made her mark in French cinema, playing Martine in *Lunegarde* and Etiennette in *Gates of the Night* (both 1946). Comedy swiftly proved her forte, and more French fancies followed, notably *Destiny Has Fun*, directed by Emil E. Reinert, in

which she co-starred opposite romantic superstar André Claveau, and *Man About Town*, in which she was cast as Lucette, by the delicate comic director René Clair, in his first return to France for over a decade, following Hollywood success.

Throughout the early 1950s, Dany lit up French comedy films, starring as Juliette in Guy Lefranc's *Elle et Moi* (She and Me), and taking the title role in Julien Duvivier's *La Fête à Henriette* (Holiday for Henrietta), both 1952. By the end of the decade,

A Peter Rogers Production 'A'
SIDNEY KENNETH JIM CHARLES JOAN DANY
JAMES WILLIAMS DALE HAWTREY SIMS ROBIN
in Colour **DON'T LOSE YOUR HEAD**

PRINTED IN ITALY BY GRAPHICOLOR S.P.A. - ROMA

Citizen Camembert (Kenneth Williams) is convinced that Jacqueline (Dany Robin) is the Black Fingernail in disguise! Citizen Bidet (Peter Butterworth) isn't too convinced, in this Front of House still for *Don't Lose Your Head*.

Dany was still France's favourite glamorous comedienne, starring as Danielle in Robert Vernay's *Let's Be Daring, Madame* (1957); and in the title role in Robert Darène's *Mimi Pinson* (1958).

Dany spent the 1960s as an international star, playing Marilyn in Cyril Frankel's German-based romantic comedy *Grounds for Divorce* (1960), and travelling to England to play Ghislaine, the gleeful French mistress of General Leo Fitzjohn (Peter Sellers) in *Waltz of the Toreadors* (1962). Although her homeland was casting her more as Madame than Mademoiselle, her comic stock was still high in the mid-1960s, when cinephile Gerald Thomas suggested casting her as the flamboyant and daring Jacqueline in *Don't Lose Your Head*.

Her fee for the role was relatively modest, at £3,500, but agent Michael Sullivan was heavily negotiating some £80,000 of travel insurance from her home in Paris. On 13 July 1966, Sullivan also ascertained with Rogers that, 'I have further confirmed that you have agreed her billing to be "special guest appearance DANY ROBIN"', which was a requirement unfulfilled on screen and in publicity.

One of the great Breasts in Vests of the series, her effervescent charm and translucent beauty

are sheer perfection for the role. Moreover, her decades of film experience are an equal match for the roguish dependability of Sid James. The shared moments of breaking the fourth wall and addressing the cinema audience with their innermost thoughts are expertly played. As natural, charming and bewitching as Dany Robin herself.

Agent Michael Sullivan ended up with much more than his usual 10 per cent. He got the lady herself, marrying Dany Robin at Epsom Registry Office in November 1969. In attendance were such clients as Dick Emery, Jon Pertwee, Jack Douglas and Joe Baker, Mike and Bernie Winters, and Sid James and Kenneth Connor, both of whom were in the midst of their schedule for *Carry On Up the Jungle*.

Dany Robin was proud of her menagerie of exotic animals back in her home in France, so naturally a stuffed crocodile was located in the Pinewood props store for a hasty publicity photograph and a press release to alert people to the production of *Don't Lose Your Head*.

JENNIFER CLULOW

Jennifer was one of the prim and proper young ladies and was bewitched then bothered then bewildered, and ultimately decidedly turned off, by Charles Hawtrey in *Don't Lose Your Head*. Soon after, the 24-year-old Jennifer became established on television, taking over from Francesca Annis as the presenter of *Disney Wonderland*, and replacing Gillian Lewis, to play new character, Jessica Dalton, secretary to the mysterious Mr Rose (William Mervyn) in the television series of that name. An in-vision continuity announcer for Westward Television, and latterly Television South, for much of the 1980s, Jennifer was also the star of the long-running Cointreau commercial campaign, in which she played Englishwoman Catherine, forever flirting with the Frenchman, played by Christian Toma, over a glass or two of liqueur, of course.

JACQUELINE PEARCE (1943–2018)

Having graduated from the Royal Academy of Dramatic Art, Jacqueline featured in *Sky West and Crooked*, the romance film directed by actor John Mills. Jacqueline was joined by Ian McShane, a contemporary from her RADA days, who was cast as her boyfriend. The film was released in January 1966, while the previous spring had seen her meet with Hammer Films producer Anthony Nelson Keys. 'He told me that I had a wonderful face for film, which was a rather lovely thing to hear.' The result was back-to-back horror films at Bray studios: *The Plague of the Zombies*, in which she played the troubled and ill-fated Alice Mary Tompson, and *The Reptile*, in which Jacqueline was cast as the mild-mannered, ill-treated, but ultimately deadly Anna Franklyn. The Hammer classics emerged in the spring of 1966, just as Jacqueline was preparing to join the *Carry On* team at Pinewood Studios for *Don't Lose Your Head*:

> The part was a nothing bit of nonsense – as a rather silly party guest – but I simply had to do it. My little scene was with Charles Hawtrey, who was just lovely, and I got to say I did a *Carry On* film.

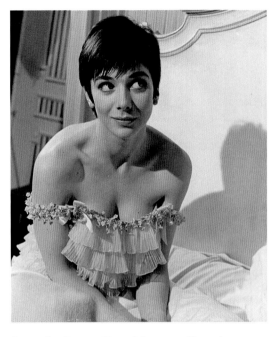

Jacqueline Pearce. One of the most elfin and bewitching talents of mid-1960s British cinema.

In 1968, she was the leading lady, Pamela Lester, in the little-seen Jerry Lewis vs. Terry-Thomas comedy *Don't Raise the Bridge, Lower the River*; while she would become a cult television star, as the villainous Servalan, in *Blake's 7* (1978–81).

NIKKI VAN DER ZYL (1935–2021)

Berlin-born Nikki was the go-to actress for redubbing a bevy of James Bond girls, stretching back to *Dr. No*, in 1962. Continually employed at Pinewood Studios, she was re-voicing Mie Hama's role in *You Only Live Twice* at the time of filming *Don't Lose Your Head*. Nikki's role as

the messenger, delivering the note to the Duc de Pommfrit (Charles Hawtrey) was a rare on-screen appearance. His hilarious reaction line, 'Oh drop it in the basket I'll read it later ...' was coined on the spot by Sid James and Jim Dale.

Don't Lose Your Head, and Malabonce the executioner (Leon Greene) and his assistant (Alf Mangan) had a job to do: namely detaching the giggling head of the Duc de Pommfrit (Charles Hawtrey) from his body. Nikki Van Der Zyl has an urgent message for him!

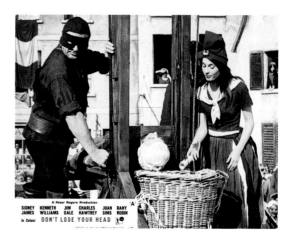

ELSPETH MARCH (1911–1999)

Elspeth March studied at the Central School of Speech and Drama, a near contemporary of Laurence Olivier and just before Kenneth Connor. Elspeth made her stage debut at the Westminster Theatre in 1932, and continued acting on stage and screen, playing Mrs Smith in Montgomery Tully's borstal drama *Boys in Brown* (1949), and the wife of Fernando (John Salew) in the minor gem Ealing comedy *His Excellency* (1952).

Her first venture into *Carry On* comedy was as the enthused Lady Binder, who waxes lyrical about the social soirees of Sir Rodney (Sid James). 'You've always had magnificent balls, and I wouldn't miss one of them!' It's a belter of a line, delivered with energetic gusto. Elspeth is also in *Carry On Again, Doctor*, as a frosty-faced member of the hospital tribunal, deciding the fate of lovable idiot Doctor Nookey (Jim Dale) to a life on a tropical island.

DIANA MACNAMARA

Diana enjoyed not one but four separate roles in *Don't Lose Your Head*: she is a woman baying at the beheading in the opening guillotine scene; she is the glamorous Princess Stephanie at the ball; she doubled for a French soldier on horseback;

and, most intriguing of all, her equine skills were deployed again when she was Charles Hawtrey's stand-in during his tricky horse-riding sequence. With her glasses on she even momentarily fooled Gerald Thomas. Oh, Hello!

ANITA HARRIS

The delectable and seemingly ageless Anita Harris is so associated with the swinging sixties that she was invited to climb aboard that decade's bus for the Platinum Jubilee Parade in the summer of 2022. It's fitting, therefore, that her brief but potent membership of the *Carry On* club was during the 'Summer of Love'.

Her boisterous pop singing saw her represent Great Britain at the Sanremo Song Festival, for which she was awarded the gold medal. Her first studio album, *Somebody's in My Orchard*, was named the Critics' Choice Album of the Year for 1967, while on television she had supported mild-mannered magician David Nixon, even posing with her head on his execution block for a *TV Times* publicity session. She played kind witch 'Nitty' alongside Nixon in the popular children's show *Jumbleland*, a role which helped win her the TV Times Award for Most Popular Female Entertainer.

She joined the *Carry On* team for *Follow That Camel*, with her dusky beauty perfect for the seductive but duplicitous Corktip, supposedly attracted to naive B.O. West (Jim Dale) but really the obsessed acolyte of Sheikh Abdul Abulbul (Bernard Bresslaw). The cinephile gag of scriptwriter Talbot Rothwell is a loving reference to the adventure yarn *Under Two Flags*, a 1936 classic starring Ronald Colman, and featuring Claudette Colbert as native girl Cigarette: Corktip. Cigarette. Get it. Oh well, please yourselves …

Anita loved this particular role, regularly recalling how she had been sent for belly dancing lessons from Julie Mendez and how wonderful it was to learn a new skill.

The year 1967 certainly was Anita's year when she was headlining alongside Frankie Howerd in the West End revue *Way Out in Piccadilly*. That's comic clout for you. Anita was spending all day with Frank too, filming *Carry On Doctor* at Pinewood Studios:

> He was the most darling man. We both sort of found our feet on the *Carry Ons* together, really, not that it was a chore. It was a delight from start to finish. Everybody, but everybody was an absolute sweetheart to me. And I learned so much. They were the best in this business.

Autumn Leaves: The delectable Anita Harris, photographed out of character, at Pinewood Studios, during the production of *Carry On Doctor*.

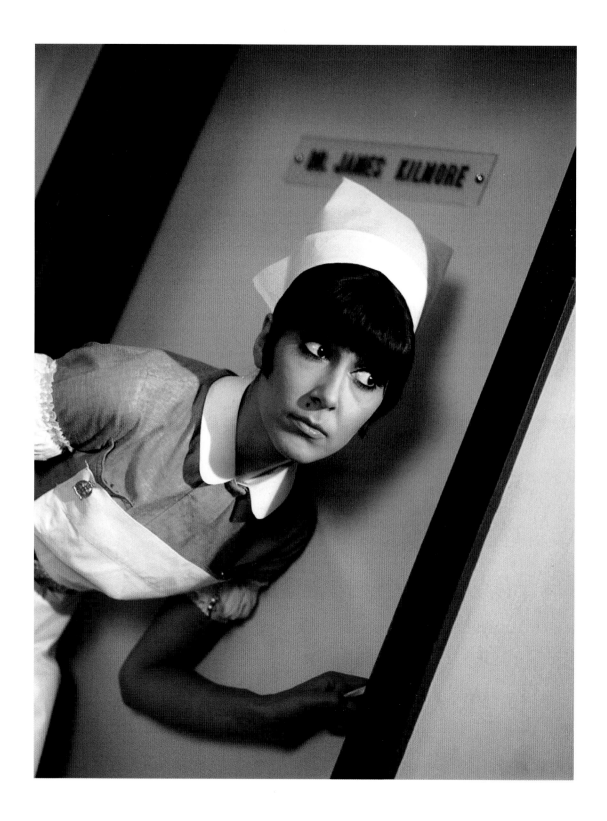

In *Carry On Doctor*, we see Anita come to the fore-front of the *Carry On*s as she plays Nurse Clarke. With beautiful big brown eyes, she is a diligent and caring nurse who has fallen for Dr Kilmore (Jim Dale). Of course, in the 1960s it was very common for doctors and nurses to date and end up married to each other. These days it's less the case, with doctors marrying other doctors. However, for a young Anita, we see her gathering up her inner monologue thoughts, telling herself, 'I must try and control my feelings,' before entering into the room and finding Jim Dale talking to a skeleton.

She is so demure in her role, that one can really imagine her being that caring nurse. The patients take quite a shine to their young nurse with the fondly remembered exchange, 'I dreamt about you last night,' with Anita professionally going about her business and following up with, 'Did you?' Anita reads the line beautifully, not really thinking too much about the potential innuendo in the scene. It's this laidback belief that allows Bernard Bresslaw the maximum power in the punchline, 'No, you wouldn't let me.' She offers a cheeky smile and skilfully continues with her duties. Very true of Anita, who is ever the professional, but with a cheery wink now and again. She makes extreme talent look easy.

Of course, the dedicated Nurse Clarke is put to the test by Francis Bigger (Frankie Howerd). Upon arrival, he grumbles and protests whilst Anita tries to get him into bed (for his bad back, not the other). We see a classic example of the hierarchy within the nursing profession of the 1960s in this scene when the Sister arrives to see what all the fuss is about. Nurses would never speak first to the Ward Sisters, who were incredibly fierce, and certainly never speak first to Matron, unless

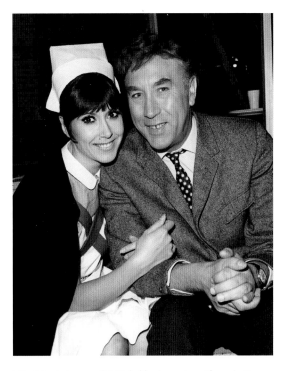

West End stars and British film icons together: Anita cuddles up with mighty guest turn Frankie Howerd, during a break in the filming of *Carry On Doctor*.

A delightful subtle comic twist on a television soap opera cliché: Anita Harris brilliantly walks the fine line between farce and fantasy in her performance as the lovesick Nurse Clarke, in *Carry On Doctor*.

they were spoken to. When sister comes to her aid, you hear a young Anita trying to take hold of the situation by saying, 'He won't let me take his underpants off, the silly boy!' Of course, in trying to show her authority, by keeping a calm manner and referring to Frankie Howerd as a boy, she only enrages him more. Anita blushes when he says, 'And I'm not a boy, as you'd soon find out!' For a small scene, it stands out, not only because Frankie Howerd could make any scene stand out but because it is a good reflection on how women were still judged at the time by men. Because Anita is young, he goes to put her down, by claiming she's a mere 'chit of a girl' instead of facing the reality that he's the one not in control. Thankfully, Matron saves the day (as always!), and we see the real reason for his protests – saucy boxers!

Anita was and still is an incredibly busy lady. In fact, Anita would have been a great lead in *Carry On … Up the Khyber* as the dusky-eyed Princess Jelhi (in the end the return of the delectable Angela Douglas). Moreover, Jim Dale could have also gone on to play the nervous but heroic Captain Keene (played by the one-off *Carry On* hunk Roy Castle). Whilst their time in *Follow That Camel* had practically been a dry-run, both Jim and Anita were actively and eagerly pursuing their pop careers, with an eye on West End musicals and legitimate theatre. Anita's recording of *Just Loving You* had reached number 6 in the British Hit Parade in the June of 1967, just in the wake of shooting *Follow That Camel*, while, having just finished filming *Carry On Doctor*, in January 1968 she was back in the charts with *Anniversary Waltz*. That August, Anita's scrumptious recording of *Dream a Little Dream of Me* did well for her too. The session was produced by Mike Margolis. The couple married in 1973.

Yes, incredibly busy. Anita has continued to work in pantomime, and famously played Peter Pan, the definitive imp of Never-Never Land, under the direction of Pauline Grant, at the National Theatre. It was a role Anita returned to many times, most memorably of all as *The Millennium Peter Pan*.

Anita has worked on extensive theatrical tours, including *The House of Stairs*; the Agatha Christie mysteries *The Verdict* and *Unexpected Guest*; *My Cousin Rachel*; *Bell, Book and Candle*; *Come On Jeeves*, with Victor Spinetti; playing Miss Hannigan in *Annie*, with Mark Wynter; and *Five Blue Haired Ladies Sitting on a Green Park Bench*. An actress of integrity and intensity, Anita's heart is still in variety theatre too. She has notched up seven Royal Command Performances; took on the reality television challenge of *Last Laugh in*

A breathtaking behind-the-scenes moment from the making of *Follow That Camel*, as Anita Harris touches up her eye make-up; Vi Murray, Stella Rivers and Margaret Lewin attend to costume and hair.

Vegas; and played Beatrice Lillie in *Remember Jack Buchanan*; the film won the Golden Palm award at the New York Film Festival.

Although always in demand, Anita explains:

Not for a moment would I ever have said 'no more *Carry Ons*'. I was asked to do more, but I was always on tour, or in the studio, or abroad. Working in the business I absolutely adore.

One regret came in 1987 when Peter Rogers offered Anita a role in his spoof of the American soap opera *Carry On Dallas*:

The script was a dream, and I so wanted to do it. Alas, it never happened. But, you know, it was such a privilege to make those films; and it remains a real honour to be considered part of that team. They really were the greatest.

ANGELA GRANT

A most welcome glamour girl to the *Carry On* team, Angie was a teenage fashion model for the Lucie Clayton Charm Academy before entering the British film industry for Pinewood-based producers Peter Rogers and Betty Box. She was part of Bernard Bresslaw's harem in *Follow That Camel* and cavorted with Leslie Phillips in *Doctor in Trouble*.

Angie's return to the *Carry On*s saw her cast as the gloriously named Miss Bangor in *Carry On Girls*. 'That last scene was a riot,' she remembers. 'They used real itching powder. Fancy using the real thing! Who could tell when watching the film? We didn't question it though. We were far too busy hooting with laughter.'

Angie's subsequent comedy credentials included stooging – and just about keeping a straight face – opposite Eric and Ernie for *The Morecambe and Wise Show* and shedding all her inhibitions for Derek Ford's *What's Up Nurse?*, a jolly sex comedy of 1977 which was inspired

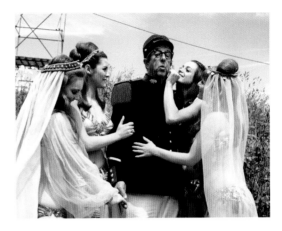

Angela Grant, fondling the ear of Phil Silvers, joins the *Follow That Camel* harem girls, in backlot Pinewood Studios publicity from spring 1967.

enough to recruit Peter Butterworth and Jack Douglas into the full-on slap and tickle.

Says Angie:

> That was a clever move. The *Carry On* team were the tops, and any trace of those fantastic comedy actors was good for business. I'm so proud to be part of it all. The *Carry On*s were good, saucy British humour. Your granny could watch it.

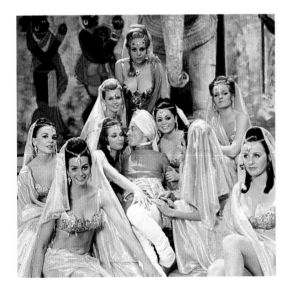

Angela Grant, out in front with her hand on the right foot of Kenneth Williams, adds to the glamour quota of *Carry On ... Up the Khyber*, with newcomer Valerie Leon getting all of Kenny's outrageous attention and, at the top, Alexandra Dane busting out, as Busti. The other hospitality girls include: Josephine Blain, June Cooper, Ann Curthoys, Carmen Dene, Sue Vaughan and Karen Young.

ALEXANDRA DANE

Gloriously over-ripe and bountiful, Alex Dane originally hailed from Orange County, Bethlehem, South Africa, and spent much of the 1960s and 1970s as low-top-wearing eye candy for the great and the good of British comedy, notably playing the flirtatious Nefertiti Skupinski in Spike Milligan's *The Melting Pot*, flirtatious factory worker Brenda alongside Rodney Bewes in *Albert!*: 'Trouble at T'mill (9 May 1972), and Betsy, the flirtatious wife of Bernard Bresslaw, in Terry Gilliam's *Jabberwocky* (1977).

It had been the even earlier jolly espionage romp that had caught the eye of Peter Rogers one day on television. Alex was playing Mathilde, the rather sour-faced home help in an episode of *The Saint*: 'The Good Medicine' (6 February 1964).

She certainly fitted the bill when Rogers cast her as one of Doctor Watt's permanently petrified shop dummies in *Carry On Screaming!*, and as the pre-natal fitness instructor in *Carry On Doctor*. Although the role was a small one, albeit funny by default, Alex's ample charms were skilfully exploited by the publicity department for the Christmas of 1967. It was months before the release of the film, but it paid to advertise, and it was hardly surprising that this most busty of series assets was offered the pivotal glamour girl role of Busti in *Carry On … Up the Khyber*. Once the film had wrapped, Alex went straight into a stage farce, and was so proud of the opportunity the *Carry Ons* had opened up to her that she wanted more and more work from Peter Rogers. On 26 June 1968 she wrote to him from her seaside digs:

As you see I am summer seasoning in Blackpool in a play called *Don't Tell the Wife*. It is a board comedy by Sam Cree and Jack Douglas stars … he is a smashing actor … The

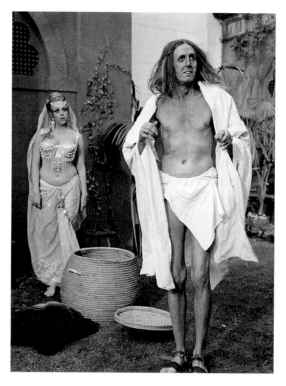

A brilliant foil for comedians, from Eric Sykes to Jerry Lewis, Alexandra Dane was perfectly matched with Cardew Robinson's Fakir in *Carry On … Up the Khyber*. The snake basket sequence proved tricky. 'They dug a 5-foot hole in the Pinewood ground and put the basket over it,' remembers Alex. 'The top of the basket was very small, and my top was rather big! Getting in was alright. It was the getting out that proved problematic. That's not in the film though. A pity. My struggle was hilarious!'

play is being televised on 12th July on BBC One at seven thirty and it would be great if you could look in as you haven't seen much of my work … and it's quite a showy part. I absolutely adored being on *Up the Khyber* – and have had so much publicity … it's really fantastic … but there was such a marvellous

atmosphere and everyone was so nice … I hope you have a lovely summer … plenty of relaxation etc. etc. and that etc. is the best part!!!!!!! Lots of good wishes Alex Dane.

Sure enough, Alex was back with the team, in the spring of 1969, for *Carry On Again, Doctor*. Talk about a showy role. This one was almost spectacularly show-stopping, as the weight-reducing patient is pinned into a tummy-toning conveyor belt machine which speeds up and, thanks to speeded-up film, really whizzes and bangs until it collapses completely. It took three takes on this slimming device to get the shot in the can, not without a little damage … not only to the machine but to the actress. The accident report of Friday, 21 March details that:

> The vibrator came away from the mounting and Miss Dane fell backwards to the floor still holding the machine, hitting her left hip on a

A moment of pure clowning: Peter Butterworth and Alexandra Dane, at Pinewood Studios, for *Carry On … Up the Khyber*.

rowing machine slimming device which was also being used in the scene.

Alex was unperturbed and carried on like the trouper she was. In fact, she was rather buoyed by the added interest, gleeful that it resulted in publicity both for the film and her.

It was a publicity push that was embraced, once more, exactly a year later when Alex was signed up as Emily, one of Kenneth Williams's disgruntled marriage guidance counsellor clients in *Carry On Loving*. A large photograph from

Alexandra Dane as distraught wife Emily. Marriage advice to purchase a step ladder in order for her diminutive husband (Ronnie Brody) to reach her doesn't impress much, in *Carry On Loving*, but there was always time for some glamorous cheesecake shots for publication in *Parade*, *Titbits* and *Weekend*. Here, on location in Windsor, Berkshire, in May 1970.

her publicity session for the film was included in *Photoplay* just ahead of the film's release – helping, no doubt, to make it one of the most instantly profitable entries in the series. It's a typical saucy cameo for Alex, but she works the scene beautifully, playing opposite tiny Ronnie Brody. She is game on for following the ridiculous advice, but her diminutive sexual partner is less convinced – a step ladder being the solution for reaching the parts little men can't reach!

Alex remained a go-to *Carry On* girl, although her scenes were cut from *Carry On At Your Convenience*. She was Barbara Windsor's understudy for the Birmingham previews of the stage show *Carry On London!* Finally, in the spring of 1975, Alex was back on the Pinewood Studios set for *Carry On Behind*, displaying her fabulous cleavage one more time, as the unsuspecting audience member of Kenneth Williams's lecture-cum-striptease film show. It is that naughty Jeremy Connor, son of *Carry On* legend Kenneth Connor, who gets overly excited at Jenny Cox's cinematic gyrating, squeezes too hard on his choc ice, and squirts the freezing cold cream down Alex's top. Ooh!

And it's a very Merry Christmas from Alexandra Dane, in an outrageously saucy *Carry On Doctor* pre-release publicity pose from December 1967.

Shapely Dominique Don, who had been one of the *Follow That Camel* harem girls alongside the likes of Helga Jones, Margot Maxin and Anne Scott, was cast as McNutt's Lure, seduces Peter Butterworth, as Brother Belcher, in this hilarious honey trap scene for *Carry On ... Up the Khyber*. Surprisingly, given the effect she clearly had on Terry Scott, this was Dominique's final appearance for Peter Rogers, although she would later crop up as an attractive La Belle Amie girl in Michael Relph's high-octane comic adventure *The Assassination Bureau*.

VALERIE LEON

Voluptuous, vivacious and lots of other words beginning with V, by the 1970s Valerie Leon had become the most recognisable and beloved screen goddess of British cinema. Strong, independent, and with a look of determination, the persona was that of control of her destiny, and control of her sexuality. While there was always a hint of playfulness, the iconic image of a no-nonsense powerhouse remains.

The Hai-Karate aftershave advertising campaign relentlessly tapped into this Valerie Leon brand that the actress eagerly embraced. Those commercials are still discussed in hushed tones today. Indeed, Valerie is well aware of the impact they made:

> This was in the late 1990s, years and years after we had made them. I was at the National Film Theatre giving a *Carry On* lecture on the films' success, and afterwards this man came rushing up to me and said: 'Your Hai-Karate adverts helped me get through puberty!'

Typically, even at the time, Valerie could see the funny side. Within the commercials, Valerie, statuesque, busty, and beautiful, is overcome with desire at the fragrance of the cologne, doggedly pursuing the nervous little man who wears it. In 'It Might as Well Be String', the October 1976 episode of *The Goodies* that satirised the advertising industry, Valerie self-mocked with gusto. The little man here is Tim Brooke-Taylor and the outcome when Valerie finally gets her man is revealed at last: it's not lust but brutality, she

hai-karate chops the living daylights out of him.

It was this sheer sense of fun that Valerie injected into her celebrated contribution to the *Carry On*s: whether it be lowly serving wench (in *Carry On Christmas*) or reigning Queen of the Jungle (in *Carry On Up the Jungle*) there is a palpable joy beneath the stoic sexuality. Quite simply, Valerie couldn't help showing traces of her own sweetness and sense of fun. 'The *Carry On*s were full of saucy innuendo and sexual overtones, so I fitted the bill,' she chuckles.

Still, her shyness was a hurdle too:

> I do regret not going off to the restaurant with the others and joining in with the riotous *Carry On* table at lunchtime, but I just didn't

The ultimate babe of British cult cinema: Valerie Leon, with customised VL1 licence plate, at Pinewood Studios, for *Carry On Matron*, in October 1971.

have the nerve. They all knew each other so well. Not that they were aloof. Quite the opposite. It was all me. Silly really.

Certainly, the established team took Valerie under their collective wing from the outset:

One got the impression that the fact Gerry Thomas had asked me back [for *Carry On Camping*] that I was clearly all right. I was in the inner circle. You really were part of the team. Straight away. In that hilarious scene with me and Charlie Hawtrey in the tent, he was so lovely while we were waiting for the camera to turn over and our cue to emerge together. I've only just recently noticed that when the store manager [Brian Oulton] is talking to me, you can see Charlie gently poking me into position, so I hit my mark. I didn't know what I was doing in those days, so there was this lovely actor, who had been making films since the early 1920s, coaxing me, quite literally on the job, and on camera. That was typical of each and every one of them.

Of course, we see Valerie transform from an Ugly Duckling to a Beautiful Swan in *Carry On Girls*. She played Paula Perkins, the smart girlfriend of

'We don't sell toothpaste, sir!': Valerie, smouldering, in her unforgettable turn as the sultry shop assistant in *Carry On Camping*, shot on Stage 'C', Pinewood Studios, on 19 November 1968.

Peter Potter (Bernard Bresslaw) who gets swept up in the glamour of the beauty contest. In fact, Valerie has one of the most powerful lines in the film; she turns to Bernard, whose character doesn't want her to take part, and says, 'You don't own me you know.' Yes this is the 1970s and women were taking control of their own bodies and they were standing up for themselves, wanting to make their voices heard.

The film was pointing very clearly to the 1970 Miss World pageant, when a group of feminist activists flour-bombed the stage. Sally Alexander,

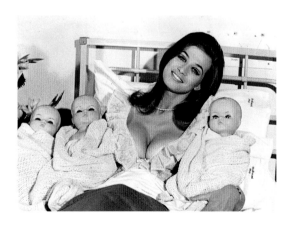

The babies may not be real, but the smile could melt stone. Valerie Leon in a publicity pose, as film star Jane Darling, in *Carry On Matron*.

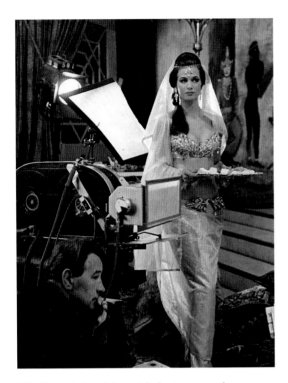

Valerie made her debut with the team, as a harem girl in *Carry On ... Up the Khyber*. Director of Photography Ernest Steward weaves cinematic magic at Pinewood Studios, about to be hugely aided by Valerie as she awaits the cry of 'Action!'.

one of the activists of the time, stated that she didn't have a problem with the contestants, it was the idea of why you had to be beautiful to get noticed as a woman. In fact, the women planned to flour-bomb the contestants at the end, but it was Bob Hope's relentless derogatory jokes that fuelled the anger. As he continued to make his comments, the women decided to bring forward the cue signal for flour-bombing. However, when the arrests came it was the beauty queens who asked the police if the women could be released.

Therefore, three years later, when *Carry On Girls* was released, we see that the scene in which the feminists destroy the beauty contest is an echo of history – although it's far more vicious. Valerie recalls:

That ending was horrendous. That platform all us girls had to walk down … or slip down, more to the point, was really slippery. We were being pelted with soot and flour and all sorts. Horrible. But we carried on … and Sid and Kenny Connor were very lovely. They were getting covered too. We were all part of the fun. Together.

Valerie first joined the team in *Carry On … Up the Khyber!*, playing a hospitality woman for five weeks. However, it was her role as Leda in *Carry On Up the Jungle* that left a lasting impression. Her journey began with the costume fittings for the role, and she was taken to Bermans to get fitted. She could have played the part as a dramatic heavyweight character, but she understood that they wanted her purely for the glamour. Valerie adds, 'I had the glamorous image, and looked sexy, but I didn't portray sexy, I'm strong, I'm not a sex object.' Indeed, this is very true as she grasps the men into her power.

Her second costume was the wonderful sparkly vest which goes over her bikini. The outfit was incredibly difficult to get into and it took the costume ladies a long time to get everything in its place. Her favourite item, though, was the pair of earrings from that same scene. Sadly, she never got to keep them. It was her make-up style that she really fell in love with – particularly the way they had done her eyeliner. Valerie recalls, 'I still do an eyeliner just like that.'

Indeed, Valerie has consciously and cleverly basked in the affection for her *Carry On* appearances, as well as the vast archive of cult film and television roles that remain as – if not more – popular today. 'It's incredible. It really is. I'm very grateful to the fans and, it's true, I've made a future for myself from my past. There's something rather lovely about that.'

TRISHA NOBLE (1944–2021)

Australian model and pop singer, originally billed as Patsy Ann Noble, Trisha had supported class comics Charlie Drake and Dick Emery on television. Trisha leaves quite a legacy in her one and only leading lady role in the series, as Sally in *Carry On Camping*. Demure and buxom, her romantic flirtation with coach driver Jim (Julian Holloway) was destined to be the pivotal love plot of the film. Indeed, a lengthy scene in which he orchestrates, then gallantly protects her from, the stray goat in the shower cubicle was filmed, but, sadly, was cut because of time constraints. Trisha could certainly handle a funny line though, and when the girls are being put into twos for sleeping quarters by headmaster Dr Soaper (Kenneth Williams) her wistful pondering that, 'I don't seem to have a pair,' is polished innuendo indeed. 'I wouldn't say that, dear!' replies Williams. Well, quite.

A beautiful portrait of Trisha Noble. Contrary to many stories of her lateness on the set, the majority of Trisha's fellow Chayste Place girls dispute this. Perhaps senior girl Barbara Windsor was wary of the competition.

Trisha is lovely and fun throughout. She was certainly happy to have been part of the team and proved herself excellent at more forthright smut, opposite a boggle-eyed Frankie Howerd, in *Up Pompeii!*. As Luscia, the High Priestess of the Vestal Virgins, she is above the temptations of the flesh. Or so she says. Trisha's haughtiness, outrage and sheer sensuality provide the perfect sounding board for Frank's perfect naughtiness.

Trisha would subsequently make her mark in America, giving excellent television performances in *Columbo*: 'Playback' (2 March

Luscious Trisha Noble, as Chayste Place schoolgirl Sally, bites her lip in fear at the untethered ram in the shower cubicle in this deleted scene from *Carry On Camping*.

1975), *Mrs. Columbo*: 'Caviar with Everything' (22 March 1979), and *The Mary Tyler Moore Show*: 'Ted's Temptation' (11 December 1976). Always watchable, always alluring, always subtly sexy, Trisha also became a valued part of the *Star Wars* family, as Jobal Naberrie, but for us she's always a beloved member of the select sisterhood of *Carry On* girls.

AMELIA BAYNTUN (1919–1988)

Fussey by name and fussy by nature, Amelia Bayntun is the definitive *Carry On* mum in her scene-stealing performance in *Carry On Camping*. Her worry is all in the best interests of her cosseted daughter (Joan Sims), but her cries of woe and foreboding are more Cassandra than caring.

On television, from 1971, she was given more of the same as Mrs Ada Bissel, the permanently suspicious mother of daughter Doreen (played by Liz Gebhardt, and then Cheryl Hall) who was betrothed to Rodney Bewes in the sitcom *Dear Mother … Love Albert* (later known as just *Albert!*).

Amelia had joined the Bristol Unity Players in 1937, and carved out a good London stage career at the Players' Theatre, and at the Theatre Royal, Stratford East. Her favourite role was as Mrs Blitzein in Lionel Bart's *Blitz!*, but she was also grateful to be part of the *Carry On* repertory company. She played small parts: being fitted for a corset by Joan Sims in *Loving*; a gossipy, rebuked neighbour in *At Your Convenience*; and meatier roles, such as Mrs Jenkins in *Matron*. Her final *Carry On* assignment was as Mrs Tuttle in *Carry On Abroad*, another overbearing mother, prompting some of the best eye-rolls ever from her mollycoddled son (Charles Hawtrey). This frantic mum is even more heightened – in *Camping* the homegrown threat of sex may be at the forefront

The very definition of the fussy mother of British comedy, here Amelia Bayntun gives her most triumphant performance, as Mrs Fussey – of course – in *Carry On Camping*.

of her mind, but in *Abroad* it's the horrendous prospect of nasty conveniences and unpalatable food that worries her.

The absurd comedy is played with such glee, such truth. One is always in good hands when Amelia Bayntun is in your cast.

PATRICIA FRANKLIN

Patricia had worked as a secretary and was a model before studying at the Royal Academy of Dramatic Art, where she won the Emile Littler Award. She continued modelling while at the academy, and was chosen to represent Great Britain in the Miss Cinema Contest, in Italy.

She was very much a September girl: she was born in September 1942; got engaged in September 1966; and in September 1967 secured her first television assignment, in *At Last the 1948 Show*. 'It was great training for the *Carry On*s. Marty Feldman, John Cleese and the rest of that gloriously madcap gang kept you on your comedy toes, that's for sure …'

She went on to be in *Uproar in the House*, at the Whitehall Theatre, with Joan Sims and Peter Butterworth:

> I was known as a bit of a glamour girl in those days … running 'round the stage, in a typical bedroom farce, standing there in nothing but a negligee. Great fun actually. Obviously, because of who was in the cast, Gerald Thomas came along to support it and spotted me … he must have seen something he liked and thought I was funny because I was signed up for my first *Carry On*.

The role was that of a pregnant country girl in *Carry On Camping*. Terry Scott has been there before – to get milk – before Charles Hawtrey stumbles into the scenario and encounters outraged father Derek Francis. He is given short shrift. In fact, he is accused of fathering the expected child. Hawtrey's cheeky aside – if the offer to take his daughter to bed still stands – is the last straw for the farmer. Still, Hawtrey's suggestion is greeted with a grateful grin from

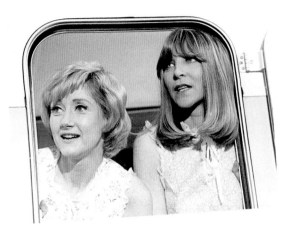

Nagging housewives no more as Sylvia Ramsden (Liz Fraser) and Vera Bragg (Patricia Franklin) gatecrash the caravan holiday of their husbands in *Carry On Behind*.

Patricia, as she sits, knitting. It's a lovely vignette within the film, beautifully played.

In *Carry On Girls* we see Patricia play masculine feminist, Rosemary. Interestingly, whilst she plays one of the saboteur feminists in the beauty pageant scene, the activists who took part in the 1970 Miss World actually went dressed very glamorously in order to fit in with the crowd. A stark difference to the role Patricia plays. Played for laughs. Played just right.

In *Carry On England* we find Patricia playing a disgruntled canteen lady. A deadpan sneer enlivens her disinterest at the squaddies' thoughts about the quality of the food. 'You can bounce it off the ceiling for all I care …' she mutters. It's Norah in *Carry On Sergeant* all over again, but without the hint of romance that brightens her day. Still, as part of the invaluable *Carry On* company, it is the expected, genuinely good bit of characterisation. A true professional, and a loyal *Carry On* girl.

SANDRA CARON

Sandra Caron trained at Aida Foster School, Finchley, and was delighted to get the call to buddy up with Barbara Windsor for *Carry On Camping*:

> We were called into the studio every day of the schedule, regardless of whether we were on the call sheet or not. I didn't mind in the slightest. I was getting a good wage, and I found the process of filming endlessly fascinating … I was excited to be at Pinewood. I remember someone with this deep voice coming to sit by me. It was Gregory Peck! I couldn't believe it. I nearly passed out!

Peck, who had decamped from filming *The Most Dangerous Man in the World*, on location, in the Welsh valley that the *Carry On … Up the Khyber* unit moved into, was now at Pinewood Studios shooting the studio scenes, with the gang already on to their next picture!

Of course, Sandra was also a blonde, and as she was playing alongside Barbara Windsor, she was asked if she wouldn't mind dyeing her hair. She recalls, 'I was asked, very politely, when I got the part whether I would mind dyeing my hair …' Of course she didn't mind, and in her words, 'I was very happy to oblige.'

Yvonne Caffin's costume design for *Carry On Camping* sets Sandra Caron's Fanny off perfectly: here is a chic young lady of style, sporting the cap as if to Carnaby Street born. A swinging sixties chick with her big, big eyes on a brand-new decade.

Barbara Windsor and Sandra Caron, as Babs and Fanny, the leading lights of the Chayste Place Girls' School, in *Carry On Camping*. They have more knowledge of sex education than their haughty superiors will ever know!

Bristol-born Jackie Poole plays Chayste Place girl Betty in *Carry On Camping*. She stooged for such top television comedians as Dick Emery, Jimmy Tarbuck, and Morecambe and Wise. Following her fun with the *Carry On* gang, she played Margie in the gender-swapping Hammer horror film *Dr Jekyll and Sister Hyde*.

Londoner Lesley Duff made her big screen debut as Chayste Place girl Norma, in *Carry On Camping*, with subsequent comedy roles ranging from work with Hale & Pace to Rod Hull and Emu. Moving into theatrical representation, Lesley teamed up with Jean Diamond to found Diamond Management in 2003.

VALERIE SHUTE

Having graduated from Chayste Place schoolgirl in *Carry On Camping*, Valerie was signed up for a fine sprinkling of *Carry On* appearances, from nurse to expectant mother. Although her role as a maid in *Carry On Henry* was sadly cut from the

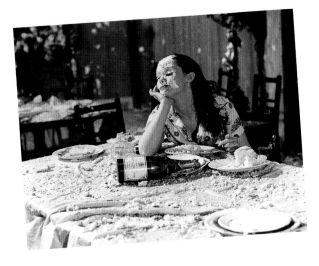

A slapstick maestro in hot pants and knee-length boots. Valerie Shute puts on the deadpan in the aftermath of the great cake fight climax of *Carry On Loving*. Pinewood Studios, May 1970.

Valerie Shute, happily caught in a clinch with Mike Grady, in *Carry On Loving*. The pair were paid £25 a day and both remember it as the happiest of experiences, 'largely,' states Mike, 'because Valerie had such a charming sense of humour about the whole prospect. Otherwise it might have been deeply embarrassing.'

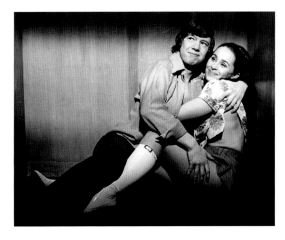

final print, she was busy in the evenings acting in the farce *Oh Clarence!*, at the Wimbledon Theatre. Valerie's best-loved film appearance was still on general release at the time, when she was the forever-snogging girl (with lover Mike Grady) in *Carry On Loving*.

Her other screen work included *The Fenn Street Gang*: 'A Fair Swap' (31 December 1971); Sarah James in *Emmerdale Farm*; and the 1983 Alan Plater play *Pride of Our Alley*. She married Willis Hall in November 1973 and turned more and

more to writing, creating the *Worzel Gummidge* comic strips, based on her husband's stories, and, in 2017, staging her play, *The Last Christmas Tree*, at the Royal Birmingham Conservatoire, at Birmingham City University.

GEORGINA MOON

The gorgeous daughter of George Moon – who played the helpful assistant of Peter Butterworth in *Carry On Camping*, telling Sid James and Bernard Bresslaw that he's gone for a P – Georgina was cast as a Chayste Place girl, and returned to the series in the spring of 1975 for the caravanning romp *Carry On Behind*. Alongside her mate, Diana Darvey, Georgina eagerly reveals her own behind, thanks to those chairs, much-painted by Hugh Futcher.

In between her two *Carry On* exploits, Georgina had become a firm favourite in saucy television

Jennifer Pyle, as Hilda; a rather deflated-looking Barbara Windsor; and Georgina Moon in the legendary *Carry On Camping* scene.

comedy, as the doe-eyed, outrageous, but really rather pious Erotica, in *Up Pompeii!* The daughter of the lustful but past-it Senator Ludicrous (played first by Max Adrian, and then Wallace Eaton), she was continually flirting with prestigious gladiators and slave-traders but seemed to keep her honour intact. Oh! Georgina's good friend Madeline Smith played the part for the film.

ELIZABETH KNIGHT (1944–2005)

Of all the Chayste Place lovelies it is Elizabeth's character that is the real minx. It's always the quiet ones … and certainly this quiet one, who stays at the camp site while the others suffer the excursion to the local monastery and befriends beleaguered Peter Potter (Terry Scott). This brow-beaten canvas-dweller is also alone, for his wife (Betty Marsden) and unwanted tent guest (Charles Hawtrey) are with the wine-producing monks too. Play time. Elizabeth doesn't smoke nor drink, but the third option is even more exciting, 'We can go to my tent if you like …' she purrs. She even insists, 'Well, come on!' … and our sex-starved businessman on holiday revs up for – off-camera – action.

As with June Whitfield's romp with Ray Brooks in *Carry On Abroad*, this holiday bit of slap and tickle fires up Terry Scott. He's suddenly man enough to sling Hawtrey out and pin Marsden down. 'Ooh, Peter!' Elizabeth, meanwhile, hot legs it off with all her sexy classmates with the hippie dropouts, the Flowerbuds, at the film's end. It's a *Carry On* for the beautiful people – hinting at the muddy excess of the Glastonbury Festival which launched in September 1970, a year after the release of the film!

While *Carry On Camping* was doing great business at the British box office, Elizabeth was back, shooting her one-day cameo on *Carry On Again, Doctor*. Looking demure and foxy in a nurse's

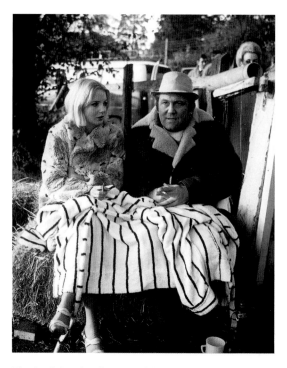

Elizabeth Knight plays arguably the most sexually forthright and independent of all *Carry On Camping*'s Chayste Place girls. That's the far from plain Jane. Here, sharing a packet of smokes and a blanket with Terry Scott, before filming the seduction of Peter Potter!

outfit and struggling to cope with the dirty old man advances of Wilfrid Brambell – just ahead of reviving his role as that dirty old man Albert Steptoe in *Steptoe and Son*, in April 1970.

ANNA KAREN (1936–2022)

Born in Durban, South Africa, Anna moved to London at the age of 17 and studied at the London School of Dramatic Art. Working her way through college, Anna realised she could double her income by dancing at the Panama Club, a London strip club. Suitably enough, Anna's film debut came in the naturist classic *Nudist Memories* (1961), a fact that makes her role as a cheeky schoolgirl in *Carry On Camping* all the more meta.

Having met while performing together in London nightclubs, a lifelong friendship with Barbara Windsor was cemented during the making of this film. Barbara tipped Anna off that Ronald Wolfe and Ronald Chesney were casting for a new sitcom. Having worked with them on *The Rag Trade*, Barbara was guaranteed a role in *Wild, Wild Women*. The writers were so impressed that they offered Anna the role of Maude and although the series was short-lived, during the show's production the Ronnies cast her as Olive, the put-upon grump in *On the Buses*. A hoot for London Weekend Television, Anna starred in all seventy-four episodes from 1969 through to 1973, as well as the three box-office busting feature films from Hammer:

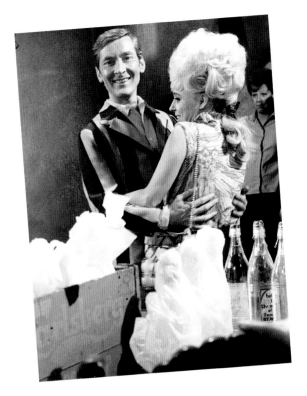

Kenneth Williams and Barbara Windsor had been firm friends since 1964, while one of Barbara's dearest, lifetime chums, Anna Karen, languid in the background, joined the team as a Chayste Place pupil, rather unfairly billed as 'Hefty Girl' in publicity material for *Carry On Camping*.

> I loved that role. It made me. And I really didn't mind playing the ugliest woman on television. It was a blessing really. When I went out to do the shopping nobody recognised me, and I was still making a good living as a fashion model during those years of unwashed hair; pebble glasses; and padding 'round the belly!

Anna also managed to squeeze in one more *Carry On* appearance, rejoining the team for *Carry On Loving*, shot between the filming of series three

and four of *On the Buses*, in the spring of 1970. You can spot Anna, as a disgruntled wife at the very end of the film, happily throwing herself into the cream cake fight with the gusto of a silent comedian. 'I loved it,' she remembered, 'and I was offered more, but I had to give my first loyalty to the *Buses* films.' Thereafter, Anna was busy in regional tours of hugely successful naughty comedies: playing Minnie in *Who Goes Bare?*, and Miss Tipdale in *Not Now, Darling*. There were

various roles in *The Kenneth Williams Show*, and a brief part as a contented knitter in the sex comedy *What's Up Nurse!*, before she was back playing Olive, for Ronald Chesney and Ronald Wolfe, in *The Rag Trade*, from 1977.

In 1996, Anna reunited on screen with Barbara Windsor, when cast as Aunt Sal, Peggy Mitchell's sister in the BBC soap opera *EastEnders*. Although she was always loyal to her comedy past, happily attending *On the Buses* conventions, the soap gave Anna an autumn-years boost; she relished a return to pantomime, to play the Wicked Stepmother in *Cinderella* at the Millfield Theatre, Edmonton, for the 2008/09 season.

SALLY KEMP

Peter Rogers knew Sally Kemp because she was the daughter of Frank Kemp of the Essoldo Circuit, a cinema chain that he was connected with through the distribution arm of Warner-Pathé. At the time of casting for *Carry On Camping*, Sally was 29 years old, with a few years of repertory theatre experience behind her. She had just played the barmaid in Francis Searle's film *The Pale-Faced Girl* (1968).

Expert at likeable naivety, Sally was teamed with Charles Hawtrey for one of the best-loved exchanges in the series. Hawtrey, rather amusingly, thinks he should try his luck with this attractive farm girl, happily leading a cow through the fields. She is taking it to the bull, she explains. 'Oh,' enquires Hawtrey, 'couldn't your father do that?' 'No,' answers Sally, 'it has to be the bull!' Boom. Hawtrey repeats, 'It has to be the bull,' mildly, under his breath, before realising the joke, looking straight down the camera lens at the viewer, giving that owl-like look of shocked amazement and carrying on. Sally, meanwhile, has given that delightful pursed-lips response, and exited screen left, never to be seen

'No it has to be the bull ...': Sally Kemp, as the naive farmer's daughter, meets Charlie Muggins (Charles Hawtrey) on the road to Paradise, in *Carry On Camping*.

in the *Carry On*s again. However, she still remains amazed and ever so grateful that the moment is so beloved by fans of the series. 'In complete screenings of the films or in compilation, that silly little moment with Charles Hawtrey has been screened and enjoyed by so many people over, gracious, half a century. What a lovely little legacy.'

PATSY ROWLANDS (1931–2005)

For someone who would become loved and respected as one of Britain's finest comedy actresses, Patsy Rowlands had little interest in going on the stage until her parents pulled her out of her shyness by enrolling her in elocution lessons. The young Patsy blossomed and, with encouragement from her teacher, she was awarded a scholarship to the Guildhall School of Speech and Drama. At the end of her three-year course, she graduated with the highest marks of anyone across the entire United Kingdom.

Not surprisingly, she was snapped up by an agent and made her stage debut in a 1951 touring production of *Annie Get Your Gun*. Following in the footsteps of Hattie Jacques, Patsy joined the ensemble of the Players' Theatre, performing old time music-hall and pantomime to huge public and critical acclaim. In 1958, character actress and influential stage director Vida Hope offered her the role of Thetis Cooke in Sandy Wilson's musical adaptation of the Ronald Firbank novel *Valmouth*. A lucky production for Fenella Fielding too, Patsy stole many a plaudit as the simple country girl who yearns for the return of her sailor sweetheart. With a typical mixture of girlish naivety and mischievous sexual desire, Patsy's performance was a revelation – her show-stopping rendition of *I Loved a Man* affording her some hilarious schtick with a fish, which she invented more and more business with until, finally, she ended the song, flat on her back, with the fish nestled between her bare toes. What a pro! Patsy remained with the company when the show transferred to the Saville Theatre in 1959, marking her debut on the West End stage.

Patsy caught the new wave of experimental theatre in the early 1960s, enjoying her all-time

Patsy Rowlands, one of the most accomplished of British screen and stage actresses, joins the team, as medical secretary Miss Fosdick, in *Carry On Again, Doctor*. Here, on location at Maidenhead Town Hall, in April 1969.

favourite role as Sylvia Groomkirby in *One Way Pendulum*, N.F. Simpson's avant-garde comedy staged at the Theatre Royal, Brighton. On screen, all kinds of appetites were stated in Tony Richardson's playful historical romp *Tom Jones*. Richardson gave her much more of the same in *Joseph Andrews* (1977), a less successful but equally raucous film, this time featuring her dear *Carry On* chum Jim Dale. The two would be reunited one last time, on the stage of the London Palladium, for Cameron Mackintosh's exuberant revival of Lionel Bart's *Oliver!* (1995).

A real jobbing film and television actress, with notable roles opposite Norman Wisdom, in a lovely bit of dream sequence surgery assistant play acting in *A Stitch in Time*, and early appearances with Charlie Drake, it was Sid James who became a faithful and forceful champion.

Always a gambling man, Sid liked to place bets with fellow actors and Pinewood technicians on which supporting player would instantly fit the *Carry On* style and be asked back. Delighted by Patsy's comic timing as his final – and forever – wife in *Carry On Again, Doctor*, Sid was not the least surprised when Rogers and Thomas cast her in *Carry On Loving*. Indeed, Talbot Rothwell's original script included a scene in which Sid advised Patsy on how to scupper the plans of her dour employer, Kenneth Williams. This was to marry Sid's business partner and live-in wife-in-waiting Hattie Jacques.

We rehearsed that little scene before we shot it, and I'd love to see it again, but I imagine it's gone forever. Anyway, I remember it vividly … and it led Sid to recommend me for his new situation comedy over at Thames Television, which was incredibly sweet of him.

The series was *Bless This House* and Patsy played nosy next-door neighbour Betty, both on television and in the Peter Rogers film version. Patsy spoke fondly of her friendship with Sid James; he was very much her 'security blanket', and not just for her, but all the girls. It was through working with Sid that she learnt a lot about comedy. He coached her to understand that all comedy comes from the reaction shots, claiming, 'He was a wise

Carry On Girls gave Patsy her biggest role with the team, as slovenly mayor's wife Mildred Bumble. Still she couldn't keep the beam off her face during the hilarious bra-burning scene. Slapstick farce as social comment.

old bird.' Patsy was also a huge champion of Sid, just as much as he was for her. In her later life, she felt he had been one of the most genuine people and went on to recall, 'For all the things that have been said about him, he was still a genuine person.'

Before starting *Bless This House*, Sid and Patsy were reunited at Pinewood, for just one day, 6 November 1970, on the 'paddock tank' set for Patsy's beheading scene in *Carry On Henry*. Small, but beautifully formed. Patsy would laugh about her time on *Henry* saying, 'I had a "blink and you'll miss it" kind of scene,' but nevertheless she loved it and was proud that it became part of British film history.

Forever self-critical, Patsy thought that perhaps she had played the role too straight for a *Carry On* film.

A sterling and sincerely played cameo, it works so perfectly and defuses the guffawing antics of Kenneth Williams and Terry Scott, purely because Patsy is so committed, and truthful in her acceptance of her fate and her footnote status in history. It's a hallmark of quality that was always part of the economic clout of the *Carry On*s; a favourite gem in the *Carry On* crown.

Patsy's dependability never faltered, with delicious bits (as the receptionist in *Carry On Abroad* and the cheery crone in *Carry On Dick*) and leading roles (as the faithful secretary in *Carry On At Your Convenience* and the suspicious wife in *Carry On Behind*). In *Carry On Laughing*: 'The Nine Old Cobblers', she was cast as simpering Miss Dawkins, an energetic member of a local amateur dramatic society who gets embroiled in a murderous case for detective Lord Peter Flimsy (Jack Douglas) and his faithful assistant Punter (Kenneth Connor). Still, it is *Carry On Girls* that remains Patsy's most satisfying role. As the downtrodden wife of the mayor (Kenneth Connor), her character enjoys a real transformation – from drudgery to rebellion. Moreover, in terms of her place in the *Carry On* team, the film is the only

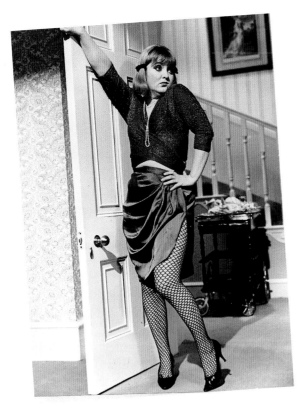

Patsy in the 'swan' mode from frumpy Ugly Duckling Miss Dempsey in *Carry On Loving*. As much of a surprise to her screen employer Percival Snooper (Kenneth Williams) as the box-office-busting audience when the film was released for Christmas 1970.

She also enjoyed television costume dramas: *Vanity Fair* and *The Cazalets*, while the West End stage continued to challenge and thrill her – as Mrs Potts in *Beauty and the Beast*, at the Criterion; and Mrs Pearce in the National Theatre's production of *My Fair Lady*.

Patsy was one of the most underestimated *Carry On* girls. She often played smaller parts, whether it be as a lowly assistant to Kenneth Williams or a bored housewife to Kenneth Connor. However, she left her mark on the films and talked often of them with great fondness. She always felt there was nothing nasty or vindictive in the films; speaking in her later years, she commented on films that were being made, saying, 'If it's not the aggression, it's the language,' and that's why she thought *Carry On* had something special.

Patsy really was a champion for all her co-stars and colleagues on set. She recalled that Gerald Thomas would never say much to the cast, but when he did they would all know it was right. He allowed the team to act their parts without imposing too much direction, and to Patsy this was the key to success for the films. She loved how she rehearsed scenes in make-up with a bacon sandwich in her hand, but by the end of the day she would have time to go and meet up with a friend and enjoy her afternoon.

As mentioned, in *Carry On Girls* Patsy played Kenneth Connor's wife, a rather downtrodden and lazy woman who's given up on life. We often see her lounging around in her dressing gown with a cigarette on the go, which was a little ironic as Patsy never smoked. Patsy enjoyed playing the part though, as she felt the character was so real, maybe because she is one of the few ladies in the film that actually makes a real

time Patsy Rowlands saw her name included on the poster.

Once the *Carry Ons* ceased production, Patsy relished lots of choice and varied comedy roles on television, notably the very last episode of *George & Mildred*: 'The Twenty-Six Year Itch' (25 December 1979). She played Sister Alice Meredith in the Thora Hird sitcom *Hallelujah!*; Netta Kinvig in Nigel Kneale's *Kinvig*; Thelma, opposite Dick Emery and Barry Evans, in *Emery Presents … Legacy of Murder*; and Lil Potato in *Bottom*: 'Parade' (22 October 1992).

In 1969, she had delighted in a little nefarious behaviour herself in the dark and daring 'An Extra Bunch of Daffodils' for *The Galton & Simpson Comedy*. Eighteen years later, Ray Galton, in tandem with co-writer John Antrobus, fictionalised his own youth in the tuberculosis sanatorium that had kick-started his writing career. *Get Well Soon* (1997) cast Patsy as Mrs Clapton.

change, by getting up and joining the Women's Lib. However, we understand her motives and respect her for it. Again, this was a time for change for women, particularly in marriages and we see how tired and fed up she is being the councillor's wife, going to all the boring events. Patsy felt this was key to the role – that the part had to be believable and she felt the writing always complemented that well.

Commenting further on the film, she also mentioned that we see a hint of domestic abuse. When she is sitting at the table not listening to her husband, Kenneth Connor picks up a rolling pin as if to hit her with it, however he doesn't – quite rightly. When watching the film, Patsy would joke, 'Go on, whack her with it.' Again, this is all very reflective of the times when domestic violence laws were being introduced. We see further evidence of her frustrating her husband, this time in public. During a scene where they are on a council visit to open the new hospital, Patsy makes a spectacle of herself by dropping all the contents of her handbag onto the floor. She plays a woman who is trying to be invisible, but not succeeding, beautifully. Her one comment about the scene was that her feet were in agony in the shoes she was wearing, so perhaps it wasn't so difficult for her to look uncomfortable.

Overall, Patsy was proud to be a part of the *Carry On* films, she felt they remained popular because you can take them or leave them, and that it didn't need to be filthy; the most important thing was that the characters were all real and believable. She felt her co-stars all had their individual gifts to offer. Her view on whether or not there should be new *Carry On*s was that, without revue performance experience, it would be too difficult to learn that level of timing and how to play all these different parts, be they big or small. The ever-loyal fans did bring her joy as she heard that people now do projects about the *Carry On*s at university.

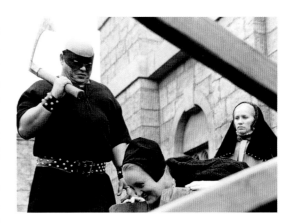

The friendly camaraderie of the series was infectious for all, and here's Patsy Rowlands cracking up, even with the prospect of the executioner (Milton Reid) beheading her, in *Carry On Henry*.

Patsy thought of her colleagues as family; whilst they were quick turnarounds, for her it never felt like just another job. Her career in repertory aided her abilities in the films, and whilst she may have only had smaller parts, it was true that those who had performed in repertory were used to that. One week you could have a big part, then the next you would just have one small scene, so for her *Carry On* was no different. However, there were times when she almost forgot she was part of a *Carry On* film. Joking about her time on *Carry On At Your Convenience*, Patsy recalled looking out of the window, after an early morning call for make-up. 'I looked up and saw Tony Curtis [who was at the studios making *The Persuaders!*]. I had to run over to Joan Sims to tell her. For that one moment I thought I was in Hollywood.'

Patsy returned to Pinewood Studios frequently, always taking her camera to snap shots of the corridors. 'I'm sure people thought I had gone mad, taking photographs of empty rooms and doorways, but I have so many happy memories of that place. I just felt so nostalgic.'

Patsy really was a beautiful soul and one of the kindest of the *Carry On* girls.

PATRICIA HAYES OBE (1909–1998)

One of the most prolific and evocative of character actresses, Patricia Hayes had a stage and screen career that stretches back to the late 1920s when, following study at the Royal Academy of Dramatic Art, she plied her trade in repertory theatre for a decade. By the late 1960s she was one of the most familiar faces in British comedy, giving peerless support to the great and good of the business in *The Arthur Askey Show*, *The Benny Hill Show* and *Hancock's Half-Hour* – as Hancock's grumbling housekeeper Mrs Cravette, creating hilarious vignettes on television. None is more memorable than 'The Cold' where her White Witchery is 'drawing it out' of his system – with no success at all. On television, she teamed with Hancock for the egg commercials too.

On radio she had become adept at playing pre-pubescent boys, memorably teaming with Charles Hawtrey for the long-running *Children's Hour* favourite *Norman and Henry Bones: The Boy Detectives*.

Patricia happily pocketed £125 for her one-day star cameo in *Carry On Again, Doctor*, a pitch-perfect encapsulation of the elderly lady with every ailment in the book. Within that tiny scene, with doctor Jim Dale and nurse Valerie Van Ost, there is a cheerful snapshot of old London; a proud working-class lady who revels in her pills and potions, loves getting near the knuckle in her comic observations and, fundamentally, is a simple, lonely woman, who loves coming in to see her medic friends for a good old winge and a gossip. 'See you tomorrow, ah!'

These were qualities that went into informing her signature role, that of the BAFTA award-winning performance in the 1971 *Play for Today*

Children's Hour chums reunited, as Charles Hawtrey rolls up his trouser legs to get back into character for the *This Is Your Life* of his *Norman and Henry Bones* co-star Patricia Hayes, at the Duke of York's Theatre, in April 1972.

'Edna, the Inebriate Woman'. A portrait of social history and desperation, all those years of comic reality come together in one role. Even in her dotage, Patricia was an actress of heartbreaking sincerity and slapstick genius: witness the shape-shifting sorceress Fin Raziel in *Willow*; and the dog-loving and dog-losing Mrs Coady in *A Fish Called Wanda* (both 1988).

SHAKIRA BAKSH

Before that faithful Maxwell House coffee commercial that first attracted a film superstar, and before meeting and marrying that same film superstar Michael Caine, in 1973, Shakira Baksh was a model and actress. She had left school at 16 to work as a secretary in a US Information Service office. During the Guyana trouble her office was bombed and this led her to entering beauty contests simply as a means of getting out of the country and to safety. Named Miss Guyana, she represented her country in the 1967 Miss World competition, held in London. Shakira stayed, and made her first film appearance as Scrubba in *Carry On Again, Doctor*.

Shakira appeared opposite Michael Caine in John Houston's *The Man Who Would Be King*, but happily settled into family life, and full support of her husband's career. Now Lady Caine, fifty years of happy marriage has been the result of that first meeting. For Sir Michael it was love at first sight. 'She was the most beautiful girl I'd ever seen.'

Shakira in her eye-catching role as Scrubba, in *Carry On Again, Doctor*. After taking the secret serum, of course.

YUTTE STENSGAARD

Yutte Stensgaard was originally from Denmark, and moved to England at the age of 17, in 1963. She was employed as an au pair with a family in Cambridge, before training as a secretary and interpreter. Her stunning looks gained her modelling assignments in London. Desperate to prove herself an actress, she enrolled in the Studio Film Craft Drama School, run by Ronald Curtis. After a three-year course, she married Ronald's son, film art director Tony Curtis, in 1967.

Her early films include Ralph Thomas's January 1969 release *Some Girls Do*, in which Yutte was 'Robot No. 1', part of a fiendish army of beautiful women with electronic brains; and as the blonde and beautiful Erika in Gordon Hessler's *Scream and Scream Again*, which hit cinemas in January 1970. Yutte's ubiquitous *Carry On* girl assignment

A beauty with affectionate aptitude for bedpan humour: Yutte Stensgaard in glamorous promotion for her role as troubled Mrs Roxby in *Carry On Loving*. Sadly, her entire contribution to the film hit the cutting-room floor, along with that of her screen husband, James Beck, who at the time was playing Private Walker in *Dad's Army*. The cut scene saw Mr Roxby discuss his suspicions of his wife with Percival Snooper (Kenneth Williams). Yutte is coy: 'See what I mean? He doesn't trust me.' Roxby is proved correct. A suggestion of a celebratory lunch was scuppered with Mrs Roxby's exclamation, 'He can if he wants. I've already got a date with someone!'

was also on general release at the time. She wiggles in the ward as a trolley nurse in *Carry On Again, Doctor* and, after filming, enjoyed more medical mayhem, as semi-regular Helga, in television's *Doctor in the House*. Yutte was cast as Eve, one of the ship-based fashion models who bewitch Leslie Phillips in *Doctor in Trouble* (1970), and she made a second foray into *Carry On* comedy in the spring of that year. Alas, her hilarious scene with marriage guidance counsellor Kenneth Williams in *Carry On Loving* was cut from the film. Yutte was Mrs Roxby, discussing her problems with her husband, played by James Beck, who was also completely jettisoned.

It was Hammer Films that really wanted to make her a star, giving her the lead, dual role of innocent beauty Mircalla Herritzen and deadly

Carmilla Karnstein, in *Lust for a Vampire*, filmed in July 1970. Yutte told the publicity department that her ambition was not just to be a successful screen personality but a good and competent actress. In 1971, she became one of the most popular hostesses on *The Golden Shot*.

JACKI PIPER

Delightful Jacki Piper would become one of the pivotal leading ladies of *Carry On*, and certainly one of the franchise's most accomplished actresses. A celebrated asset of the Birmingham Repertory Company, she was still a little overawed

when Peter Rogers offered her the female lead in his latest film *Carry On Up the Jungle*:

> I had only done one film … a very small scene with Roger Moore in *The Man Who Haunted*

Himself. I said to Peter Rogers, Mr *Carry On* himself, that I couldn't possibly do this massive female lead in the film. I've only ever done theatre. He threw his head back, roared with laughter, and gave me the part in *Jungle*!

Jacki was thrilled to join the team!

Speaking of her co-stars, she was delighted to work with Frankie Howerd. 'He was brilliant. They all were. I just couldn't believe my luck to be cast alongside such great actors.' One actor she was very impressed with during the filming of *Carry On Up the Jungle* was Bernard Bresslaw. As a young actress, she was in awe of how he put so much into his parts, and in this film he learnt to speak Urdu, an example of the depth of research he carried out for every part he played. Jacki was incredibly impressed by this, although the actors they had hired were in fact from the Caribbean and couldn't understand what he was saying.

Jacki's first day of filming was the scene where she had to dig a big hole in the ground. In the afternoon, the cast would go along to the rushes; however, Jacki hated seeing herself on screen and didn't go. It was later that afternoon when Gerald Thomas approached Jacki, and said he had something 'rather unpleasant to say'. Jacki thought, 'this is it, I'm off the film.' She thought she was in trouble and they were going to recast after watching the rushes. Gerald went on to say, 'I'm going to throw a bucket of water in your face tomorrow.' Jacki beamed and was thrilled; she really thought she was going to be replaced.

Jacki's greatest respect goes towards Gerald Thomas; she found him to be so relaxed on set despite the quick turnaround. Gerald always took care of the cast. During one of her scenes – the one where the promised bucket of water was

thrown over her – the crew member threw the bucket so hard on the first take that Jacki's hair piece and eyelashes came flying off. Poor Jacki had to be dried off and the scene taken again. Jacki recalls, 'Gerald was so sweet, he turned to the man and said, "This time when you throw the water please do it gently."'

All the cast were very helpful towards the young actress, with both Sid and Joan taking Jacki under their wing. The atmosphere was relaxed, and despite Gerald being the driving force:

> He managed to keep his cool and remain calm, and would laugh at every joke, which was just lovely. There were no tantrums, in fact the only problem we had was the laughter. Gerald would struggle to get us to stop laughing long enough to do the scenes!

And the laughter continued into the lunch times, when the cast all sat in the canteen together. Jacki

Jacki photographed in the splendid grounds of Pinewood Studios, during the making of *Carry On At Your Convenience*, in spring 1971.

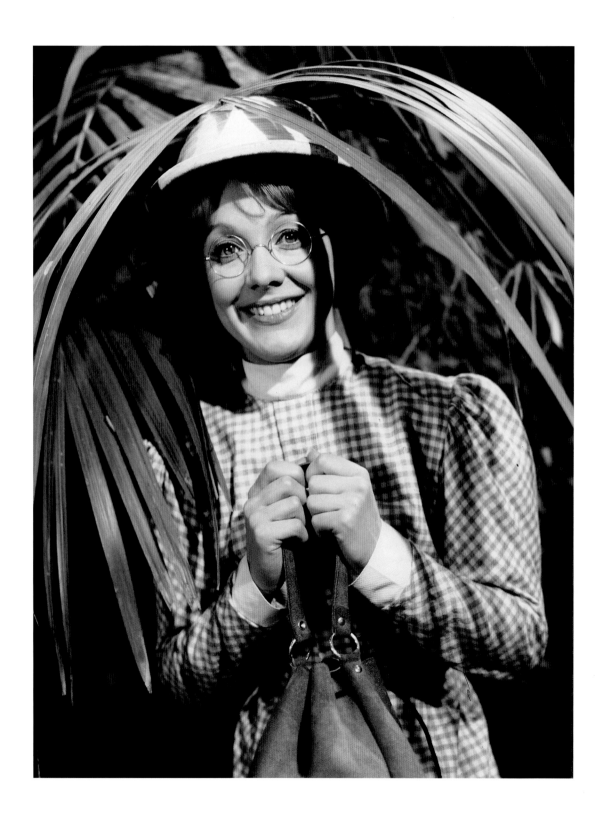

recalls, 'You knew in the canteen who the *Carry On* team were, we were the loudest, and there's no other table I'd rather have sat at.' After lunch, Jacki and Joan Sims would have to go back into make-up, because they had been laughing so much they had cried, and all their make-up had run. Jacki remembers another little-known fact. The amount the cast would eat on set: at 10.30 a.m. the bacon roll trolley would come round, then there would be lunch, and tea and cake in the afternoon. Jacki felt very looked after.

Jacki remembers her co-star Frankie Howerd finding filming to be different compared to performing stand-up comedy – she didn't see any problem. Although he was known to have struggled with understanding why he was so funny, she always found him fun to be with on set. Although, she goes on to say, 'I think at 8.30 in the morning, everyone finds it hard to be funny.' Jacki also formed a close bond with Joan Sims; they often had tea together and hung out on set. Jacki felt Joan was one of the few actors who would stay in character, no matter what she was filming, so you always got to sit with a different version of Joan. 'She was always fun though. One of the best actresses we have ever had, too!'

Jacki also holds great affection for Nora Rodway who was her make-up artist. Jacki jokes now that she felt in the opening of the film she was made up to look like a young Charles Hawtrey, but Nora was a genius and managed to transform her into the beautiful jungle girl we later see.

Jacki was cast with Jim Dale in mind as romantic lead. However, Jim was unavailable. Instead she worked with Terry Scott, who she found to be extremely funny. Jacki always remembers him getting into character so well, so if he crashed

Jacki joined the team as June in *Carry On Up the Jungle* 'looking like the daughter Charles Hawtrey never had!'

One of Jacki's closest chums in comedy was Terry Scott, here together in a candid snap radiating pure fun and friendship in a break from filming *Carry On Up the Jungle*.

into a tree, he would go about walking with a limp – perfectly researched, like all of the cast. When Jacki rehearsed her scenes with Terry, they both decided that they should play their romantic scenes very realistically. Feeling that her scenes were quite risqué at the time, both Jacki and Terry felt that amongst all the comedy, 'It was important to have some tender bits in the middle, which can then highlight the comedy and balance everything out.' Although not everything went smoothly for Terry and Jacki. During the scene where they both have to use the swing and crash into the trees, Jacki had a hook on her bikini and Terry a hook on his loincloth. The rope pulled and hurt them, so at the end of the day they had to visit the studio nurse because they were so sore from rope burns.

Jacki also recalls fun with the gorilla, played by Reuben Martin. His costume was so heavy that his wife came on set to carry the head around. She was there so much they cast her as one of the Lubi Dubbis (seen picking up Frankie Howerd during the mating ceremony):

> The gorilla had very long claws and during the scene where he sits on my bed, I couldn't believe how heavy the costume was. It was years later, when I was working with the Two Ronnies at the BBC that an unexpected encounter happened. Whilst queuing for lunch a man came running up to me and said 'Are you Jacki Piper? My father went to bed with you!' It was Reuben Martin's son. This amused the Two Ronnies greatly. It's just my luck though. My only bedroom scene on screen is with a gorilla!

Producer Betty Box had also spotted Jacki's comic potential, casting her as the jilted girlfriend of Leslie Phillips in the denouement of *Doctor in Trouble* (1970). Peter Rogers was so taken with her that he 'actually put me under contract for three years which amazed me. I was known for theatre and I thought he must have been mad.' Indeed, Jacki was hard at work in the West End during this time, in *The Secretary Bird*, with Terence Longdon, and *Big Bad Mouse*, with Eric Sykes and Jimmy Edwards. 'Peter actually told me I was the only person he contracted for so long!' Even Jacki's agent couldn't quite believe his luck and said, 'Of all the contracts I've negotiated, this has been the simplest and most straightforward'. Still, Peter only used Jacki when the part was right, making lots of films – both comic and straight – during the three-year time frame and utilising her for three further *Carry On* films: *Loving*, *At Your Convenience* and *Matron*.

Jacki's on-screen husband/boyfriend was played by Patricia Hayes's son, Richard O'Callaghan.

Jacki takes a moment out for a publicity session during the filming of the closing wedding scene for *Carry On Matron*, on location at Denham Church, in Buckinghamshire.

Both brought a sense of charm and innocence to the team, taking forward the sweet dynamics she had created with Terry Scott in *Up the Jungle*. In fact, Richard always jokes that he was Jacki's first husband, marrying her in *Carry On Loving*. After completing the film, Jacki married her long-term boyfriend, Douglas. Then, during the filming of *Carry On Matron*, she fell pregnant with her first son. After the birth of her second son Jacki decided to give up the business for seven years, as she wanted to stay at home to look after her family. Looking back, she has no regrets, and the door was always open for her to return to the *Carry On*s if she wanted. By the time Jacki returned to acting, the *Carry On*s had ceased production. Jacki regrets missing out on all that fun, but obviously she feels she gained so much more with her family.

NINA BADEN-SEMPER

Hailing from Trinidad and Tobago, 24-year-old Nina Baden-Semper made her feature film debut as the startled member of the Nosha tribe in *Carry On Up the Jungle*. Don't blink else you'll miss her, disturbed with lover (Lincoln Webb) by butterfly enthusiast Charles Hawtrey. Producer Betty Box certainly didn't miss her, casting her as the Skyline Waitress in *The Love Ban* (1973). Of course, by then, Nina had become a comedy star, playing the delectable Barbie Reynolds, in the Thames Television sitcom *Love Thy Neighbour*. The series ran for four years, from April 1972, and spawned a hugely popular Hammer Films adaptation.

An early 1970s publicity pose for Nina Baden-Semper, when she was one of the country's best-loved sitcom stars in Thames Television's *Love Thy Neighbour*.

IMOGEN HASSALL (1942–1980)

The personification of the tragic starlet of the British screen, Imogen Hassall was a huge cut above the average bikini-clad actress. Hammer Films had recruited her as the latest in a long line of fur-clad prehistoric lovelies for *When Dinosaurs Ruled the Earth* (1970). Imogen was a divine but somewhat tormented beauty in *Carry On Loving*. Despite being in only one *Carry On* film, Imogen has remained fondly in our hearts.

Cheesecake shots of her *Carry On Loving* publicity session were eagerly used in *Parade*,

Weekend and *Titbits* (in the latter the readers were really spoiled, because shots of Jacki Piper were included too).

Her role as Jenny Grubb is an excellent portrayal of the evolution of women in the 1970s. When we first meet Jenny she is trapped in an ancestral home, with numerous family members trying to find her a husband. At the start of the film we meet a meek girl, who appears to be afraid of her own shadow. The family's treatment of her is almost Victorian in their sedate

approach to finding her a husband –
attitudes which were still around in the
1970s but dwindling rapidly. She can
only meet a man with a chaperone,
and there would be no meetings alone
until they are married.

If we explore what women were
up against in the 1970s, it does fit
rather well into the scene where Jenny
Grubb meets her match from the
Wedded Bliss Agency. Women were
still required to have a man's counter
signature to borrow money from the
bank. Jobs were advertised by gender.
Out of 650 Members of Parliament,
only twenty-six were women. Domestic violence
and marital rape were not considered crimes.
Marriage was only allowed between heterosexuals
and this was still romanticised as the high point
of a woman's life. It was not until 1975 that the Sex
Discrimination Act was passed along with equal
pay, which was phased in over the coming years.
Therefore, these attitudes in 1970 would not have
been too shocking for its audiences.

It is not until the end of Imogen's first scene,
when a disturbed Terry Scott leaves rather
quickly and we get a wink from Imogen straight
into camera, that we learn there's more to this girl
than meets the eye. She is clearly suppressed by
her family, and desperately wants to break out,
which she does, in more ways than one.

She returns later as a completely different
woman. No longer the meek and mild girl, but
a woman – much to Terry Scott's surprise. She's
moved out, got a job and is having fun. She has
entered the phase of the sexual revolution of the

Jenny Grubb (Imogen Hassall) doesn't have to try very
hard to convince Terry Philpott (Terry Scott) that those
falsies are not hers in *Carry On Loving*. They belong to
her flat mate Gay: 'she really is a flat mate!'

The absolutely stunning Imogen Hassall, fully
developed as model Jenny Grubb in *Carry On
Loving*. Few British film actresses have left such an
indelible impression on the audience with just one
single performance.

late 1960s and early 1970s. Women were demand-
ing more of their sexual freedom and control over
their bodies. So we see Imogen in a skimpy dress,
bursting out, showing off her own body, loud and
proud. This is a great example of how women
were taking control.

We later see Imogen living in a flat with other
models – a clear nod to the upcoming punk
movement where Debbie Harry and Siouxsie
Sioux would lead the way, although it took quite
some foresight for the writer to see that coming.
It's worth noting that whilst Imogen brings Terry
Scott back to her flat and is repeatedly telling Jacki
Piper, 'This is my night – Wednesday,' she is not
looking for marriage. She represents the women
looking for more sexual freedom and choice. By
hinting that it's 'her night', means that all of the
girls in the flat were entertaining various men
through the course of the week. Women were also
aware of the contraceptive pill, although initially it
was only available for women who were married.
Moreover, abortion had been legalised in 1967.
The friendship between the flatmates also shows

that women were talking more openly about their sexual experiences. Even Jacki Piper is seen waltzing around the flat in nothing but her underwear, as she's clearly in control of her own body.

Ultimately, though, attitudes still hadn't changed that much, and whilst the ladies all have their fun, by the end of the film we see Imogen finally married to Terry Scott. She doesn't look happy about it either, having given in to the goal for women in 1970 to get married. However, she'd had a taste of a freer life, so why does she give it up? At the time the film could only go so far with this story. Thanks to Imogen, and her small part in the *Carry On* films, she has played an important role in highlighting the changes and women's liberation movement.

After her all-too-brief stint with the *Carry On* team, Imogen carried on in various decorative roles on film and television, notably a rather bizarrely and very badly dubbed part as Maria opposite Roger Moore in *The Persuaders!*: 'Overture' (17 September 1971), and the leading role in the comedy film *White Cargo* (1973), with David Jason, as well as that dinosaur role for Hammer films, released just ahead of *Carry On Loving* in October 1970.

On stage, Imogen tried everything from a stint with the Royal Shakespeare Company,

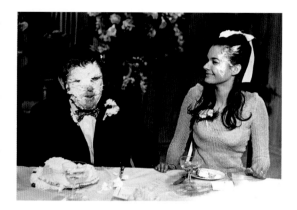

Getting mucky in the name of comedy: Terry Scott doesn't look too impressed during the cream-slinging final act of *Carry On Loving*, while Imogen Hassall seems to be enjoying herself immensely.

at the Aldwych, to pantomime – *Babes in the Wood*, in Bournemouth; all to undermine the moniker of the Countess of Cleavage. Still, her post-*Carry On* roles tended to be in farce: playing Julia Carrington in the 1973 tour of *The Mating Game*, and Diane Reaper in the 1975 tour of *A Bit Between the Teeth*, for Brian Rix. And Imogen truly loved the social whirlwind of first nights and film premieres. Richard O'Callaghan remembers his *Carry On* co-star 'as a poor little girl, rather lost, but terribly sweet'.

JANET MAHONEY

Janet Mahoney enjoyed a decade or so on stage and screen, fitting in perfectly with the swift jolliness of the Pinewood Studios comedies. She played Dawn Daily for Betty Box in *Doctor in Trouble*, and followed it up with her role as Gay, the flat-chested model in *Carry On Loving*. That boyish look, so in vogue in the preceding years, is gently mocked and usurped by the hourglass figure of Imogen Hassall. The role of Gay in the plot is the neurotic, jilted girlfriend of Julian Holloway, with the pistol-packing antics played out in the flat shared with Jacki Piper. A true moment of dramatic farce.

The daffodils were in bloom in the grounds of Pinewood Studios for the spring 1970 filming of *Carry On Loving*. Janet Mahoney's press publicity session took full advantage. It's a new dawn, it's a new day, it's a new decade …

Janet Mahoney seems deliciously unconcerned during this rehearsal of the tense loaded-gun scene in *Carry On Loving*. Julian Holloway and Jacki Piper are going for the full drama of the moment. The costume designs of Courtenay Elliott (1918–2001) scream now. Having joined the team with *Carry On Up the Jungle*, Courtenay worked on nine other *Carry Ons*, ending with *Carry On Emmannuelle*, as well as the Peter Rogers thrillers *Assault* and *Revenge*, and a Betty Box collaboration on *Doctor in Trouble*, which also saw her design for Jacki Piper.

MARJIE LAWRENCE (1932–2010)

So keen on a life on the stage was young Marjie that, from the age of 12, she started weekend acting lessons at the Birmingham Theatre School, going on to a three-year course at the Birmingham School of Speech and Drama. Repertory experience with George Dare's Norfolk-based company saw her hone her craft, performing a staggering thirty-six plays over an eight-week period. At the age of 21 she moved to London and auditioned for Joan Littlewood's Theatre Workshop company in Stratford, East London. Marjie got the job, and

met actor and presenter Harry Greene, whom she later married. The couple had a daughter – actress and presenter Sarah Greene.

Marjie and Harry were cast as a married couple in the Associated-Rediffusion soap opera *Round the Redways*. Marjie swiftly became an indispensable glamour feed for television's top comedians, including Arthur Haynes, Benny Hill, and Eric Sykes. Her film credits include *Only Two Can Play* (1962), with Peter Sellers, *On the Beat* (also 1962) and *The Early Bird* (1965), with Norman

Wisdom. The latter cast her as a sultry woman in a negligee, and it was inevitable that Peter Rogers would sign her up. In *Carry On Henry* she is a serving wench, with Terry Scott pinching her bottom. Eighteen months later she was back at Pinewood Studios, as Alma, in the Peter Rogers's film production of *Bless This House*.

British horror utilised Marjie as a couple of come-hither ladies of the night: as Dolly in Hammer's *Hands of the Ripper* and Annie in Amicus's *I, Monster* (both 1971), while she gave the sex comedy franchise her caretaker's wife in *I'm Not Feeling Myself Tonight* (1976).

Marjie continued to work and in 2004, despite suffering with ill-health, she had a bed-bound appearance in *Doctors*. A trouper who continued to *Carry On*.

'Oh, your Eminence!': Cardinal Wolsey (Terry Scott) gets handy with the obliging serving wench (Marjie Lawrence), much to the disapproval of Thomas Cromwell (Kenneth Williams). You never got this sort of raucous fun in *Wolf Hall*!

WENDY RICHARD MBE (1943–2009)

Wendy had cornered the market in cockney sweethearts with regular appearances alongside Hugh Lloyd and Terry Scott in *Hugh and I*, on BBC Television, between 1962 and 1966. She had also added all the choice putdowns to Michael Sarne's 1962 hit record *Come Outside*. If the truth be told, it was Wendy's cheeky and critical inter-actions that sold the disc. And everybody knew it. Further BBC comedy roles were forthcoming, including *The Likely Lads*: 'Last of the Big Spenders' (7 July 1965) and as Private Walker's spirited girlfriend in *Dad's Army*.

She cavorted with Frankie Howerd and the Beatles – what a combination – in the cut elocution lesson sequence in *Help!* (1965), and played 'Nurse with false eyelashes' in *Doctor in Clover* (1966). All

of which proved useful experience ahead of joining the *Carry On* team as Kate, the less-than-willing wench of the Admiral Benbow inn, for the 1970 television special *Carry On Again Christmas*.

She had quite a shocking role in *Carry On Matron* as the argumentative new mother Miss Willing, who moans about her baby: 'Yes, well if you run into the same bloke as I did, you can have one …' Indeed, premarital pregnancies were quite high despite what we might think of the 1970s and the boom of birth control.

Wendy Richard for *Carry On Matron* publicity in the autumn of 1971. The sexy pose is unrepresentative of her role, which involves a wet baby and an encounter with Sir Bernard Cutting (Kenneth Williams).

Shiver M'Timbers: Wendy Richard, as Kate, serving lass of the inn, is unimpressed with Long Dick Silver (Sidney James) in Dave Freeman's *Treasure Island* parody for the Thames Television *Carry On Again Christmas*, Christmas Eve, 1970.

Before returning to the *Carry On*s as beauty contestant Ida Downes in *Carry On Girls*, Wendy was cast as Miss Brahms in the 1972 *Comedy Playhouse*: 'Are You Being Served?' Her popularity in what would become a beloved sitcom, set in Grace Brothers department store, led to her being unavailable for *Carry On*s for the rest of the 1970s.

Are You Being Served? would run until 1985, with a summer season stage show and a feature film along the way.

Wendy was part of the original cast of *EastEnders*, playing the downtrodden but resourceful Pauline Fowler from 1985 to 2006. However, the soap didn't prevent her from returning as Miss Brahms for *Grace and Favour* in 1992 or

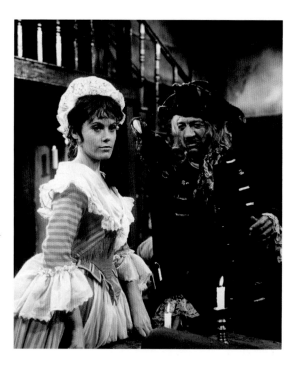

continuing to celebrate the legacy of the *Carry On*s in the 1998 documentary *What's a Carry On?*

CAROL HAWKINS

Carol-Ann Hawkins has provided decoration to an array of cult comedy and science-fiction, notably Hammer Films' *When Dinosaurs Ruled the Earth*, and some glamorous support for Patrick Allen in *The Body Stealers*, both 1969. Carol entered the *Carry On* universe at Christmas 1970 when she was one of Sid James's desert island lovelies at the very end of Thames Television's *Carry On Again Christmas*.

Her major break was her replacing of a reluctant Penny Spencer in the film version of hit London Weekend Television sitcom *Please Sir!*. As a result, Carol thought it worthwhile reminding Peter Rogers that she was ready and willing to *Carry On* again. On 6 March 1972, she wrote:

As I have recently completed the film *Please Sir!* and the comedy TV series *The Fenn Street Gang* playing the part of Sharon, I thought perhaps you would like a photograph of myself to keep in your files for future casting reference.

It worked. Not once, but twice, in that same year. In a matter of weeks, she was at Pinewood Studios, making *Carry On Abroad*.

Sidney James, very much the elder statesman and head of the family, enjoying a pipe and a lark with Sally Geeson and Carol Hawkins, during the filming of *Carry On Abroad*, on the Pinewood Studios backlot, in April 1972.

Sally Geeson played Carol's chum in *Carry On Abroad*. A sweet demure girl, who makes eyes at Brother Bernard (Bernard Bresslaw). As mentioned, she and Sally are the Yin and Yang, just like Liz Fraser and Dilys Laye in *Cruising*. Of course, Carol's character takes an interesting look at women. She falls for a seminarian. Why? Maybe because he's gentle and dashingly handsome. Moreover, Carol's character is so sweet, why wouldn't she fall for a man just as sweet and kind as her? Naturally, she drives him to give up his vows (and let's face it, he's not exactly cut out for the priesthood) and by the end of the film they are an item. It's less *Thornbirds* and more romantic fairy tale.

In the summer of 1972 Peter Rogers cast Carol in *Bless This House* – notably drafting in Terry Scott and June Whitfield as the new neighbours, with Peter Butterworth stepping in for Trevor, as played by Anthony Jackson on television.

In 1975 Carol was back with the *Carry On*s on film and television. While producer Betty Box had Carol trying to seduce Leigh Lawson in *Percy's Progress* (1974), Carol performed a striptease, much

Intense fun: Bosom Buddies Carol (Sherrie Hewson) and Sandra (Carol Hawkins) under canvas for the caravanning romp *Carry On Behind*. As the poster tagline screamed, it was big screen comedy: '... with the '76 touch!'.

to the dismay of Leslie Phillips, in Ray Cooney's *Not Now, Comrade* (1975). A firm favourite of Cooney, Carol excelled in *Run For Your Wife*. Carol is proud to be part of the *Carry On*s: 'Laughter is so important. It's kind of healing.'

LINDA REGAN

The daughter of influential talent scout and agent Joe Regan, Linda was youthful and eager when she first joined the *Carry On* team, as an Island girl on Sid James's seasonal treasure island for the 1970 television special *Carry On Again Christmas*. She had bewitched Bob Grant in a miniskirt – Linda wearing it, not Bob – in the opening scene of Hammer Films' *On the Buses*, the company's biggest money-spinner on the home market.

Linda also appeared in *Confessions of a Pop Performer*, the second in the series that was proving a threat to the 'nudge, nudge, wink, wink' style of the *Carry On*s. When the film was released in the summer of 1975, full-frontal nudity peppered with innuendo was becoming the house style for Peter Rogers and the *Carry On*s too. *Carry On Behind*, released that December, was a distinct wobble towards that; while *Carry On England*, set for production in spring 1976 factored in topless

Uniform on, and hair up for the 1940s look, to play Private Taylor, in *Carry On England*. 'It's funny,' says Linda. 'Looking at that photograph I look very much like I did in the lovely black and white war film in the *Hi-de-Hi* episode 'Only the Brave', ten years later. I've been very lucky. I've worked with master craftsmen of comedy. You can see the fun in every frame.'

It pays to advertise: Linda Regan wrapped up in the Union Jack, and little else, for *Carry On England* publicity. Pinewood Studios, May 1976.

scenes which would not just be a quick flash but bosoms proudly on display. Linda jokes now that they got their 'pound of flesh for a few quid' but was happy to go along with it.

Of course, it was on *Carry On England* that Linda worked with Kenneth Connor, who would take over from Leslie Dwyer as the children's entertainer in *Hi-de-Hi*. Connor played the new character Sammy the Tramp, whilst Linda was sweet Yellowcoat, April. Linda had missed out on joining *Carry On England* co-star Diane Langton in the revival of *The Rag Trade*, as she turned it down because she couldn't resist the opportunity of working with a stellar cast of comedy greats for *Adventures of a Private Eye* (1977): settling down to breakfast with Liz Fraser, Harry H. Corbett and Anna Quayle. Linda is now a respected and bestselling crime novelist.

SHIRLEY STELFOX (1941–2015)

Shirley signed up as the Bunny Girl waitress in *Carry On At Your Convenience* for a one-day fee of £50 and a contract that noted 'the artist understands that there will be a degree of nudity as indicated in the script'. Minor nudity, for sure, but a great gag: Bernard Bresslaw and Kenneth Cope debating the pros and multiple cons of life as a topless server …

With Jacki Piper's skirt already ripped off, Roger (Julian Holloway) whips off the bra of the Bunny Girl waitress (Shirley Stelfox) in this deleted scene from *Carry On At Your Convenience*. Lindsay Hooper plays the disgruntled date, while Bill Pertwee can be spotted. Cast as the manager of the Whippit Inn, Pertwee's entire performance was cut from the final print. Sheila found comedy fame as Rose, sister to Hyacinth Bucket, in the first series of *Keeping Up Appearances*, and was married to *Carry On Columbus* actor Don Henderson.

ANOUSHKA HEMPEL

Anouska came from New Zealand and is now distinguished property designer Lady Weinberg, most notably creating the, now sadly demolished, minimalist Hempel Hotel, off Hyde Park. Rather wonderfully, in between she enjoyed a brief but brilliant career as proper 1960s/70s girl, Anoushka Hempel. Anoushka clocked up the holy trinity too: as Bondian 'Angel of Death' in *On Her Majesty's Secret Service* (1969); as vampiric victim in Hammer Films' *Scars of Dracula* (1970); and as a *Carry On* lovely. She is uncredited but never unnoticed, popping up right at the very end of *Carry On At Your Convenience* as the new canteen girl, cheerfully admitting that on the day she was employed the firm of W.C. Boggs went on strike. So saying, she unwittingly prompts militant union man Vic Spanner (Kenneth Cope) to return to work. Lust conquers equality. The end.

The resolve to strike with Vic Spanner (Kenneth Cope) evaporates as soon as he spots the new canteen girl (Anouska Hempel) in the rousing climax of *Carry On At Your Convenience*.

ZENA CLIFTON

There's something deliciously wholesome and sultrily sexy about Zena Clifton. A starlet that burned bright in her two *Carry On* appearances; as the saucy au pair girl in *Carry On Matron* she is ready, willing and able to jump into bed with Mr Darling (Robin Hunter) when his wife, Jane (Valerie Leon) is rushed off to hospital to give birth to triplets! And in the spring of 1973

Zena was back with the gang in *Carry On Girls*, as Scots stunner Susan Brooks or, as a sneezing Peter Potter (Bernard Bresslaw) announces her: 'from Bonnie Scot – *[sneeze]* – land …' Slipping and sliding down that theatre slope, bombarded by the women's libbers, but still keeping her smile and most of her footing, it's a snapshot of social history … played out as a raucous farce.

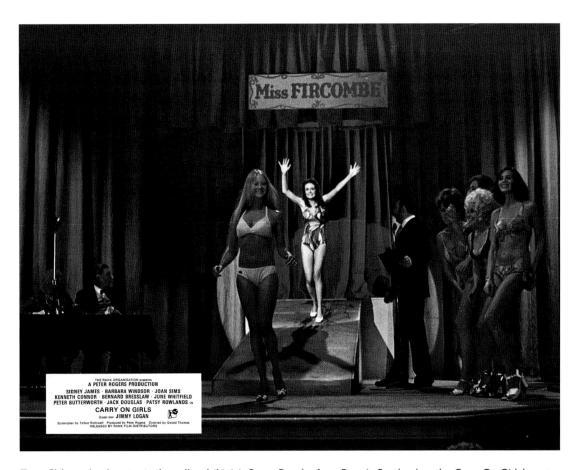

Zena Clifton, dead centre in the yellow bikini, is Susan Brooks, from Bonnie Scotland, as the *Carry On Girls* beauty contest goes horribly wrong. Bernard Bresslaw announces Eileen Denby (Laraine Humphrys), skidding on to stage, to join fellow suffering contestants Margaret Nolan, Valerie Leon, Barbara Windsor and Angela Grant.

MADELINE SMITH

One of the most beautiful of beautiful people, doe-eyed Maddy Smith was an advertising model who broke into British comedy as part of Bernard's relentlessly jolly repertory company for the Thames Television sketch show *Cribbins*. Her stage debut was in *Blue Comedy*, in Guildford, in 1970. Her early television comedy credits went on to include the Yorkshire Television sitcom *His and Hers*, in which she played Janet Burgess, the wife of Tim Brooke-Taylor; LWT's *Doctor at Large*, in which she played Sue Maxwell, the daughter of Arthur Lowe; and *On the House*, also for Yorkshire Television, in which she played Angela, and ended up sitting on the lap of Kenneth Connor. And he got paid for it …

Soon afterwards, Maddy was cast as Erotica in the 1971 feature film spin-off of *Up Pompeii!*; and returned for the Great War hi-jinks of *Up the Front* (1972), gleefully teasing the roving-eye and roving-hand of Bill Fraser, as Groper!

In between shooting those two films with Frankie Howerd, Maddy joined the *Carry On* team in *Carry On Matron*:

> It was only half a day, no more, but I look back on my time filming *Carry On Matron* as one of the most enjoyable roles I was ever lucky enough to get. Peter Rogers was the most charming of men, and Gerald Thomas made that set the happiest I have ever known. There was love in every corner, and no messing about. At all. Hattie Jacques and Barbara Windsor knew exactly what they were doing. They walked on set, and we filmed it. Job done. I was always much more at home in comedy. Rather than all that horror I was doing at the time.

The porcelain beauty of Madeline Smith as the delectable new mother Mrs Pullitt in *Carry On Matron*. Sweetly convinced there is something wrong with her baby boy's 'little thing', she pleads for assistance from Matron and Nurse Ball …

The role of Mrs Pullitt was slightly longer in the script. When she frets about her newborn son's 'little thing' being all 'bent to one side', she cheekily observed that it was 'unlike his father's'. This last comment was considered far too naughty by the British Board of Film Classification and was cut. With such a sense of humour, it is unsurprising that Maddy was welcomed into the *Carry On* team.

Maddy remembers that she was well chaperoned and looked after: 'Never once did I feel

exploited at all. It was pure joy!' Her only regret is that it was over so quickly, but she was asked to go back if she wanted to. She heard that they wanted her for one of the girls on holiday in *Carry On Abroad*, but she certainly didn't want to have taken a job away from either Sally Geeson or Carol Hawkins because, as she says, 'They are both lovely, very talented girls.' Although, Maddy jokes:

Maybe they could have made it *three* girls on holiday. That's wishful thinking on my part, of course, but that would have been huge fun. It's more than fifty years ago now, and people still ask me about the *Carry On*. They are fascinated by them, and I'm so chuffed to have been a very tiny part of it all. It really is a tangible legacy of laughter.

A valued part of Hammer Glamour, with roles in *The Vampire Lovers*, and *Frankenstein and the Monster from Hell*, Maddy joined the ranks of James Bond girls as Italian agent Miss Caruso in *Live and Let Die*. Maddy chuckles at the thought that James Bond and *Carry On* have given her ever-lasting cult status: 'I adored the *Carry On* people, of course,

... who reassure her that 'everything will be straightened out' by the time she leaves. Ooh Matron!

but you couldn't compare them to James Bond. *Carry On* was bed and breakfast. Bond was the Ritz.' However, it is comedy that remains closest to Maddy's heart, following her *Carry On* assignment with work for Betty Box, playing Miss Partridge in *The Love Ban* and a gloriously forthright Miss UK in *Percy's Progress*. Moreover, she would tease the heck out of Leslie Phillips in *Casanova '73*; Terry Scott in *Happy Ever After*; and Frankie Howerd in *The Howerd Confessions*, in which she played a buxom nurse. Once a *Carry On* girl, always a *Carry On* girl!

LAURA COLLINS

A bundle of fresh-faced energy and coy sexuality, Laura Collins had already been a frequent visitor to the *Carry On* set before her appearance as a nurse in *Carry On Matron:*

> Yes, my dad was part of the orchestra that Peter Rogers often employed for his films. They were featured, in-vision, during the now very famous dinner party climax of *Carry On … Up the Khyber*, and I was there. A witness to history. And film history!

Laura's appearance in *Carry On Matron* saw her enjoy a lovely little scene with Kenneth Williams, as surgeon Sir Bernard Cutting, and Wendy Richard, as new mother Miss Willing! Laura remembers:

> It was such a thrill to be on that set, with such professionals. It was only a tiny little part but I'm so proud of my association with the *Carry*

Already a *Carry On* girl, and celebrating her twenty-first birthday in style, the ever vivacious Laura Collins.

*On*s. And I'm in the trailer for the film too, which is just lovely to see.

GAIL GRAINGER

Actress, dancer and model Gail Grainger skilfully stepped into the vacancy left by Valerie Leon's absence in *Carry On Abroad* and made the role not only her own, but also a firm fan favourite ever since. At the time of filming, Gail had been playing opposite Leslie Phillips in *The Man Most Likely To …* at the Duke of York's Theatre in London's West End. Gail had played Madame Gerda in the stage presentation of *The Avengers*, which Leslie

had directed at first in Birmingham and later at the Prince of Wales Theatre in London in 1971.

That secure gaze down the lens, sat atop an office box file, tells you everything you need to know about Gail Grainger's performance as Moira: a gorgeous and independent woman completely in control of her sexuality. Kenneth Williams is in mid-gurn for a *Carry On Abroad* scene that Gail already seems to know will hit the cutting-room floor.

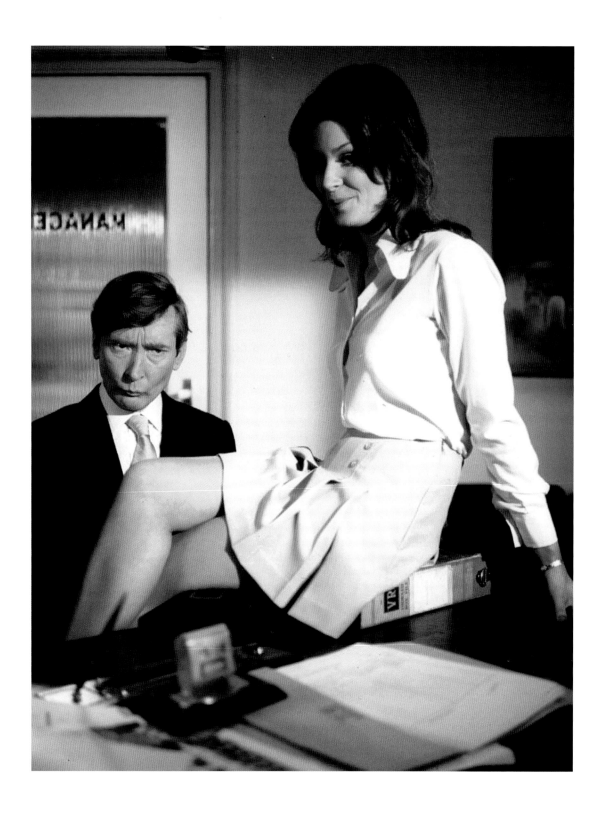

Leslie was so impressed that Peter and Gerald's old favourite cad gave the *Carry On* people a tip-off as to just how good Gail was. Certainly, the *Carry On* filming and publicity machines gave plenty of leeway and respect of her professionalism for commitments to Friday and Saturday matinees for the stage show. Leslie was a vibrant champion of her talents, getting her a supporting role as Clare in his Ray Galton and Alan Simpson scripted sitcom *Casanova '73*.

Subsequent acting work included episodes of *The Sweeney* ('Sweet Smell of Succession') and *Butterflies* ('Lunch with Leonard'). She is also in the 1979 martial arts film *Jaguar Lives!*, in which she plays Consuela, alongside snarling villainous turns from Christopher Lee and Donald Pleasance.

She left acting to concentrate on her successful career as an interior designer, happily fading from show business, before being lured to her first *Carry On* convention in 2023.

OLGA LOWE (1919–2013)

One of the oldest and dearest friends of Sid James, it was Olga Lowe who got him his first film break in 1946. Fresh off the boat from South Africa, she persuaded him to go and see the producer of *Black Memory*, Oswald Mitchell. Olga and Sid remained friends, and were happily reunited on the Pinewood set of *Carry On Abroad* in 1972. And it was Olga who was on stage at the Sunderland Empire when Sid collapsed and died during a performance of *The Mating Season*, in April 1976.

Dear Old Pals: Sidney James and Olga Lowe as Madam Fifi, reunited at Pinewood Studios, in April 1972, for the making of *Carry On Abroad*.

BRENDA COWLING (1925–2010)

Very much an ersatz Hattie Jacques in her first role in the series, as the maternity ward matron in *Carry On Girls*, Brenda Cowling plays the role with that same air of determined professionalism and no-nonsense authority.

In the legendary episode of *Fawlty Towers*: 'The Germans' (24 October 1975), Brenda is yet again the hospital matron, successfully tapping into that collective consciousness of exactly what a hospital matron should look like. The comic observations

of John Cleese are cruel indeed, as he gazes at her and mutters, 'My God you're ugly aren't you?', although the comedic lapse is more to do with his recovering from a concussion rather than malignant spite. Still, the knock on the head removes the filter. She even played a matron again in the television series of *The Secret Diary of Adrian Mole aged 13 and ¾* in 1985.

Brenda was back for *Carry On Behind* in 1975, cast in the role of 'wife'. She had become a beloved member of the David Croft and Jimmy Perry repertory company, most notably playing the dogged and stoic, but still occasionally sensitive, cook and housekeeper, Mrs Lipton, in the BBC sitcom *You Rang, M'Lord?*

LARAINE HUMPHRYS

Born in Guinea and brought up in Barbados by her English father and Canadian mother, Laraine came to London to train at the Elmhurst Ballet School – although she soon became more interested in the drama lessons. She made her stage debut as Wendy in *Peter Pan*, before supporting Jean Simmons in *Say Hello to Yesterday*. Her first major film role was at the age of 17, when she was cast as Flavia, the handmaiden to Voluptua (Julie Ege), in the big screen presentation of *Up Pompeii!* At the time, Laraine was living with her parents and her brother in Woking and explained that she was 'a party bird, who loved buying clothes, dancing, and pop, and that there were too many boyfriends about to choose from!'

Laraine joined the *Carry On* team to play beauty contestant Eileen Denby in *Carry On Girls*, a saucy shopper in the 1973 *Carry On Christmas*, and a Bird of Paradise in *Carry On Dick*.

Laraine Humphrys knows exactly what's going on behind her back, and conquers the male gazes of Bernard Bresslaw, Sidney James and Kenneth Connor, in a playful publicity break from shooting *Carry On Girls*, at Pinewood Studios.

PAULINE PEART

Having won the title of Miss Jamaica in 1966, Pauline moved to England to find work as a model and an actress. Her two best-loved film appearances were both released in 1973: as one of Christopher Lee's victims in Hammer's *The Satanic Rites of Dracula*; and as beauty contestant Gloria Winch in *Carry On Girls*.

Later notable comedy roles included Arthur Lowe's secretary in Hammer's *Man About the House*, and Nicholas Courtney's companion in *The Galton & Simpson Playhouse*: 'Cheers!' On stage, she joined those splendid farceurs John Inman and Jack Douglas in *When the Wife's Away*.

Barbara Windsor happily seated with the old guard, Bernard Bresslaw, Sidney James, Joan Sims and Peter Butterworth, rather than being lined up with the glamorous *Carry On Girls*: Caroline Whitaker, Barbara Wise, Mavis Fyson, Pauline Peart, Carol Wyler and bountiful Margaret Nolan.

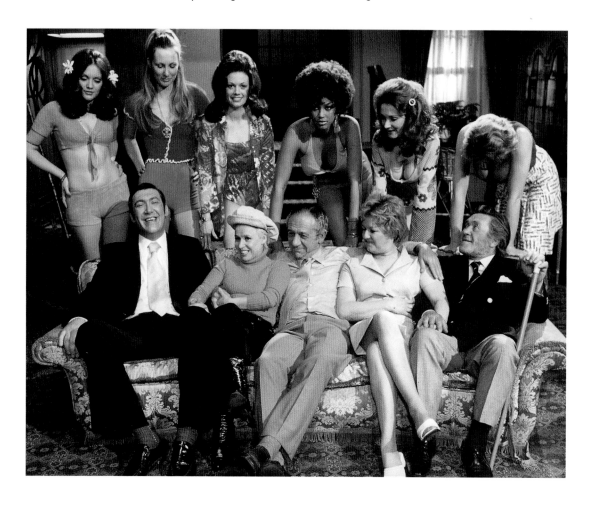

LINDA HOOKS

Liverpudlian beauty Linda Hooks was named Miss Great Britain in 1972 and inevitably was earmarked for stardom. Linda certainly fitted the bill for the *Carry On*s and although she somehow missed the casting call for *Carry On Girls*, she was one of the four Birds of Paradise under the watchful eye of Joan Sims in *Carry On Dick*. Much more than just a pretty face, she joined the team for the ATV television series *Carry On Laughing*, and played a handful of memorable glamour girls and sultry serving wenches. Shot at the tail end of 1974 for a January 1975 launch, Linda first appeared in 'The Baron Outlook' as Rosie the goose girl. For the spring of 1975 the gang were back at Pinewood Studios to shoot *Carry On Behind*, where Linda was primed

Sexy. Stoic. And successful. Linda Hooks embodies the essence of the 1970s *Carry On* girl: here, happily out of her historical garb and even more happily slipping out of her stylish contemporary attire, for Pinewood Studios garden publicity during the making of *Carry On Dick*, in March 1974.

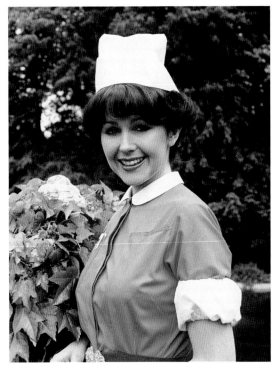

Here, in character as a 1940s military nurse, in the twenty-eighth film in the series, *Carry On England*. As the poster tagline had it: 'It's the biggest BANG of the war!' Yes! Yes, it is!

to be one of the great clichés of *Carry On* comedy: the seductive nurse. In tandem with dashing George Layton, last seen as Doc on the Box Paul Collier in London Weekend Television's *Doctor in Charge*, Linda throws herself into her cheeky role, lovingly tending to the supposedly injured Kenneth Williams, before the good doctor ascertains the blood spurting from his wound is, in actual fact, tomato sauce. The tomato sauce, tomato ketchup, what's the difference debate, ushers in Linda's giggling interjection: '2p a bottle!' That's it, but beautifully played.

It's hardly surprising that Linda was back, in a nurse's uniform, exactly one year later, to aid and abet doctor Julian Holloway in *Carry On England*. The military angle makes no difference to this self-confident, unflappable wartime angel of mercy.

Having made a delightful Nellie in the *Carry On Laughing* episode 'One in the Eye for Harold', Linda was back with the team, in Scarborough, for the 1976 summer season show of *Carry On Laughing* – typically scantily clad and throwing herself into the rollicking farce as Hilde.

After appearing as a glamorous alien or two in *Space: 1999*, the luscious Linda retired from show business …

The gorgeous Linda Hooks, in 1976 civvies, in the grounds of Pinewood Studios, during the production of *Carry On England*. Over an intensive three-year period she was a near constant *Carry On* girl, and little wonder.

The lavish West End stage revue *Carry On London!* was performed at the Victoria Palace and headlined glamorous guest vocal stars Trudi Van Doorn (1950–87) and Lynn Rogers. Trudi was a regular on *The Benny Hill Show*, she had appeared in the Betty Box science-fiction romance *Quest For Love*, and would go on to decorate comic romps *Not Now, Darling* and *Queen Kong*. Lynn was an Australian-born torch singer who had had late 1960s hits with *Just Loving You* and *Ask Anyone*. In the wake of her *Carry On* success, Pye Records released her recording of *Where is Tomorrow*.

PENNY IRVING

Penny had only joined the team for one appearance, as one of the four beguiling Birds of Paradise in *Carry On Dick*, but the publicity department were quick off the mark to snap her in various, decidedly contemporary, states of unbuttoned cheesecake shots in and around Pinewood Studios. A shapely Scots lass, Penny was born in Paisley and readily exposed her 34-20-34 measurements. She moved to London with her parents as a youngster, left home at 16 and spent six months in Australia before getting homesick and returning to England. She starred in Pete Walker's exploitation horror films, memorably *House of Whipcord* (1974).

Following the completion of *Carry On Dick*, Gerald Thomas recommended her to his film director brother, Ralph Thomas. He immediately cast her as the continental bordello-working lovely Chiquita, who, in a world where impotency has affected every man on the planet save one, eagerly beds new boy Leigh Lawson in *Percy's Progress*.

On television, she was a favourite of David Croft, playing Young Mr Grace's sexy secretary Miss Nicholson in *Are You Being Served?* and in the 1977 feature film version. She decided to relinquish her part because she became more and more uncomfortable with the sexualisation of the role, but she happily returned to the Croft stable for the first series of *Hi-De-Hi!* in 1980, as Scottish Yellowcoat Mary. A lover of fine wine and good food, Penny lived for speed, with her passion being motor racing. She even took flying lessons at Biggin Hill Airfield.

Penny Irving, photographed at Pinewood Studios, during a break in making *Carry On Dick*. A favourite of producers Peter Rogers and David Croft, she would give her most revealing comedy performance for Betty Box, in *Percy's Progress*.

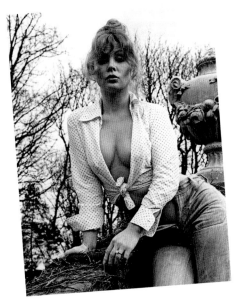

A sultry pose – out of her Birds of Paradise costume – for *Carry On Dick* promotion. The tied shirt and unbuttoned jeans signalling this was destined for a 1970s glamour magazine such as *Titbits*, and assured male interest in the upcoming release of the film.

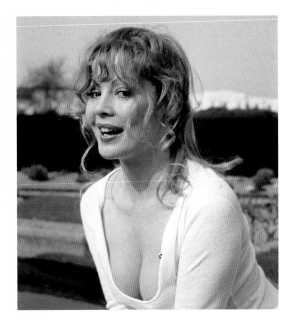

EVA REUBER-STAIER

Hailing from Bruck an der Mur, in Austria, Eva won the title of Miss Austria and took part in the 1969 Miss Universe contest and won that year's Miss World. As a result, she toured South Vietnam war zones with Bob Hope for the United Service Organizations Incorporated. Eva married film director Ronald Fouracre in January 1973, and was gleefully cast as one of the Birds of Paradise in *Carry On Dick*. In 1977, she was back at Pinewood Studios, as KGB operative Rublevitch, the inscrutable assistant to General Gogol (Walter Gotell), in the James Bond film *The Spy Who Loved Me*. Eva reprised the role in *For Your Eyes Only* (1981) and *Octopussy* (1983). Ronald Fouracre died that same year. Now married to publisher Brian Cowan, Eva lives in happy retirement from show business, producing sculptures in metal; occasionally exhibiting her work, notably at the Hertfordshire Visual Arts Forum, in 2008.

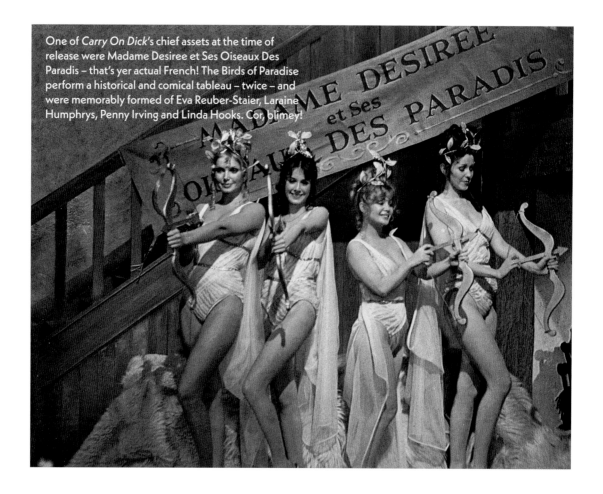

One of *Carry On Dick*'s chief assets at the time of release were Madame Desiree et Ses Oiseaux Des Paradis – that's yer actual French! The Birds of Paradise perform a historical and comical tableau – twice – and were memorably formed of Eva Reuber-Staier, Laraine Humphrys, Penny Irving and Linda Hooks. Cor, blimey!

PATSY SMART (1918–1996)

Patsy Smart happily and successfully personified the silly old crone in British film and television for decades. Even her uncredited turn as the mother in the Norman Hudis-scripted thriller *The Flying Scot* (1957) seemed a little long in the tooth.

On television, she was Miss Jenks in four episodes of *Hugh and I*, and proved a popular stooge for Tony Hancock in *Hancock*: 'The Night Out' (28 February 1963), and *Benny Hill*: 'The Mystery of Black Bog Manor' (30 November 1962) and 'Cry of Innocence' (7 December 1962). She notched up a handful of episodes of *Happy Ever After*, and was Matron Edwards in *Doctor in Charge*: 'The Fox' (18 June 1972). She was also best loved at the time as Miss Roberts in *Upstairs, Downstairs*, a role she played from 1971 until 1973.

Her one and only *Carry On* role was typical: credited as Old Hag in the *Carry On Laughing* episode 'One in the Eye for Harold'. More of the same followed: most notably as an Old Maid in Walt Disney's *One of Our Dinosaurs is Missing* (1975); servant Mrs Japonica in *The Pink Panther Strikes Again*; a Village Gossip in *The Bawdy Adventures of Tom Jones* (both 1976); and a career high point as a Ghoul in *Doctor Who*: 'The Talons of Weng-Chiang' (1977). Patsy's entire career was summed up in one scene, when she discovers a dead body in the London docks. 'Make an 'orse sick that would!' she stammers. Well, quite. Love her.

ELKE SOMMER

An ice-cool international glamour icon is not the totally expected addition to the glorious caravan romp of *Carry On Behind* but the headlining recruitment of Elke Sommer – the first actress since Shirley Eaton to be given top billing in a *Carry On* – was a natural one indeed. Not only had she proved she had a wicked, self-deprecating sense of humour, opposite Peter Sellers in the second Inspector Clouseau classic *A Shot in the Dark* (1964) and Bob Hope in the pastiche of American commercialism *Boy, Did I Get the Wrong Number* (1966), but she had swiftly caught the eye

Kenneth Williams was utterly charmed by Elke Sommer, and the mutual professional respect and shared thirst for knowledge radiates throughout their gloriously mismatched double act in *Carry On Behind*. Here on location, in Maidenhead, Berkshire.

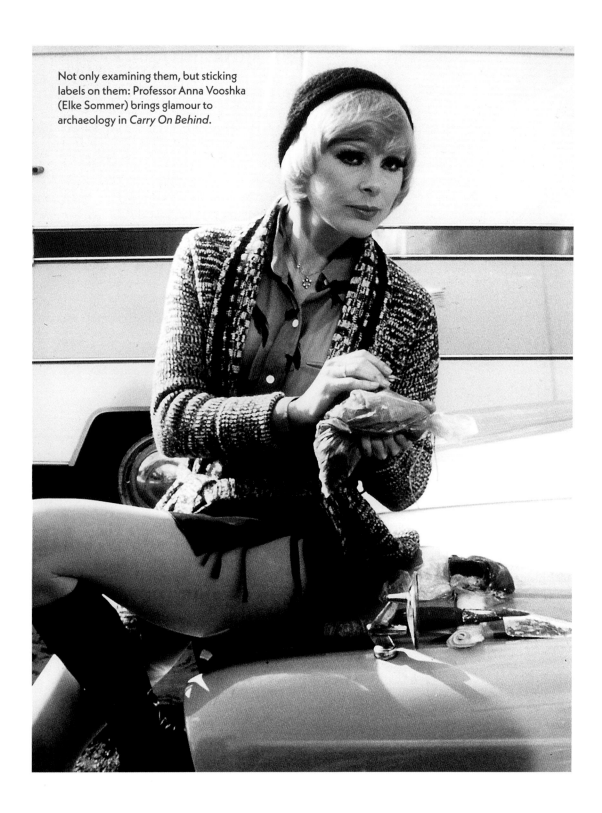

Not only examining them, but sticking labels on them: Professor Anna Vooshka (Elke Sommer) brings glamour to archaeology in *Carry On Behind*.

and heart of *Carry On* creator Peter Rogers when she co-starred with Richard Johnson in *Deadlier Than the Male* (1967), Betty Box's second Bulldog Drummond film. Elke made her stage debut in 1970, starring in the musical *Irma La Douce*, and the following year made her first appearance at the Drury Lane Theatre, Chicago, playing Stephanie Dickinson in the comedy play *Cactus Flower*.

Elke married Hollywood newspaperman Joe Hyams, who had befriended and interviewed such legends as Spencer Tracy, Frank Sinatra, Lauren Bacall and Humphrey Bogart. His 1966 biography, *Bogie*, had been a big success, and while Elke was filming the *Carry On*, Hyams was promoting his latest book, *Bogart & Bacall: A Love Story*. The Hyams remained friends with Betty and Peter. Marriage made all the difference to Elke:

> I like men. I would much rather be surrounded by men than women. At my school in Germany, boys outnumbered girls by 500 to 2. All my life I have fought against a belief that other girls are more intelligent and more beautiful than myself. It is only since my marriage that I have got over this lack of self-confidence. To me, being married means being a complete woman to my man.

Elke was chatting on the Pinewood Studios set of *Percy's Progress* (1974), her third film for Betty Box and Ralph Thomas, and their raucous sequel to their penis-transplant comedy *Percy*:

> I came back to London to play a guest role in *Percy* for the same company [as *Deadlier Than the Male*]. The follow-up, I think, is perhaps saucier than we were allowed to be three years ago – and it has a very funny script.

Original star Hywel Bennett had given way to Leigh Lawson, and the supporting cast was rich indeed: from Harry H. Corbett as a Harold

Elke Sommer in discussion with her director, Gerald Thomas, during the making of *Carry On Behind*. The close-knit Pinewood crew all respected her, and even Kenneth Connor – who had been in the films from the very beginning – looks on admiringly.

Wilson-inspired Prime Minister to confirmed anglophile Vincent Price as a mad doctor.

Elke's part, as Anna Vooshka, in *Carry On Behind* was written especially for her, relishing the European misunderstanding and misconception for full-on innuendo clout. In her contract it stated: 'Miss Sommer will not be required to speak any offensive language or commit any pornographic act or appear nude.'

It was further noted that 'the reference to appearing semi-nude should be deleted', simply because no one seemed to know at what state of undress one became semi-nude!

Not that any such dilemma would have bothered Elke. This was something she had been used to and at ease with in Hollywood:

> I know many of the parts I play have been saucy. But what is wrong with that? I do not mind them. It is possible to feel free and comfortable without clothes. There is nothing to be ashamed of if these scenes are done well and are in good taste. Sometimes they can be very beautiful.

Not that Elke had anything to worry about on the *Carry On* set. Her only bedroom scene was with a very reluctant Kenneth Williams, and it was Elke who was doing all the pursuing. No, the only nudity was some rather fetching, low-cut negligee and that final flash of cheek – right, lower – at the very end of the film. The result? A ripe ''Ere, no. Stop messing about!' from Kenneth, and all was right in the *Carry On* world.

Speaking of her co-star Kenneth Williams, she said:

> Listening to him talking, one would think he was a real-life professor. He even knows the German words of every verse of one of our most famous old songs, 'Die Lorelei' word perfect – which is more than I do. He is a real mine of information.

Elke summed up her *Carry On* experience by saying:

> Before I started I was quite nervous … I thought they had all worked so often together it would be difficult for an outsider to break in … However, I felt like one of the family after only the first day and even when I wasn't acting I was standing on the set laughing at all the others … I learnt a lot about life and people on *Carry On Behind* and never had so much fun in my life while I was doing it.

After completing work on *Carry On Behind* she returned to the stage, in Chicago, to star in *Ninotchka*, the comedy that Greta Garbo had filmed in 1939 and Betty Box had reworked as *The Iron Petticoat* (1956) with Katherine Hepburn. In 1976 Elke was set for a role in the proposed and never made Peter Rogers production *We Have Ways of Making You Larf*, a prisoner-of-war comedy that would have starred Ronnie Barker, John Cleese, John Thaw, Richard Briers and John Inman. Instead, she went on location to South Africa with Patrick Mower to film *One Away*.

Elke reunited with Peter Sellers for the 1979 comedy version of *The Prisoner of Zenda*. Thereafter she has thoroughly enjoyed splitting her time between Hollywood and making films back in Germany.

SHERRIE HEWSON

Sherrie was a proactive member of the Burton Joyce Players before enrolling with the Midland Academy to study drama and poetry. A scholarship to the Royal Academy of Dramatic Art followed, before making her television debut in the double 1971 episode of *Z-Cars*: 'Grandstand Finish'. Also that year, she played Anna's servant in the *BBC Play of the Month*: 'Rasputin' and as Charity Ablewhite in *The Moonstone*. She then played Christine in *Thirty-Minute Theatre*: 'Ronnie's So Long at the Fair' (26 October 1972).

In the spring of 1975, she was cast as Carol in *Carry On Behind*, joining Carol Hawkins as yet another friendship couple on holiday.

After the film was wrapped and well before it hit British cinemas for the Christmas of 1975 – with its cheery New Year tag: 'with the '76 touch' – Sherrie was back full-time with the gang for

Holidaying hunnies Sandra (Carol Hawkins) and Carol (Sherrie Hewson) rebuff the corny chat-up lines of butcher Fred Ramsden (Windsor Davies), in *Carry On Behind*.

the second batch of *Carry On Laughing* episodes for ATV. Jack Douglas and Kenneth Connor re-teamed as the 1920s crime-busting duo Lord Peter Flimsy and Punter – loosely modelled on Lord Peter Wimsey and Bunter, of course – and Sherrie accepted good featured roles in both 'The Case of the Screaming Winkles' and 'The Case of the Coughing Parrot', as well as affectionately sending-up Lesley-Anne Down's performance as Georgina Worsley and relishing the social history of the *Upstairs, Downstairs* pastiches:

> I was so happy to be in the *Carry On* team. It was an absolute thrill. I spent most of my time just watching how good everybody else was, and trying my best to fit in with the fun.

Sherrie's stint as part of the *Carry On* team may have been done and dusted in just that one year of 1975 but in her film contribution she happily

relishes the theme of girlfriends having a good time on holiday.

Since then she has done the lot: soap opera queen in *Coronation Street*, bestselling author of *Nana's Kitchen* and show-business personality as a regular on *Loose Women*. Still, it is always comedy Sherrie loves best. She inherited the spectre of Mollie Sugden's pussy when she played Mrs Slocombe in *Are You Being Served?* and also appeared as a regular in *Benidorm* as Joyce Temple-Savage, the manager of the Solana Hotel. Still Carrying On with the same spirit as she had during her time as part of the *Carry On* team.

There's something mysterious going on in *Carry On Laughing*: 'The Case of the Screaming Winkles', but Admiral Clanger (Peter Butterworth) doesn't seem bothered, just so long as gorgeous Nurse Millie Teazel (Sherrie Hewson) is near by. The second episode of the second series, it was originally transmitted on 2 November 1975.

ADRIENNE POSTA

Adrienne, as she says in her own words, 'joined the pop parade at the ripe old age of 16', although she was already something of a performing veteran, having attended stage school from the age of 6 and made her film debut, in *No Time for Tears*, aged 7. By the time she was 12, Adrienne was starring as Helen Keller, in *The Miracle Worker*, at the Wyndham's Theatre.

That pop hit, *Something Beautiful*, had resulted from bumping into songwriters Roger Atkins and Helen Miller while on holiday in America. Adrienne became an integral part of the late swinging sixties revolution of flower power, freedom, and psychedelic fashion. She was cast as pivotal schoolkid Moira Joseph in *To Sir, With Love* (1967) and, on television in 1973, supported the star of the show in the variety spectacular *It's Lulu*. In 1968, Adrienne personified the sexual

A breath of 1970s hip in the shape of pop icon Adrienne Posta. For a brief spell, Adrienne seemed to be the answer to British screen comedy.

rebellion and kitchen-sink reality of the period when she was cast as Linda, opposite Barry Evans, in *Here We Go Round the Mulberry Bush* and Ruby in *Up the Junction*.

She relished working for Betty Box, playing Drummond's Daily in *Some Girls Do*, the adorable Maggie Hyde in *Percy* and Percy, PC 217, in *Percy's Progress*. Indeed, her sex comedy assignments could shift from sweetly demure to the outlandish cabaret star Lisa Moroni in *Adventures of a Private Eye* – a pitch-perfect, wide-eyed pastiche of Liza Minnelli. Adrienne could do it all: from Chekhov's *The Cherry Orchard* for the *BBC Play of the Month* to music-hall superstar Marie Lloyd in *Edward the Seventh*.

In between all that she had flirted with big screen spin-offs of popular television sitcoms: limp of eye and sorrowful of nature as Scrubba, alongside Frankie Howerd, in *Up Pompeii!* (1971) and as Rita, stepping in for Una Stubbs in *The Alf Garnett Saga* (1972).

Adrienne was back with the Garnetts, in the *Till Death Us Do Part* television episode 'Party Night' (30 January 1974). In a figure-hugging sparkling outfit and fur hat she was the image of the modern girl.

Just perfect then to play Norma Baxter in *Carry On Behind*, with a marriage (to Ian Lavender) dominated by her passion for her wolfhound, and hilarious suspicions arising from night-time bumbling round the tent of Bernard Bresslaw. Pure farce.

Straight after filming, Adrienne flew off to America to super-substitute for Goldie Hawn in *Rowan and Martin's Laugh-In*, while back in Britain she channelled her inner Marilyn Monroe for a regional tour of *The Seven Year Itch*, and enjoyed a reunion with Kenneth Connor for that pantomime season. She starred as Aladdin, at the New Victoria Theatre, and was delighted that *Carry On Behind* was playing British cinemas at the time.

Still a stupid boy in television's *Dad's Army*, Ian Lavender was a stupid husband, Joe Baxter, married to Norma (Adrienne Posta), and saddled with a huge wolfhound, in Dave Freeman's joyous caravanning romp *Carry On Behind*.

Major Leep (Kenneth Connor) runs his caravan site like a military operation. His only weakness being the fairer sex, and few fairer than Norma Baxter (Adrienne Posta), on the lookout for a Peeping Tom. Spoiler Alert: it's the cheeky mynah bird of Joan Sims!

DIANA DARVEY (1945–2000)

Diana made her first appearance in the chorus of a pantomime at the age of 17. The following year, she was hired as a Redcoat at Butlins. Touring Europe as part of a ballet troupe, she settled in Madrid, performing musical theatre and cabaret, and catching the eye of a certain Benny Hill who was holidaying on the continent.

Making her first appearance on *The Benny Hill Show* on 7 February 1974, Diana's easy charm with a classic from the great American songbook was clear to hear. In the Benny Hill-approved lexicon her dumplings were always on the point of boiling over. The figure-hugging 'party frock' Diana slipped on when she joined the team to play Maureen in *Carry On Behind* in the spring of 1975 certainly left little to the imagination. It undoubtedly attracts the attention of likely lad caravanners Ernie (Jack Douglas) and Fred (Windsor Davies). The chairs, still wet with paint, provide a ripping climax, with Diana's character just one of the young ladies cheekily exposed.

After a ripping night in the caravan site bar, Carol (Sherrie Hewson), Ernie (Jack Douglas), Maureen (Diana Darvey), Sandra (Carol Hawkins), Sally (Georgina Moon) and Fred (Windsor Davies) are caught in a – thoroughly innocent – compromising position, in *Carry On Behind*.

JENNY COX

Jenny was asked to perform a striptease – twice – for 1975's *Carry On Behind*: once as a film within a film during the misunderstanding during the lecture on archaeology by Professor Crump (Kenneth Williams) and, secondly, live, up close and in person, as a result of the confusion of a 'stripper' recruited for the caravan site cabaret (they wanted a paint stripper, you see). Jenny was nervous but fabulous on the day and, according to the publicity brochure for the film, she got a huge round of applause from the seasoned *Carry On*-ers Kenneth Williams, Joan Sims, Bernard Bresslaw and Jack Douglas after filming the scene. Jenny was in fact no stranger to shedding her clothes for the purposes of entertainment, for she had just been appearing in extensive regional tours of mildly naughty stage productions: *The Dirtiest Show in Town* and *Pyjama Tops*.

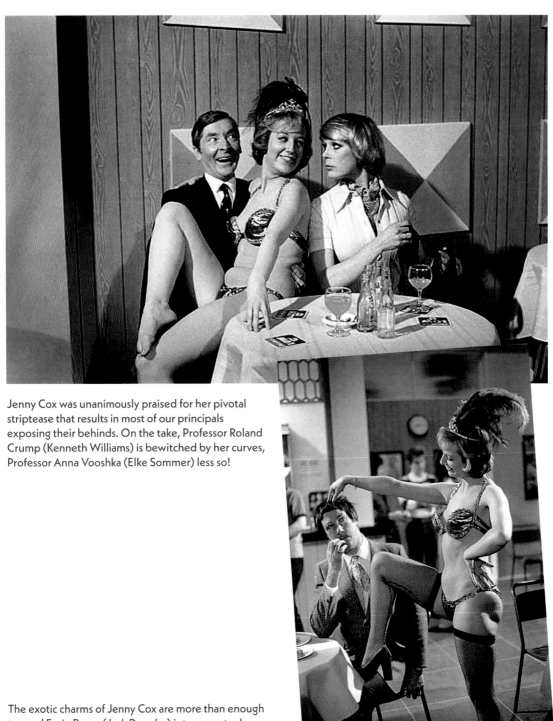

Jenny Cox was unanimously praised for her pivotal striptease that results in most of our principals exposing their behinds. On the take, Professor Roland Crump (Kenneth Williams) is bewitched by her curves, Professor Anna Vooshka (Elke Sommer) less so!

The exotic charms of Jenny Cox are more than enough to send Ernie Bragg (Jack Douglas) into perpetual jitters, in *Carry On Behind*.

HELLI LOUISE JACOBSON (1949–2018)

Born in Copenhagen, Denmark, Helli moved to England to study at the London Film School, and soon her stunning blonde looks were getting her work in such films as *Soft Beds, Hard Battles* (1973), with Peter Sellers, and *Confessions of a Pop Performer* (1975), with Robin Askwith. The roles invariably required Helli Louise to shed her clothing, and she was more than happy to oblige. Certainly, her only *Carry On* appearance, as the young lady taking a shower in *Carry On Behind*, saw her atypically shocked by the unexpected appearance of Peter Butterworth, unwittingly revealing her nakedness. Surprising, considering her most recent film work and, even more surprising, considering she was appearing in the musical *Hair* at the time. The *Carry On* then was real acting.

That delightful broken Scandinavian-cum-Cockney delivery of hers, coupled with her freedom of sexuality on screen, allowed Helli Louise to really make a mark in comedy: she was thrice a feed for *The Goodies*, playing Peter Jones's frisky secretary Eskimo Nell, who tests the energy of 'Winter Olympics' competitors, the puppy-petting game-show hostess in 'The Goodies and the Beanstalk', and the delectable Dana in 'The Race'. She was a favourite of Benny Hill too. Naturally …

So impactful and good was Helli Louise's shower exposure scene in *Carry On Behind* that it was used for the opening credits of the compilation film *That's Carry On* two years later. Here, with only a few more clothes on, from the casting file from producer Peter Rogers.

VIVIENNE JOHNSON

As well as proving a useful way of keeping the *Carry On*s carrying on between feature films, the ATV series *Carry On Laughing* was often used as a way to try out new talent alongside the established team. One such case is Sheffield-born Vivienne Johnson who was cast as flirty

Hoarding for the Great War: Downstairs staff Lilly (Carol Hawkins), Mrs Breeches (Joan Sims), and Teeny (Vivienne Johnson) get down to it as butler Clodson (Jack Douglas) reads his newspaper, in *Carry On Laughing*: 'Who Needs Kitchener?'.

Freda Filey in 'The Case of the Coughing Parrot'. Intrepid 1920s detectives Flimsy and Punter (Jack Douglas and Kenneth Connor) are on the case of yet another mystery when the trail leads them to a shady takeaway tuck wagon, run, of course, by an overspilling Ms Johnson. Broadcast in the November of 1975, the series would also showcase Vivienne as Teeny, a delightfully dippy member of the grand Edwardian household of dithering Sir Harry Bulger-Plunger (Kenneth Connor).

Vivienne's skill in underplaying the most outrageous of innuendo with unaware charm was more than enough to secure her the role of Freda in *Carry On England*, in the spring of 1976.

Much of *Carry On* director Gerald Thomas's time in early 1977 was taken up working alongside his dear friend, scriptwriter Vince Powell, on their Thames Television vehicle for John Inman. *Odd Man Out* told the tale of a Blackpool fish 'n' chip owner, Neville Sutcliffe (Inman, of course) who

Vivienne Johnson, running the tea stall business as buxom Freda Filey in *Carry On Laughing*: 'The Case of the Coughing Parrot'.

inherits his father's rock factory and emporium in Littlehampton (where else?). Best remembered now for sterling support by *Carry On* hero Peter Butterworth, whose role as factory worker Wilf gloried in the catchphrase 'How's your rock, cock?', Vivienne, with her busty substances and shock of peroxide blonde hair, was cast as Marilyn. Utilising a distinct West Country drawl and foolishly spending most of her time shamelessly flirting with Inman's character, her party trick is bending sweet candy bananas with her knees. Very bendy those bananas. And very bendy Vivienne's knees, it would seem. *Odd Man Out* only lasted for one series, transmitted from the end of October 1977. However, it was a natural leg up and stocking top down for Vivienne to join Inman over on the BBC, in his most laughter-guaranteed environs of the Grace Brothers department store in *Are You Being Served?* Vivienne played the fulsome personal nurse to Young Mr Grace (Harold Bennett).

SUSAN SKIPPER

Susan Skipper's long and illustrious career ranges from appearing as Pat Cooper in Terence Rattigan's *Separate Tables* at the Mill Theatre in Sonning, to becoming the first female voice of the satnav. She is best loved as Victoria Bourne in the 1970s television series *The Cedar Tree*.

Having graduated from the Central School of Speech and Drama, Susan's early acting work included a television debut in the Thames Television anthology series *Rooms*: 'Jo and Anne'. Her one and only brush with *Carry On* followed swiftly on its heels. She plays Mabel, at the Court of King Arthur (Kenneth Connor), in *Carry On Laughing*: 'Short Knight, Long Daze'.

JUDY GEESON

The older sister of our Sally, Judy too attended the Corona Stage Academy, an establishment whose reputation was for 'turning out individual adults' rather than clichéd types. Judy made her stage debut in 1957, making several uncredited appearances in films following alongside her modelling assignments.

On television, she made her debut in *Dixon of Dock Green* at the age of 12, and appeared in *The Probation Officer* in July 1962. By the close of the 1960s she was one of *the* faces of the decade, memorably playing East End schoolgirl Pamela Dare in *To Sir, With Love* (1967) opposite Sidney Poitier; Angela Rivers in *Berserk!* (1967), with Diana Dors and Joan Crawford; and free-wheeling Mary Gloucester in 1968's hip and happening reflection of swinging sixties culture *Here We Go Round the Mulberry Bush*. In *Prudence and the Pill* (1968), starring Hollywood royalty David Niven and Deborah Kerr, Judy was the teenage daughter of Henry and Grace Hardcastle (Robert Coote and Joyce Redman). *Three into Two Won't Go*, directed by Peter Hall, starred Rod Steiger and

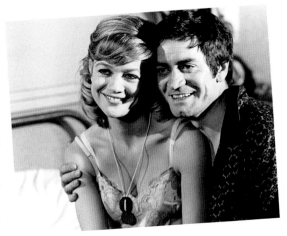

Judy Geeson and Patrick Mower as the latest love interest for the series, posing during the laughter-filled filming of *Carry On England*, in May 1976.

Claire Bloom as Steve and Frances Howard, who see their childless middle-class existence invaded by young and sexy Judy as Ella Patterson. She is a teenage hitchhiker who seduces the husband and ends up at the family home, pregnant and

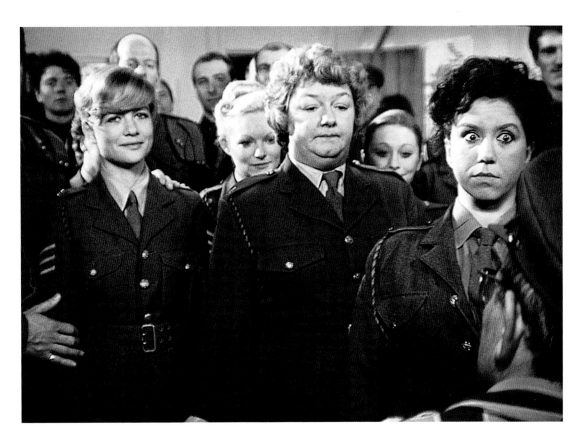

Note Kenneth Connor has his glasses on, so this is a *Carry On England* rehearsal for the troop and five of our beloved *Carry On* girls: Judy Geeson, Linda Regan, Joan Sims, Louise Burton and Diane Langton.

desperate for help. It's the third element that won't go into two, obviously, and it was something of a revelation when it was first released in July 1969. The cinema of Judy Geeson was really tackling the issues of permissiveness and liberation that were the real talking points of the day. The *Carry On* gang may have been battling the bulge in *Carry On Again, Doctor*; Judy was tackling even more pressing social questions.

While Judy's glittering film career had already seen her working alongside Richard Attenborough (*Ten Rillington Place*); Peter Cushing (*Fear in the Night*) and even John Wayne (*Brannigan*), it is undoubtedly the *Carry On* that was the most joyous experience:

It is a most enjoyable and relaxing experience, with none of the strain and tension you

get on some films. As Jack Douglas says, the director Gerald Thomas has a way of painting a scene visually instead of filling your head with words. The producer, Peter Rogers, is on the set every day. He even has a little office in a shed on location, and he seems to know instinctively when anyone is worried about anything and wants to discuss it with him.

Again, although a historical romp, set at the peak of the Second World War, *Carry On England* saw Judy as a free-thinking, self-contained young woman. Sergeant Tilly Willing is strong and sexy,

brave and belligerent, coy and comical. The very model of a modern woman in 1940s battledress. In the wake of her time as part of the *Carry On* team, Judy found herself immediately back in khaki for the film *The Eagle Has Landed*, and the television series *Danger UXB*.

And when *Carry On England* first hit British television during the Christmas fortnight of 1982, Judy had been touring in the Yvonne Arnaud Theatre production of George Bernard Shaw's *Getting Married*. Also in the cast was Kenneth Connor. 'It was all just lovely. It brought back such happy, happy memories.'

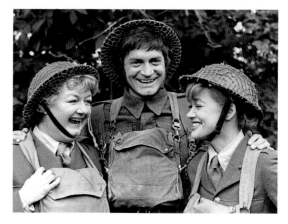

Joan Sims welcomes the newest *Carry On* stars Patrick Mower and Judy Geeson, in the grounds of Pinewood Studios, for *Carry On England*.

TRICIA NEWBY

Tricia brightened up two tail-ender *Carry On* classics with her cheery smile and cheerful disregard for a blouse. In *Carry On England*, she leads the half-naked parade of female squaddies, while in *Carry On Emmannuelle* she is the assistant to Doctor Albert Moses who, unperturbed and professional, opens up her white top coat to reveal her naked breasts. This is to helpfully prove to Emile Prevert (Kenneth Williams) that his manhood is in perfect working order.

Tricia's first television appearance was in comedy drama *Moody and Pegg*, along with hip and happening Adrienne Posta (just a few months before she joined the gang with *Carry On Behind*).

Tricia's other films include more gleeful slap and tickle: the role of Betty in *The Bawdy Adventures of Tom Jones*; and a saucy French girl in *Aces High* (both 1976).

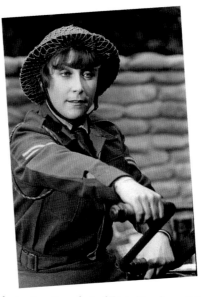

A fantastic action shot of Tricia Newby as Private Murray, during the anti-aircraft attack climax of *Carry On England*. Tricia was also happy to pop out of her uniform, stepping in for a reluctant Judy Geeson during the topless parade ground scene.

LOUISE BURTON

Louise Burton was a Brighton belle fresh out of drama school when she was invited to join the team for the khaki comedy *Carry On England*.

As with all the girls in that, now legendary, fall-out parade, Louise's contract included a special clause that specified 'the artiste will be requested to appear nude to the waist during the filming'. Louise says, 'I didn't mind! I was ready for anything! I was just so thrilled to be in a *Carry On* film. It was all so exciting …'

Louise caught the eye of the resident head of the *Carry On* cast, Kenneth Connor:

> Ooh, I loved Kenny Connor. Such a lovely man!! I arrived on set and he whispered in my 17-year-old ear, 'Well … I think you're lovely!!! I don't care what others think!!' He then spent the rest of the day apologising in case I hadn't realised he was joking!! Lovely, lovely man. A laugh a minute.

She certainly made an impression on Peter Rogers too. It may have been two years since filming *England* but, at the earliest opportunity, he employed her on *Carry On Emmannuelle* on location at London Zoo, with butler Lyons (Jack Douglas) and a gorilla (who else but Reuben Martin). Louise, in low-cut top and grasping her iconic lollipop emblazoned with the word 'Knickers', threw herself into the saucy slapstick of the scene: an impromptu liaison in the English rain. It's hilarious, romantic, and very, very *Carry On*. Little wonder then that Louise was in the frame and in the proposed casting list for the planned but never filmed *Carry On Again Nurse*. Louise was to have played a prominent role as one of the nurses, all set to get the pulses of the nation racing.

Louise Burton in khaki and in character as Private Evans, and charming Peter Rogers, making his twenty-eighth *Carry On* film, *Carry On* England, in the grounds of Pinewood Studios. Melvyn Hayes and Barbara Rosenblat join in on the frolics.

Just when she should have been at Pinewood Studios filming that *Carry On*, Louise did get to play a sexy nurse in the *Mind Your Language* episode 'No Flowers by Request', transmitted in the November of 1979. And, on stage, she had cavorted with Robin Askwith in the touring production of *The Further Confessions of a Window Cleaner*. Louise long held a desire to leave the scantily clad lovelies behind and concentrate on Shakespearian roles. Toward the end of his tenure as artistic director of the Royal Shakespeare Company in 1978, Trevor Nunn cast Louise as Phoebe in *As You Like It*:

> He told me I was perfect for the role. I was thrilled, of course, but the RSC contract specified I had to be employed for the whole season and Trevor only wanted me for that one play … So it was not to be.

Still, it was the Jeremy Lloyd and David Croft sitcom *Are You Being Served?* that galvanised her sexy image. As Virginia Edwards, secretary to Old Mr Grace (Kenneth Waller), Louise wiggled and weaved her way through Grace Brothers department store, happily took dictation while perched on her employer's lap and expertly underplayed every glorious innuendo the writers gave her. The show, like her *Carry On*s, remains an international cult success.

ANNE ASTON

Glaswegian Anne Aston successfully auditioned for *The Golden Shot* girl and, whittled down from 100 hopefuls, made her first appearance just after her twenty-first birthday in January 1969. 'I'd seen the girls on it and thought how pretty and lovely they were and how amazing it would be to have a job like that,' she told the *Daily Express* in 2017. To an audience of 16 million, her kooky good looks and less than proficient grasp of mathematics made her something of a national figure. Host Bob Monkhouse knew comedy gold when he saw it, and would cheerfully send her up, joking that she couldn't even count to two unless she lifted up her jumper! Anne was delighted, and remembered Bob as 'very kind, always trying to help you get a laugh as well as him. He was witty off camera too.'

Anne's special 'with ...' bill on the poster for the 1976 summer season show *Carry On Laughing*.

Comedy film roles were swift to come, most memorably as the dippy Princess Lobelia in *Up the Chastity Belt*, a medieval romp scripted by Ray Galton and Alan Simpson, for Frankie Howerd. In 1973, she joined the established cast of *There's a Girl in My Soup*, and went on tour in the role of Marion, which had also been played by Katy Manning.

In 1974, Anne capitalised on her *Golden Shot* fame by launching her own line of fashion wear called Golden Made, of course! Then in October that year she attempted a pop recording career with the Martin Rushent-produced single *I Can't Stop Myself from Loving You Babe*. Released on the Pye Records label, it failed to chart and is now something of a collector's item. Fittingly, from 1975 she hosted Southern Television's *Goin' a Bundle*, a children's programme about collectors and their collections.

She joined the *Carry On* team, on stage as Candy Maple, a stripper who feels her belly is getting too big for the 'Belly' dance, though no full-blooded male can see the reason for her concern. It was perfect for the sunshine personality of Anne Aston. Although the hot summer of 1976 put pay to any commercial success for the show, Anne acquitted herself admirably and, before the rather less than encouraging box-office receipts were totted up, Peter Rogers was already planning another summer season run for 1977. Anne was cast as saucy Scots maid Nancy McSmith in *Who Goes Bare?*, due to be performed as *What a Carry On*. Alas, the official *Carry On* branding of the play never happened, and with it vanished Anne's opportunity to carry on further.

Anne went on to appear in pantomime, starring as Cinderella at the Alhambra, Bradford, for the 1977/78 season, alongside Bernard Bresslaw, as

Anne Aston didn't need her winter clothes for *Carry On Laughing*. It was the hottest summer on record, and the year of the ladybirds.

ugly sister Bernadette, and Dora Bryan, as the Fairy Godmother. Later Anne went into property development, leaving the roar of the crowd and the smell of the greasepaint far behind, but even now, she says, 'I feel about 40. If I put my make-up on I still get recognised. I've got the same sort of blonde hairdo and I still get the line, "Didn't you used to be …?"'

Yes, she did. And yes, she is a *Carry On* girl. For always.

SUZANNE DANIELLE

While Australian novelist Lance Peters was credited for writing the original screenplay for *Carry On Emmannuelle*, Peter Rogers was adamant that the book had very little to do with the film. Even refusing the publisher permission to include stills within the publication. Rogers himself 're-wrote the Peters script out of existence' before Gerald Thomas approached his good chum Vince Powell, the pair having just worked together on the sitcom *Odd Man Out*.

Powell's major television hit at the time was *Mind Your Language*, the series that had made a major comedy star of Françoise Pascal. As the delectable French Danielle on television, Françoise was Powell's first thought when it came to casting Emmannuelle Prevert. She said:

> I had just done naughty comedy for Robert Young, *Keep It Up Downstairs*, a sexy bit of fun set in an Edwardian house. A sort of *Carry On Upstairs, Downstairs*. I was the saucy maid. Of course. All popping blouses and stocking tops. I had decided after that film not to do any more roles like that. The *Carry On* came along at just the wrong time. When I had made that decision. I don't have many regrets but I do wish I had done that film!

In the end the role went to Suzanne Danielle. Having trained as a dancer at the Bush Davies School of Theatre Arts in her home town of Romford in Essex, Suzanne landed her first West End experience in the chorus of *Billy*, alongside Michael Crawford, at the Theatre Royal, Drury Lane, in May 1974. Soon after she was recruited for the Bruce Forsyth spectacular *Bruce and More Girls*, and made a clutch of decorative appearances in film and television. She

A bulging portfolio of publicity shots were taken of Suzanne Danielle during the spring 1978 production of *Carry On Emmannuelle*. As co-star Jack Douglas recalled, 'We all fell madly in love with Suzanne. Of course. Beautiful. A brilliant actress, and the nicest person to have on the set. I just wish we could have carried on ... if you follow me!'

was credited as Pretty Girl in *The Professionals* episode 'Killer with a Long Arm', went uncredited as a Girl at Party in *The Wild Geese*, and a disco dancer in *The Stud* (all 1978). Uncredited maybe but not unnoticed, the Jackie Collins film earned her the press nickname of 'The

Suzanne Danielle sporting a natty pair of bed socks to keep her feet warm during a discussion about a scene in *Carry On Emmannuelle*. She immediately meshed with the established team: here with Gerald Thomas, directing his thirtieth *Carry On* film, and Kenneth Williams, starring in his twenty-sixth.

Body'. All of which more than justified the *Carry On* team taking a chance on her for their new leading lady.

Suzanne's agent Hazel Malone secured her a fee of £2,750 for twenty-one days of filming over the five-week schedule. Her contract specified that 'the artist agrees to appear nude in certain scenes as discussed and agreed with the director' which was understandable given the subject matter. Still, rather surprisingly, it was hoped that the British Board of Film Classification would grant the film a 'U' certificate.

They swiftly listed the cuts needed to achieve this, most of which involved Suzanne's scantily clad exploits, including: 'Bare breasted girl goes upstairs. Two shots of a woman in bed with her husband & her leg over him. Dialogue "Bullshit". Emmannuelle seen from rear & nude in the shower. Emmannuelle bends over & lifts dress in front of the sentry …'

Realising that there would be little left, the decision was made to accept the 'AA' certificate. It would mean losing that family-orientated audience for the pantomime season release in 1978 but the trailer was keen to signpost this as a new era in the series: 'Peter Rogers and Gerald Thomas add a dash of French undressing to good old English relish in the sauciest *Carry On* of them all.' *Films and Filming* (volume 25, 1978) stated: 'Many of the stalwarts … are reduced to support for the eponymous hero- ine in the athletic and long-legged person of Suzanne Danielle.'

She is a sexually confident, adventurous and, above all, fun-loving personification of the revolution of women being in control of their own bodies – and their own destinies.

The film was and is incorrectly perceived as being too obscene; however, in the 1960s and 1970s these films were appearing in the form of softcore sex films. These were starting to dominate British cinema. In fact, during the 1970s, when politically the country was facing financial tumult, this was one of the few genres that was a sure-fire commercial prospect. Alongside sitcom spin-offs, these films were incredibly cheap to make. Even the British Film Institute credits earlier *Carry On* films as building blocks in the development of British smut. Therefore, it is hardly surprising we end up with *Carry On Emmannuelle* marking the final fade out of the 1970s *Carry On* films.

Emmannuelle is a positive representation of a sexually liberated, free woman. While many audiences dislike the film, it has one of the strongest female leads in the series: a sexual predator who loves sex and gets sex. We see this character echoed almost twenty years on with the role of Samantha (Kim Cattrall) in *Sex and the City*. Even that role now has its critics, along with the series in general, its sexually empowered women not being too far a cry away from those in the *Carry On* films. Politically, *Emmannuelle* came just before Margaret Thatcher and the 1980s, which is seen as the period of the superwoman. In 1980, we also saw that women could finally apply for credit cards and loans, and by 1982 women were also no longer to be refused a drink in a British pub. Women were starting to be liberated and free.

The character Suzanne plays demonstrates female triumph over the men who look on at her. The character even says, 'None of them had a weapon for me to worry about!' We've lost the characters such as Bernie Bishop (Kenneth Connor) who takes a sneaky look at a nurse standing at the bedside table, or the Admiral (Peter Butterworth) in *Carry On Girls*, who looks through a telescope

The personification of the sexually liberated screen character: Suzanne Danielle is fully in control as Emmannuelle Prevert in *Carry On Emmannuelle*.

to get a sneaky glance. Emmannuelle doesn't care if they look or not look, in fact she wants them to look. *Carry On England* too had given the girls the upper hand. There was confidence in their nakedness – much to the embarrassment of Kenneth Connor and Windsor Davies.

It harked back to the earliest ingénues of Shirley Eaton, and the doe-eyed simpleton of Cleo. She may be a little slow on the uptake but she certainly isn't sexually naive. She is at one with her sexuality, and sexual desires.

Subsequent notable screen roles for Suzanne include fantasy: as an Eastern dancer in *Arabian Adventure* (1979), and a serving girl in *Flash Gordon* (1980); comedy: Candice Rawlinson in *Sir Henry at Rawlinson End* (1980), and Kim alongside Tommy Cannon and Bobby Ball in *The Boys in Blue* (1982); and television chills as Agella the Movellan in *Doctor Who*: 'Destiny of the Daleks' (1979), and the deadly attractive

Natalie in *Hammer House of Horror*: 'Carpathian Eagle' (1980).

She was equally as seductive as Lola Pagola in *Jane*, the 1982 resurrection of Norman Pett's *Daily Mail* comic strip, and relished light entertainment exposure as a regular player of *Give Us a Clue*, and a frequent cohort of Eric Morecambe and Ernie Wise, and impressionist Mike Yarwood. Suzanne was of the zeitgeist with her breathy impersonation of Lady Diana Spencer.

The early 1980s also saw her tour the Far East and New Zealand in *The Monkey Walk*, John Murray's two-hander in which she starred with long-term boyfriend Patrick Mower. For the 1985/86 pantomime season she starred in the Richmond Theatre's production of *Jack and the Beanstalk*, reunited with *Carry On* co-stars Kenneth Connor and Joan Sims.

She met champion golfer Sam Torrance in 1986 and married him two years later, just before the long-delayed release of Burt Kennedy's comedy film *The Trouble with Spies*, which featured Suzanne as Maria Sola.

However, it is Suzanne's iconic performance as Emmannuelle for which she is best remembered. In the role Suzanne rings in a new era of women, adding her own insight and natural sense of fun to the scripted role. As a result, her performance allowed for the development of female liberated characters in comedy.

BERYL REID OBE (1919–1996)

A BAFTA- and Tony-winning, copper-bottomed National Treasure, Beryl's diverse and dazzling credits range from *The Killing of Sister George* to *Smiley's People*. Her British film classics include monocled schoolteacher Miss Wilson in *The Belles of St. Trinians* (1954) and Bertha Hunter in *No Sex Please, We're British* (1973). As a matter of fact, Beryl witnessed plenty of sex, as Matron in *Rosie Dixon – Night Nurse* (1979), and whilst worrying about her overly protected, sex-obsessed son (Larry Dann) in *Carry On Emmannuelle*. There's a wealth of stagecraft, radio comic characterisation, and malicious kindness at play in her self-contained maternal scenes. This mother knows exactly what she is doing: manipulating and controlling with the sweetest of intonations masking the most cynical of observations. A masterclass.

Beryl Reid brought a lifetime's experience in both comedy and drama to her guest starring supporting role as mollycoddling mother Mrs Valentine, in *Carry On Emmannuelle*.

DAME MAUREEN LIPMAN

Maureen studied at the London Academy of Music and Dramatic Art. She made her debut in *The Knack*, at the Watford Palace Theatre, and from 1971 was a member of Laurence Olivier's National Theatre Company, at the Old Vic. From 1973, she worked as part of the Royal Shakespeare Company. Maureen's earliest television appearances included sitcoms *The Lovers, Doctor at Large*: 'Saturday Matinee' (9 May 1971), and the starring role of agony aunt Jane Lucas in the London Weekend Television hit *Agony* (1979-81), reprising the role for the BBC series *Agony Again*, in 1995.

In the meantime, she had launched her critically acclaimed solo show celebration of Joyce Grenfell, *Re:Joyce!*. She had also starred in the anthology comedy showcase *About Face*, the second series of which was broadcast in early 1991, and liberally displayed her comedic versatility.

The call to join the *Carry On* team was just twelve months away:

From literally bumping into a visiting party of nuns from the local convent – honestly! – to working with the most elite and fun bunch of people in the industry, the *Carry On* was a delight from start to finish. The only nerve-wracking thing was that on my first day I spoke the first line and, of course, you never rehearse on a film, you just sort of do it, and nobody, including me, seemed to know what my character was supposed to be doing there! The plot was all about my daughter falling in love with Columbus' brother, and I was this ogress of a Spanish lady, just in it for the money and ending up sailing to the West Indies … or somewhere! I ended up phoning the writer [Dave Freeman] in a bit of a panic, because I was told I wasn't allowed to use a Spanish accent. He said, 'Have you thought of having a fan?' Great *Carry On* philosophy – if in doubt, hold something!

2176
CARRY ON COLUMBUS
Countess Esmeralda (Maureen Lipman) and Felipe
(Richard Wilson) plot the downfall of Chris Columbus
DISTRIBUTED BY UNITED INTERNATIONAL PICTURES (UK)

Don Juan Felipe (Richard Wilson) and Countess Esmeralda (Maureen Lipman) plot the downfall of intrepid explorer Chris Columbus in *Carry On Columbus* (1992).

A stunning publicity pose of Maureen Lipman as the Countess Esmeralda in *Carry On Columbus* (1992). Without fan!

SARA CROWE

At the time of her casting as the female lead, Fatima, in *Carry On Columbus*, Sara was best known and best loved as that silly, snorting blonde in the Philadelphia Cheese adverts with friend Ann Bryson. By 1990, Sara was already an accomplished interpreter of the works of Noël Coward – nominated for an Olivier Award for Best Comedy Performance as Jackie Coryton in *Hay Fever*, and winning the London Critics' Circle Theatre Award for Most Promising Newcomer as Sibyl Chase, in *Private Lives*.

Sara made quite the impact on *Carry On* – even marrying cast member and Columbus stand-in Toby Dale. The *Carry On* crew were certainly bewitched by her performance, with Peter Rogers categorically saying that he would cast her in any subsequent *Carry On*s that may go into production.

Sara Crowe, as the duplicitous Fatima, and Jim Dale as Chris Columbus, promoting *Carry On Columbus* for the October 1992 release.

REBECCA LACEY

Watford-born Rebecca Lacey took on the role of Chiquita in *Carry On Columbus* – the part that Barbara Windsor would have played twenty years earlier. Rebecca's petite figure, cute persona, blonde locks and cheeky smile fully tapped into the old *Carry On* tradition. Indeed, critics and fans alike attest that she shared one of the greatest jokes in the film – one of the greatest jokes in the series – with seasoned *Carry On* warhorse Jack Douglas. Watching sharks, man-eating sharks, as she looks overboard from the *Santa Maria*, Rebecca is coquettish, though worried. 'Goodness, you don't think they'll eat me whole?' 'No, I'm told they spit that bit out!' replies Jack.

He is deadpan and succinct, his funny bones not twitching but polished. That she gives such a controlled and balanced performance is testament to Rebecca's professionalism too. Her father, the sublime actor Ronald Lacey, had died less than a year before, in May 1991, but her commitment to frivolous fun and corny comedy is clear to see. Rebecca brings the same quality as she was giving to the wonderfully dippy Hilary in the BBC sitcom *May to December*.

SARA STOCKBRIDGE

Talking of belting lines in *Carry On Columbus*, model and trend-setter Sara Stockbridge may only pop in and out for the most eye-catching of cameos, but she has a cultural cracker alongside wannabe artist Bart Columbus (Peter Richardson) and wry map-maker Chris Columbus, the mighty Jim Dale. Jim mugs and milks and makes gold out of the Dave Freeman quip, as Sara, mirroring her 1990s modelling career, reflects that master painter Michelangelo is going to 'do me up on the ceiling'. 'Well mind you hang on to something while you're up there ...' chuckles Jim. Sara was a favoured fashion model for exquisite designer Vivienne Westwood, and had an air of punk freedom and slender chic even in the world of lads' mags and angry satire that she populated. Interestingly enough, Sara had been a guest on a January 1991 edition of *Tonight with Jonathan Ross*, alongside fellow guest Jim Dale. Jim was chuffed at Ross's fandom, but philosophical that the time for new *Carry On* was gone, believing them to be a lovely museum piece. A little over a year is a lifetime on planet showbiz!

HOLLY AIRD

Demure, loving, sweet and fresh-faced, Holly Aird, as Maria, gives a small but really rather beautiful supporting ingénue performance, taking up the baton of Angela Douglas and Jacki Piper. Holly plays the *Carry On Columbus* script with complete conviction, nay, affection. While her potential lover, Peter Richardson, is all wide-eyed expressions and overly confident, boasting Holly's performance is quiet, contained and measured; perfectly still and sentimental for that massive screen on which it was first seen. Director Gerald Thomas was particularly impressed with her intuitive understanding of the small gestures that work best for the cinema, particularly considering she was more used to television at this stage in her career, playing Sgt Nancy Thorpe in *Soldier, Soldier* (1991–95) and, later, Dr Frankie Wharton in *Waking the Dead* (2000–05).

Right: 'I wonder what he has for breakfast!': *Carry On Doctor*'s roof-top drama climaxes with Dr Kilmore (Jim Dale) crashing into the bath of Jenny White (1943–2023). Jenny, who left the business to marry Granada TV floor manager and later newspaper magnate Eddie Shah, remembered that the chief concern of director Gerald Thomas was that there would be enough bubbles to cover her modesty! The scene proved popular enough for *Carry On Matron* to reprise it – that time with Gilly Grant (the star of *Carry On Camping*'s nudist film within a film) interrupted in her bath by Sidney James.

Above: Sid wasn't always so lucky. In *Carry On Doctor* he is married to Dandy Nichols (1907–86). For the two years before her *Carry On* cameo, Dandy had been beloved as that 'silly old moo' Else Garnett in the sitcom *Till Death Us Do Part*.

Left: In 1992 the compilation television shows of the early 1980s were commercially released, this collection capitalising on the eternal appeal of the hospital films.

CARRY ON GIRLS CARRY ON ...

We now find ourselves in the twenty-first century, with celebration of women at the forefront of our society. We observe International Women's Day, reflecting on the remarkable achievement of women who have helped to make the world a better place. It would be too difficult to single out the women who have and continue to achieve that, but we can reflect on these *Carry On* girls and the small part they contributed to our social history. Be it something you agree or disagree with, these ladies have made a mark and represented a time of strong change for women.

Ultimately though, these films are fun, good clean family fun. Yes, we can look back and say 'oh you wouldn't get away with that now' but it's important not to erase these films from history altogether. They represent a time and place and, ultimately, we can learn from them, both the fantastic comedy and attitudes which have changed.

For the twenty-first-century women, we know that unlike me, they won't be stumbling across these films in a Blockbuster, and seeing the likes of our beautiful Valerie Leon on the cover. I see my role now as introducing my young niece to these films and saying this was a time when her grandparents were growing up, and as your aunt I was introduced to them by my grandmother. It's the family factor here that really counts. Through family, we can show the next generation what life was all about in the twentieth century. They may love them or hate them, but *Carry On* will bring people together to discuss them.

It's also good to remember, there's not one clear *Carry On* girl; we all have our favourites, but these women complement one another and have incredible affection towards each other. Something we can all take away is having your colleagues', friends' or family members' backs.

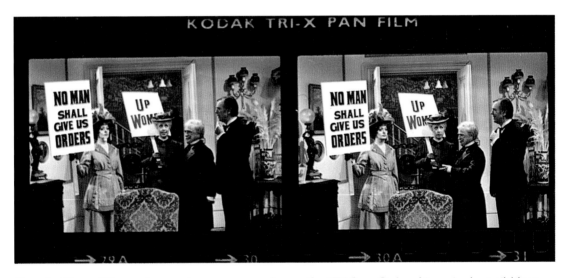

Votes For Women! Unseen for seventeen years, 1992 also saw the ATV *Carry On Laughing* episodes available on home video. Here Virginia (Sherrie Hewson) rallies the downstairs staff around her support of the Suffragette movement in 'Who Needs Kitchener?'

Author Gemma Ross in November 2015, with Barbara Windsor, at the Cinema Museum in Kennington, South London. The venue is host to many an affectionate gathering of *Carry On* players and admirers.

These ladies really do all stick together and support one another. They praise each other and miss the ones that are gone. They are simply just girls carrying on with life, and laughing their way through the highs and the lows.

From hearing the words of the girls, it's clear that the cast and crew felt it was very much a family atmosphere and that they had a sense of togetherness. What was it that brought these people all together? It was laughter. It wasn't always just about a job, it was the fact that they went to work and had a jolly good time with their colleagues. They laughed. As the great Charlie Chaplin once said, 'A day without laughter is a day wasted.' As a piece of history we can look at the *Carry On*s and say there is something for everyone, whether you are short, tall, blonde, brunette, slim, large – we come in all shapes and sizes but we all have one thing in common: laughter!

Gemma Ross

Today it's a case of 'Carry On Streaming', with the films finding a brand-new loyal audience on BritBox, who are delighting in such irresistible comic sights as Constables Kenneth Williams and Charles Hawtrey undercover and under the suspicious gaze of shop assistant Mary Law.

And this is where you came in ... Sixty-five years after pioneering the *Carry On* Girl, Shirley Eaton joins the regulars on the cover of this first in a series of blu-ray box-sets from Australian company Via Vision Entertainment. Carry On carries on...

ACKNOWLEDGEMENTS

To Mark Beynon, Alex Boulton, Rebecca Newton and all at The History Press for making the progress of this very special book so fun and fluid. It was a speedy turnaround in order to be out for Christmas 2023 and, thus, in time to mark the fiftieth anniversary of the release of *Carry On Girls*.

To Peter Rogers, producer and creator of the *Carry Ons*, who not only supported and championed Robert's research in to his work and that of his wife, Betty Box, but also entrusted so many precious images from his personal archive, many of which are published here for the first time.

To Gerald Thomas, director of the *Carry Ons*, whose tireless enthusiasm for the brand remains an inspiration; and whose foresight to preserve his papers with the British Film Institute has been a gift to the nation.

The films and shows celebrated within these pages were distributed by and have been made commercially available by Studio Canal and ITV. If you have gaps in your libraries, we hope this book encourages you to fill them.

Finally, to those all-important *Carry On* girls themselves. Each and every one of them has made a vital and vivacious contribution to a collection of comedies which continues to cheer us all up. Unless where specified, the exclusive quotes come from conversations with the authors: from chats with Joan Sims over a slice of cherry cake and diet coke in the late nineties to a jolly last-minute phone call of clarification with Louise Burton just a day before the book was signed off.

Thank you for all the love and laughter. This book is a salute to your talents.

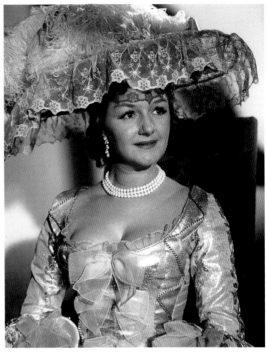

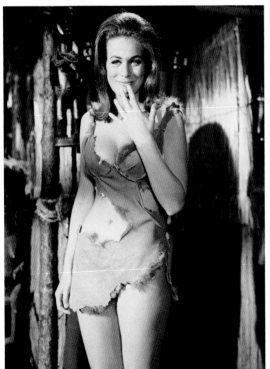

Clockwise from top left: Esma Cannon remains one of the best-loved of *Carry On* girls, here looking through the script for *Carry On Cabby*. Peter Rogers was disappointed that she retired from acting soon afterwards, keen to have employed her in his films for many more years to come.

'There's room for a few lodgers there ...' Joan Sims in a publicity pose as the bountiful and beautiful Desiree Dubarry in *Don't Lose Your Head*.

The Chayste Place Girls of *Carry On Camping*, filming outside the entrance of Heatherden Hall, Pinewood Studios, in the autumn of 1968.

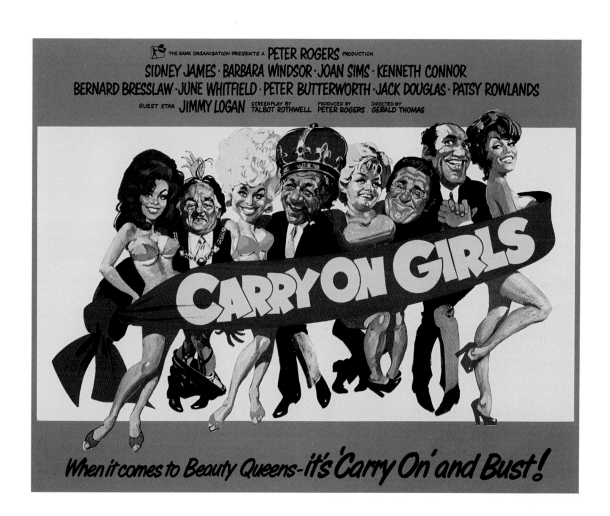

THE RANK ORGANISATION PRESENTS A PETER ROGERS PRODUCTION

SIDNEY JAMES · BARBARA WINDSOR · JOAN SIMS · KENNETH CONNOR
BERNARD BRESSLAW · JUNE WHITFIELD · PETER BUTTERWORTH · JACK DOUGLAS · PATSY ROWLANDS
GUEST STAR JIMMY LOGAN SCREENPLAY BY TALBOT ROTHWELL PRODUCED BY PETER ROGERS DIRECTED BY GERALD THOMAS

CARRY ON GIRLS

When it comes to Beauty Queens - it's 'Carry On' and Bust!

Although their names aren't billed, caricatures of Valerie Leon and Margaret Nolan flank the regular team for the film poster of *Carry On Girls*: the twenty-fifth in the series, and in cinemas for the Christmas of 1973.

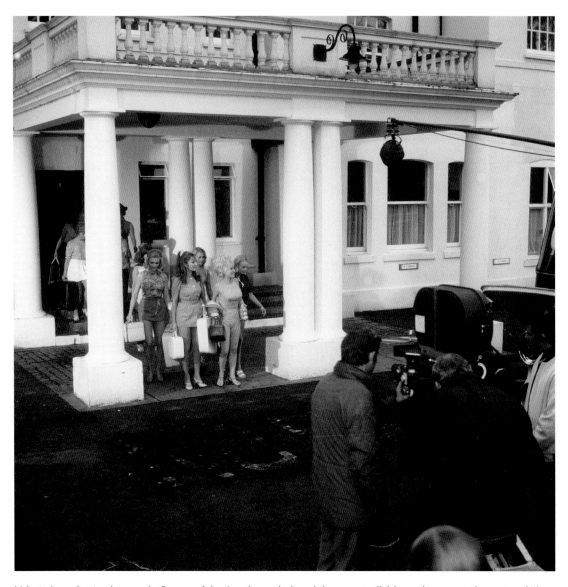

Valerie Leon letting her steely Queen of the Jungle mask slip while uncontrollably cracking up at the antics of 'the finest cinema repertory company we have ever seen ...'

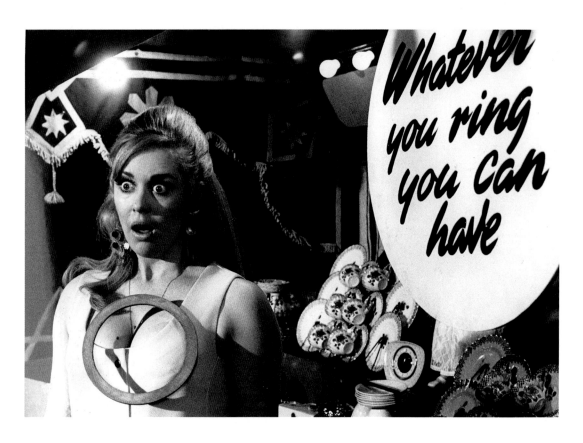

And fade out ... Jan Rossini's role as 'Hoopla Girl' on the Palace Pier, Brighton, scene for *Carry On At Your Convenience* was cut, sadly, from the final release print. A *Carry On* girl always carries on!